THE COMPLETE

AIRBRUSH *AND*

PHOTO — RETOUCHING MANUAL

PETER OWEN & JOHN SUTCLIFFE

CHARGING ■ MICHAEL ENGLISH 1977: Colin Forbes Collection, New York

THE COMPLETE
AIRBRUSH
AND
PHOTO — RETOUCHING MANUAL

NORTH
LIGHT
BOOKS

Cincinnati, Ohio

A Quarto Book

Published in North America by North Light Books,
an imprint of F & W Publications, Inc
1507 Dana Avenue, Cincinnati, Ohio 45207.
(800) 289-0963

ISBN 0-89134-170-6

Reprinted 1993, 1994, 1995

This book was designed and produced by
Quill Publishing Limited
The Old Brewery
4-6 Blundell Street
London N7 9BH

Project director Nigel Osborne
Editorial director Jim Miles
Senior editor Patricia Webster
Editors Judy Martin Emma Foa Jane Laing
Indexer Jill Ford
Designer Eva Ratanakul
Illustrators Peter Owen Simon Critchley Fraser Newman Roger Stewart
Photographers Ian Howes Bob Saunders, John Wright Photography
Brent Moore John Heseltine
Mechanicals Carol McCleeve

Filmset in Great Britain by Text Filmsetters Ltd, London
Colour origination by Rainbow Graphics Ltd, Hong Kong
Printed and bound by Leefung-Asco Printers Ltd, China

Quill would like to extend special thanks to:
The Airbrush Company; Arthur Allen, The Partnership Studios; Mike Drew, DeVilbiss Ltd;
David Draper; Ken Medwell, Conopois Instruments Ltd; Peter Nelson, Obscura Ltd;
Charles O'Farrell, Pictures Ltd; Andy Penaluna and students of the Faculty of Art and Design,
West Glamorgan Institute of Higher Education; Phil Savage, Obscura Ltd; John Shipston;
Joan Smith; Ken Warner and students of the Faculty of Art and Design, Cornwall College
of Further and Higher Education; Sue Wilkes.

The authors would also like to thank Michelle Hancock and Jacky Owen.

The extract from *Campaign* appears by courtesy of Haymarket Publications Ltd.

Joan Smith's work appears by permission of Warner Bros.

CONTENTS

CHAPTER

– TOOLS AND MATERIALS –

The basic principle of the airbrush is really very simple. A flow of air from an external source enters the body of the instrument and is directed to the tip, where it comes into contact with a flow of paint. On meeting the air, the paint atomizes and is expelled from the tip of the airbrush. The resulting fine spray, from even the most basic airbrush, can cover large areas with a rich, even coating of color. In well-qualified hands, a more sophisticated airbrush can produce controlled sprays that create a stunning array of tones and textures of almost photographic quality.

Despite a common basic principle, there are many different types of airbrush requiring varying levels of expertise and capable of performing greater or lesser tasks. At this stage, it is important to identify exactly which type is best suited to both your purpose and your pocket.

Single- and double-action

Any type of airbrush falls into one of two essential categories – single- or double-action. With single-action, the user effectively controls only the flow of air. The supply of paint is adjustable, but it must be preset and cannot be varied while actually spraying. Double-action provides continual fingertip control of both air flow and paint supply. This dual flexibility is naturally far less limiting than single-action.

The following breakdown clarifies subdivisions within these two basic categories, to give you all the information you need to assess your needs.

Single-action airbrushes

These are less expensive than their double-action counterparts, but also less professional. They are mainly suitable for work where the amount of color required is evenly spread, because the trigger controls only the air flow. You can turn the paint volume up or down, but to make the necessary adjustments you must stop spraying.

Despite this drawback, a single-action model is ideal for the beginner who does not see airbrush painting as a medium in itself, but rather as an additional dimension to a hobby. Modelers, fabric painters and ceramic artists, among others, find single action more than adequate for their purposes, with the added bonus that airbrushes of this type are easy to use and to maintain.

Single-action, external mix

This is the simplest of all airbrushes, similar in effect to an aerosol can spray but allowing the user to exercise a modicum of control. This consists of the facility to vary the spray width from about ¾in (2cm) to 2in (5cm) by adjustment of the paint tip at the front of the tool.

Unfortunately, the quality of the spray produced is relatively poor because of the 'external mix' factor. The air and paint meet outside the head of the airbrush and have little time or space to interact and diffuse thoroughly. It is difficult for this airbrush to produce really fine lines or intricate detail, except with highly skilled masking, and it has a tendency to go 'off-song' under heavy usage, obliging you to take the time and trouble to reset it. However, it is cheap, cheerful and eminently suitable for the modelmaker, amateur theater-set designer and others who wish to embellish the products of their pastimes with lively colors.

Single-action, external mix with needle

This popular model is marginally more sophisticated, in that it provides closer control over the width of the spray. It is equipped with a nozzle that directs the air jet and a needle carrying paint to air, both components being adjustable for greater or lesser paint supply. Although it delivers a much more consistent flow than its needle-less counterpart, it suffers the problems inherent with all external mix airbrushes, notably spatter and woolly-edged lines. On the credit side, most models are designed to resist solvents and paint chemicals for a prolonged working life.

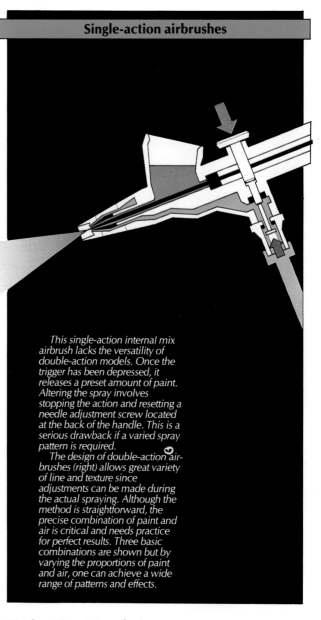

Single-action airbrushes

This single-action internal mix airbrush lacks the versatility of double-action models. Once the trigger has been depressed, it releases a preset amount of paint. Altering the spray involves stopping the action and resetting a needle adjustment screw located at the back of the handle. This is a serious drawback if a varied spray pattern is required.

The design of double-action airbrushes (right) allows great variety of line and texture since adjustments can be made during the actual spraying. Although the method is straightforward, the precise combination of paint and air is critical and needs practice for perfect results. Three basic combinations are shown but by varying the proportions of paint and air, one can achieve a wide range of patterns and effects.

Single-action, internal mix

Internal mix means that paint and air combine within the body of the airbrush to produce a much finer spray than is possible with external mix types. While you cannot control the speed or texture of paint flow on some models, you can retract the needle mechanically by adjusting the rear screw, thereby altering the spray width. Again, this is an efficient tool for the enthusiastic hobbyist but, for its price, it probably doesn't match the value of the cheapest of the double-action models now well established worldwide.

Double-action airbrushes

Generally more expensive than single-action models, double-action airbrushes are a hundred times more versatile, because you have total, touch-sensitive control over both the amount of air and the amount of paint passing through the tool. With independent double-action models, there are no mechanically preset grades of flow; the pressure of the artist's finger regulates supply.

It is this kind of airbrush that is used by professional illustrators and retouchers, but this is not to say that beginners are excluded from participation. In fact, almost anyone is capable of operating a double action airbrush – lever down for air, lever back for paint – but mastering its capabilities calls for concentration and application. If you're serious about the airbrush, then double-action is the only choice you can make and there are two types to choose from.

Independent double-action

This all-purpose tool is the most versatile and popular airbrush available. Its successful use requires a delicate balancing act in operating the finger control to achieve the desired combination of paint and air. Proportions can vary tremendously, which means the range of effects at your disposal with this type of airbrush is unlimited.

A useful aid on some models of this kind is a tubular cam on the barrel, which acts as an adjustable control lock to limit backward movement of the lever. In this way you can preset the width of your spray pattern, the failsafe mechanism preventing an over-abundance of paint. Manufacturers who do not include a cam as an integral part of their design sometimes offer the optional extra of an interchangeable handle, which can be preset to restrict the lever control.

Buying an airbrush is very much a horses for courses exercise. You don't need independent double-action for the county fair poster, but if you aspire to greater things, it's a sound investment.

Fixed double-action

Anyone who finds difficulty in mastering an independent model should consider a fixed double-action type. By their very nature they are easier to operate, though less versatile. The lever again controls both paint and air supplies, but to a fixed, preset ratio. Quality of output is excellent, and if you are prepared to take pains setting the ratios, you can produce extremely fine line work. Overall, however, fixed models have a limited capability and demand patience from the operator, rather than an advanced degree of skill.

Suction-feed and gravity-feed

How the paint is fed into the airstream is another factor that will influence your choice. Once again, there are two clear-cut categories, gravity-feed and suction-feed.

In *suction-feed* the paint is drawn up from a reservoir below the fluid channel, due to a loss of pressure caused by the air flow passing overhead. In real terms, the first advantage of a suction-feed airbrush is that large quantities of paint can be

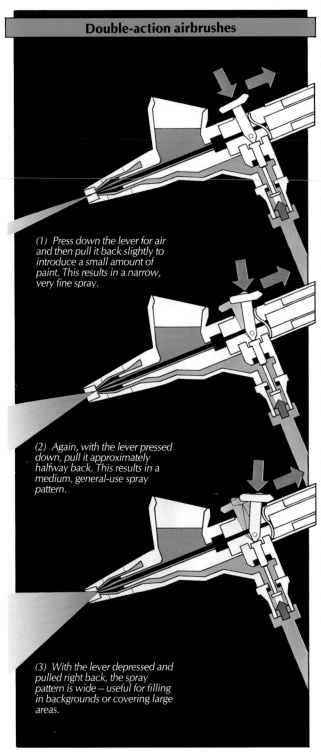

Double-action airbrushes

(1) Press down the lever for air and then pull it back slightly to introduce a small amount of paint. This results in a narrow, very fine spray.

(2) Again, with the lever pressed down, pull it approximately halfway back. This results in a medium, general-use spray pattern.

(3) With the lever depressed and pulled right back, the spray pattern is wide – useful for filling in backgrounds or covering large areas.

held in the reservoir, which is usually in the form of an underhanging jar. Secondly, the reservoir – and therefore the paint – can be easily changed, and a removable jar is easy to clean.

The disadvantages are that during close-detail work the jar can be a real hindrance. Also, it can restrict you to a horizontal operation of the airbrush; the liquid paint finds its own level and as the jar is tilted, a low level of paint runs away from the outlet and interrupts the feed. This can be altered by fitting a receptacle with a ball-joint.

Gravity-feed presents no such problems. The reservoir is in the form of either a side cup – reversible for left or right hand use – a cup mounted on top of the airbrush, or merely a recess in the top of the airbrush body. Often the cup is an integral part of the tool. Because the reservoir lies above the airstream, the paint flows downwards through gravity.

The only notable disadvantage of gravity-feed is a generally limited capacity for paint, although a couple of models are available with large cups. This is far outweighed by the various advantages, such as a well-balanced design which provides excellent handling, suitability for close work and, especially with recess types, quick and easy color change.

The odd-ones-out

There remain two types of airbrush not yet discussed, neither of which is suitable for general all-round use, neither of which is therefore recommended to beginners in the art of airbrushing. It is useful, however, to know their capacities as they represent different poles of the technical range of airbrushes.

The first is the spray gun, which bridges the gap between industrial sprayers, as used in respraying automobiles, and the artist's airbrush. This simple-to-use tool serves a valuable purpose in many commercial art studios, notably for covering large background areas quickly and efficiently. Fabric de-

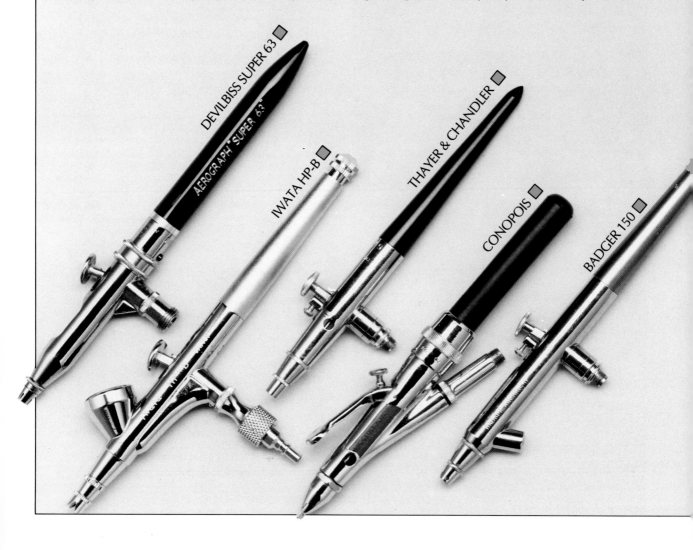

signers and mural artists also find a spray gun useful, because their work less often depends on fine detail. But if you're setting out to create interesting tone and texture on a relatively small scale the spray gun is not the implement for the job.

Right at the other end of the range is the top-of-the-line, the turbo. This expensive, highly sophisticated device is both loved and hated by professional airbrush artists, because it is at once the most precise of instruments and the most difficult to master. It is driven by a turbine that rotates at speeds up to 20,000 rpm – sounding like a dentist's drill – with the unique appeal that it allows the operator to control the speed of spray. For sensitive, delicate work it is in a class of its own, as it can be slowed to produce hairlines and the most intricate detail. But it is a highly sophisticated tool, and even the most optimistic beginner would rapidly become disillusioned with the turbo. With perseverance, you may be equipped to come back to this fascinating airbrush a couple of years from now.

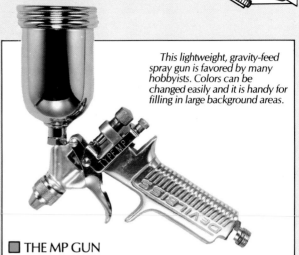

This lightweight, gravity-feed spray gun is favored by many hobbyists. Colors can be changed easily and it is handy for filling in large background areas.

■ THE MP GUN

BADGER 350 ◻

IWATA HP-C ◻

PAASCHE AB TURBO ◻

SOURCES OF AIR

It is not unknown for purchasers of good quality airbrushes to return to the supplier within a week or so complaining about the performance of a new instrument. Nine times out of ten, it isn't the airbrush that's at fault, it's the air supply.

The truth of the matter is that an inadequate air supply can confound even the most expensive airbrush. It's rather like buying hi-fi equipment: there's little point in investing in a top quality amplifier only for the sound to suffer due to poor quality speakers. Having said that, it is perhaps unreasonable to expect someone with an amateur interest to splash out on both a good airbrush and a good compressor at one and the same time. To be going on with, there are some cheap propellants that provide an adequate air supply. The following breakdown starts at the bottom of the range of air sources and works up to the most sophisticated.

The car tire

Crude yet functional, the car tire is an air source much-loved by hobbyists and modelers. Readily acquired at the local dump and easily inflated by foot pump, the tire is air on a shoestring. Note that the tire must be on a rim (ie still on a wheel) and should never be inflated above 40 psi (2.6 bar). When fitted with a pressure regulating gauge specially designed for airbrush use, it delivers an effective, albeit uneven flow for a short period. Dirt and dampness restrict its suitability to only the most basic spraying tasks.

☐ *NOT RECOMMENDED FOR THE SERIOUS AIRBRUSH ARTIST*.

The foot pump and tank

You'll find this faithful, old-fashioned combination still earning its keep in many a studio — and most likely you'll find a sweating artist next to it. The operator physically pumps air

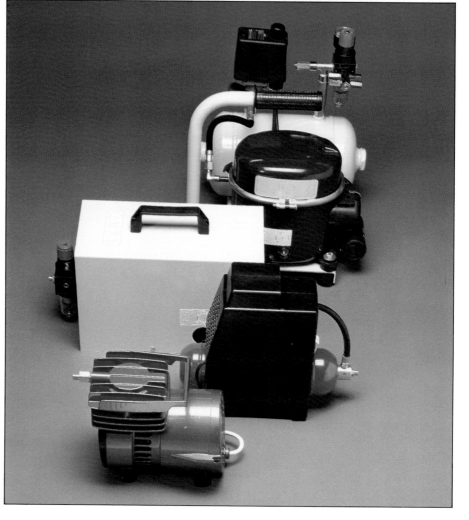

Air compressors are manufactured in a wide range of shapes and sizes each designed to cope with a different job. A beginner might start with the basic diaphragm model (1), but it is noisy and without air-storage facilities. A small manual compressor (2) would solve the "pulsing" problem as it has a small air tank. Also manual, but with a silent motor and fitted with an air filter and regulator to the small tank, is this model (3). It is ideal for the operation of one airbrush. Finally, there is the fully automatic compressor (4), capable of operating up to four airbrushes at once, which is ideal for studio use.

Diaphragm and storage compressors

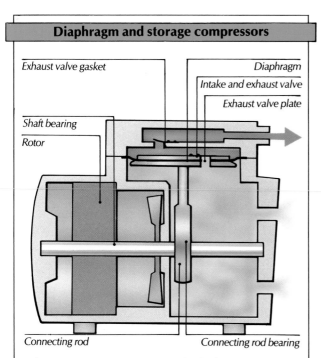

Exhaust valve gasket

Diaphragm

Intake and exhaust valve

Exhaust valve plate

Shaft bearing

Rotor

Connecting rod

Connecting rod bearing

The storage compressor (below) manufactures compressed air and then stores it in an additional air tank. The air is then fed off using an air regulator to provide a constant pressure.

The diaphragm compressor, (above) is operated by a motor which sucks air in and then, with the aid of a diaphragm, pushes it directly into the airline.

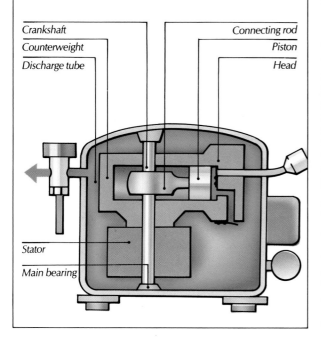

Crankshaft

Connecting rod

Counterweight

Piston

Discharge tube

Head

Stator

Main bearing

into the tank, then sits down to the artwork. When the tank is exhausted, there is a short break while it is reinflated; and so on. There is little wrong with the quality of air, but the necessary physical exertion can lead to lapses in concentration at the drawing board.

☐ *TIME CONSUMING AND TIRING, THEREFORE NOT RECOMMENDED.*

The air can

This is a relatively recent introduction that has both advantages and disadvantages. If you cannot or do not wish to afford a compressor while you are learning to use the airbrush, these cans of pressurized liquid gas are a good alternative. You will need to purchase a control valve that links the can with the air hose, and for this you have a choice of two types. The first and most widely available is a simple, inexpensive device that functions merely as an on/off valve. The second is more sophisticated altogether, a regulating valve that can meter the supply at a constant pressure.

Air supply from cans is generally quite good, although you are bound to encounter one or two hiccups. Unfortunately, the initial burst of pressure can be of whirlwind proportions, which renders your airbrush totally uncontrollable. Also, as a can empties the pressure drops progressively, making it difficult to obtain constant spray characteristics. Most damaging of all, the gas from cans sometimes adversely affects airbrush washers and 'O' rings, causing the airbrush to freeze up if it is in use over a prolonged period. However, due to a short working life of between one and three hours, cans are not cost-effective for frequent or proionged use. Many professionals keep a can handy because, being the most portable form of air, they are useful for on-the-spot alterations if a client requests a few changes on delivery of artwork.

☐ *RECOMMENDED ONLY FOR LIGHT USE AND FOR THE "TOE-IN-THE-WATER" BEGINNER.*

The carbon dioxide cylinder

The same type of cylinder that pumps beer to the tap can be used to pump air to the airbrush. Quiet and maintenance-free, the gas cylinder delivers a steady supply of air without reliance on an external power source. On the debit side, you are dependent on a reliable supplier for refills, and it is vital to fit an attachment incorporating both a pressure regulator and measuring gauge – otherwise you have no means of knowing when the air will run out, leaving you stranded halfway through your job.

☐ *RECOMMENDED, WITH RESERVATION.*

Compressors

We now move up a gear to the most universally acceptable source of air supply to the airbrush – the compressor. Once more the category subdivides and the price bracket extends from easily affordable to justifiably expensive. All the types discussed below have strengths to recommend them, though they must be considered in relation to the airbrush artist's ideal – a constant, regulated flow of moisture-free air.

To achieve this, a compressor should incorporate three vital elements. Firstly, a moisture trap is needed to extract the

humidity from the generated air, otherwise drops of condensation collect in the compressor, work their way up the airline, and are spat out all over the artwork. The second requirement is a pressure regulator, so you can exploit the full potential of your airbrush by varying the pressure. For example, thicker paint requires a higher pressure, while a lowered level will create a successful spatter effect. Thirdly, there should be a pressure gauge, which is often integrally attached to the regulator, so that you can check your operating level. Most gauges show readings in pounds per square inch and bar, and normal operating pressure is 15–40 psi (1–2.6 bar).

The direct diaphragm compressor

Inexpensive, noisy and portable, this is the most basic of electric compressors. The air supply is generated by a motor, which effectively sucks air in and blows it directly into the airline. Therein lies a fundamental problem; because the influx of air into the motor can never be uniformly constant, neither is the flow to the airbrush. This marginally spasmodic flow causes pulsing, which translates into an uneven spray especially noticeable if you're covering a large flat area. In addition, few direct compressors are supplied with either moisture filter or pressure regulator, although these are available as extras. At time of purchase, it is essential to check that the airbrush adaptor supplied with the unit incorporates a small hole that acts as an air bleed. Without this, the motor within the compressor will be working against any back pressure, resulting in harmful overheating and excessive wear and tear.
☐ RECOMMENDED FOR THE ENTHUSIASTIC HOBBYIST ONLY.

The oil-less, non-pulsing compressor

This relatively low-duty compressor offers a good standard of basic performance. It does not have a pressure regulator, but incorporates a two-gallon (one-litre) capacity tank that acts as a buffer to prevent pulsing. Electrically operated, it requires no oil and therefore little maintenance should be necessary. It is not designed for heavy usage and should be rested every half-hour to avoid overheating.
☐ RECOMMENDED FOR THE SERIOUS BEGINNER.

The small storage compressor

As its name implies, this quiet, reliable compressor not only generates air, but is also able to store it. This is a major advantage because air is drawn from the reserves in the tank and fed through the airline at a constant pressure which produces a uniform spray. The only significant drawback with this continuous-running compressor is the fact that it has a tendency to overheat. Its small wattage motor is not really engineered for prolonged use and should be allowed a ten minute rest in every hour. A further minor irritant is the manually operated on/off switch, which means you interrupt your work to switch off to avoid overheating, then stop work again to switch on and allow the compressor to replenish air stocks.

You will generally find that small storage models include a moisture trap, regulator, and gauge as standard equipment.

There is normally also an oil-level check glass, as these are piston machines that rely on oil for cooling and lubrication – hence the need for the following regulator maintenance steps.

Regulator maintenance

☐ With each use, check the oil level in the glass window. Always maintain the level close to the maximum mark, because the lower the quantity of oil, the higher the risks of damage caused by engine overheat.

☐ Only use the brand of oil specified in the manufacturer's literature. Different brands of compressor need different brands of oil, and intermixing of two incompatible brands can inflict terminal damage on your machine.

☐ Regularly drain off the moisture trap.

☐ If your compressor is fitted with a reservoir tank or chamber, use the drain-off tap to clear out any moisture that may have collected.

☐ Inspect the air-intake filter frequently, and clean it when necessary.

☐ Always make sure that your machine is standing in an upright, level position.

Correctly maintained and not overworked, the small storage compressor will deliver an excellent air supply and give dependable service over a number of years.
☐ HIGHLY RECOMMENDED FOR ALL BUT PROFESSIONAL USE.

The fully automatic compressor

This larger model is built to withstand the rigors of studio use and feed a number of airbrushes simultaneously. It performs the same basic function and requires the same maintenance procedures as the small storage compressor. Its major benefit is that it is completely automatic, cutting out when the air tank is full and re-starting when the air tank has drained to a certain level, always retaining a comfortable margin. Sophisticated and silent, the leading automatic compressors are comprehensively specified with the following features as standard:

☐ Reservoir tank with drain-off tap for moisture.

☐ Tank pressure gauge.

☐ Pressure switch with on/off modes.

☐ One-way valve between motor and tank.

☐ Safety valve.

☐ Pressure regulator, gauge and filter.

☐ Oil-level check glass.

☐ Air-intake filter.

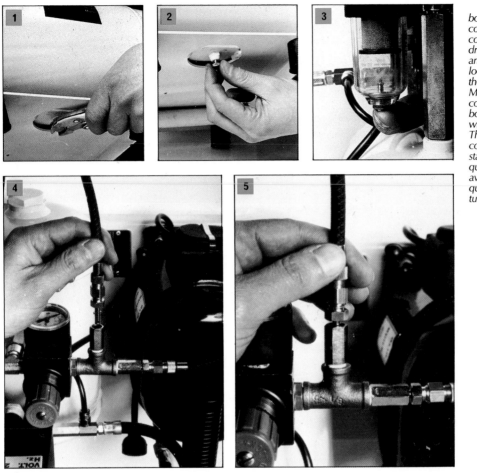

Drain taps are fitted in the bottom of the reservoir of a compressor so that the water that collects there can be periodically drained off. The screw, fitted with an air- and watertight seal, is loosened with a spanner (1). It can then be removed by hand (2). Moisture traps can be fitted to the compressor: these clear plastic bowls collect any excess water, which can then be drained (3). The airline was originally connected to the compressor by a standard screw. Today, however, quick-release couplings are available. They fit simply and quickly by pushing in (4), and turning (5).

It is not advisable to tamper with the pressure switch or safety valve in any way as this could influence the air pressure, forcing it to rise above the tested and approved upper limit. Similarly, unless you can identify and remedy a simple source of air leakage, leave well alone any automatic compressor that runs continuously instead of switching itself on and off. Just switch off the power and summon expert help in the shape of a local servicing agent. All in all, however, these models are exceptionally reliable and highly efficient.

☐ *ESSENTIAL FOR THE PROFESSIONAL: PERHAPS UNNECESSARILY COMPLEX AND TOO COSTLY FOR THE ENTHUSIAST.*

A general point must be made here. In many countries throughout the world, storage of air is governed by strict regulations. To satisfy insurance requirements regarding employees' liability and safety at work (or at home, for that matter), tank compressors must not only be officially tested before sale, but should also include an integral tank inspection boss which, when loosened, allows instant access to the air tank to check its condition. Many manufacturers now issue a test certificate with each compressor, or alternatively brand them with a safety standard plate or label. It is a good idea if you are buying a tank compressor to make sure it includes a boss and is properly certified or labeled. Even if it is not a legal requirement, it is reassuring to know that the manufacturer has adhered to a code of safety practice.

ACCESSORIES
It may be regarded as a blessing that there are remarkably few accessories available for the airbrush. The beauty of the tool lies in the fact that it is the operator who controls and creates the effects, rather than a host of "bolt-on" extras. Here are the essential accessories and others which are widely-used but optional. Basically, an airbrush, a hose and a compressor are all you need.

Air hoses
The air hose provides an airtight link between airbrush and compressor. Lengths vary from 4ft (1.2m) to 12ft (3.6m), and around 8ft (2.4m) is ideal to make sure your movements are

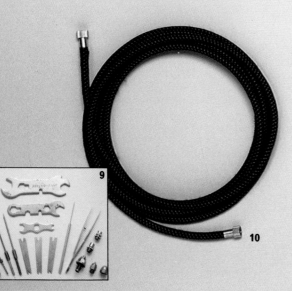

A wide variety of airbrushes are available. Shown here are: (1) DeVilbiss MP gun, used for covering large background areas; (2) Paasche AB turbo, which can produce the ultimate in fine line work; (3) Conopois F; (4) DeVilbiss super 63-A, shown with nozzle set and spatter cap; (5) Iwata HP100-B, shown with two hose connectors and an adjustable distance guide. Some airbrushes have removable cups (6), or jars (7). Dropping an airbrush onto the floor can easily damage the nozzle; these are expensive to replace, so it is wise to have an airbrush holder (8). Most airbrushes come with their own tool kits (9).

not inhibited. There are now three main types. **Vinyl** is the cheapest, but also the most vulnerable: it can be accidentally sliced or squashed underfoot. However, it is favored by some professionals because, being lightweight, it has less of a drag factor on the airbrush than other types of hose. **Braided rubber** is both resilient and enduring and therefore the common choice for heavy-duty usage. **Curly coil**, the latest introduction, is ideal in every respect. It is lightweight, compact and extremely durable, and it also has a clean, high-tech appearance.

Thread adaptors

The air hose is attached to the airbrush and compressor by means of a screw thread. To the detriment of the user, airbrush manufacturers also tend to be air hose manufacturers – which means a hose of brand "A," for example, will not fit an airbrush or compressor of brand "B." This niggling problem is easily solved by the purchase of a thread adaptor. There are many different sizes available, making it possible to connect any airbrush to any compressor.

Manifolds and couplings

It is possible to use the pressure regulator on your compressor as an on/off switch for the airflow. However, the vast majority of users prefer to fit a two-way manifold, which performs the same function and is activated with far less effort. It's a simple matter of turning a tap on a manifold, compared to twisting a regulator up and down. The two-way manifold has the added advantage of allowing you to operate two airbrushes from the same compressor simultaneously – in fact, multi-outlet manifolds are available for the use of up to five airbrushes. Much welcomed by professionals is a new device called the

quick-release coupling, which again acts as an on/off switch. It consists of a body which is attached to the compressor and a tail that fits to the end of the hose. A quick push and twist is all that's required to connect and disconnect the two.

Moisture trap and air regulator

As described earlier, these features are often integral to the compressor. If not, you can buy them individually or as a combined unit and attach them to your compressor. Also available is an "in-line" moisture trap, which intercepts the water molecules as they pass through the air hose, an old-fashioned method, but still effective.

Airbrush holder

When not in use, your airbrush should always rest horizontally, not left to lie on your board or desk, but in a holder to avoid accidental damage. If you can't stretch to a purpose-built desk clamp, an ingenious alternative is a common-or-garden screw-eye, simply screwed into the side of your desk top.

Spatter cap

As yet the spatter cap is only available for a prominent British brand of airbrush. It replaces the nozzle and automatically creates a spatter effect. Again, there is an effective and extremely simple alternative. Turn the pressure right down on your compressor and you should achieve an identical effect.

Line controller

The idea behind the line controller is so obvious and simple that it's surprising no one thought of it years ago. It is really little more than a rod than can be attached to almost any make of airbrush, thus ensuring that the airbrush tip remains a constant

The air hose connects the brush with the source of air. The DeVilbiss (10), and the Paasche hose (11) are fitted with in-line moisture traps. The air hose connects to the compressor via the manifold: single connection (12), or double (13) are available. Depending on the output of your compressor it is possible to run up to six airbrushes; six-way adapters are available for this. If a moisture trap is fitted (14), it lies between the manifold and the compressor. Of the many available air sources, shown here are the large reservoir type (inset top right); the diaphragm compressor (15); and a can of compressed air (16), used in conjunction with a control valve.

distance from the artwork. In turn, this ensures that the spray width remains constant which is especially useful if you are trying to achieve fine lines, or spray two lines of identical width with a pause between the two to change the paint color.

Color cups
As discussed earlier in relation to suction-feed and gravity-feed models, airbrushes are available with various types of paint container. Some have fixed color cups integrated with the shaft, either recessed or mounted above, below or to the side. Others have detachable cups, generally underhanging or in some cases mountable on either the left or right hand side. Your initial choice of airbrush/cup combination should be determined by the kind of work you expect to undertake. If you intend to produce mainly fine graphic work, work requiring only a small amount of one color at a time, but frequent color changes, it is best to select an airbrush with a small, fixed cup or recess. You will find these instruments are better balanced, because the positioning of the cup will have been a major design consideration.

Airbrushes that can be accessorized with different sizes of color cups, usually plastic or glass jars and bottles, are more unwieldy, but have the advantage of a greater paint capacity. This is useful if the majority of your work calls for blanket coverage of large areas with a single color. As rule of thumb, even if your airbrush allows interchanging of containers, it is perhaps not wise to use more than one or two jars. The temptation is to use a fresh jar for each new color instead of cleaning the same jar between colors. Like a chef in a kitchen, you'll find it's much easier to clean up as you go along.

BUYING COMPATIBLE EQUIPMENT
It's true to say that you can team the cheapest form of air source with the most expensive airbrush and achieve a passable result. However, it's rather like installing a lawn-mower engine in a Grand Prix racing car: you'll get to the finishing line but you might just as well have been driving a lawn-mower in the first place.

Striking the right balance is not difficult and can be achieved by taking into account three main criteria: what you're going to use an airbrush for, how long you anticipate using it, and the amount of money you have available. If, for example, airbrushing is adjunct to a primary interest or hobby such as modeling, a practical combination would be a single-action airbrush and diaphragm compressor. On the other hand, this pairing will not get you very far if your objectives lie in the field of graphic art. To achieve the necessary fineness of detail and quality of finish you must invest in a top-of-the-range independent double-action airbrush and a small storage or tank compressor.

Similarly, regular users of the airbrush, whatever their instrument or purpose, will find that it pays dividends to invest in a compressor with a greater capacity than they ostensibly need. With compressors, overworking and overhauling are directly related.

Typically, though, your ultimate choice will be determined by your budget. In an ideal world, every serious newcomer to airbrushing would be able to afford an independent double-action airbrush and a fully automatic compressor. We all know that in the real world this is not the case. Life would also be simpler if we could honestly advise you to start with a cheap airbrush, and replace it later with a better quality instrument. Although this is arguably a logical approach with compressors, it does not make financial sense with the airbrush. The reason is positive: the best airbrushes are precision-engineered to last a lifetime and so in real terms cost little more than cheaper counterparts. The price gulf between "amateur" single- or double-action airbrushes and "professional" double-action airbrushes is narrow, and it is definitely worth finding the extra to afford the most versatile tool.

Unfortunately, air source prices do range enormously and a top quality automatic compressor will set you back a substantial sum. In fact, professionals usually spend considerably more on the compressor than on airbrushes. Nevertheless, as indicated earlier, you do not need the most sophisticated compressor at the outset of your airbrushing career. Invest in an independent double-action airbrush first, then see how much is left over for an air source. With luck, you will be able to afford a small tank compressor, but it is not the end of the world if you can't. A diaphragm model should be adequate for a year or two while you acquire the sophisticated skills that warrant sophisticated equipment. It is worth noting here that unlike the airbrush, which has remained relatively unchanged since its invention, the compressor in its various forms is the subject of rapid technological advancement. As more efficient and reliable types are introduced, it is quite likely that you will wish to replace your older model. For this reason alone there is little point in over-extending your finances to accommodate a compressor that you can't really afford, at a stage when you don't really need it. In any case, with more experience and a higher level of competence, you'll have a much clearer idea of the kind of equipment you need.

Finally, there are two general shopping rules that are particularly applicable to the purchase of airbrush equipment. Firstly, beware of false economy. Whilst air cans may seem an attractive buy at a low unit cost, their useful life is short. For the price of around twenty cans you should be able to pick a new small compressor that represents a much better return for your money. Secondly, if the sales assistant shows neither product knowledge nor enthusiasm, take your business elsewhere. Buying an airbrush is not like buying a bar of soap, and the worst thing that can happen to an enthusiastic beginner is to be sold the wrong equipment by a supplier who hears only the ringing of his cash register. The airbrush is a fascinating tool and should only be bought from someone who gives you more than the time of day, and displays more than a superficial knowledge.

THE WORK AREA
Many professional airbrush artists work from home and unless you are lucky enough to have access to a studio, you will also

need to create a suitable workspace in your home. It is totally unnecessary to spend vast amounts of money equipping, say, your spare room as a studio. What is important is to ensure that you choose the room in your house where the physical conditions are best suited to this type of work. The basic requirements are few but significant.

Space
You can work at a small table or desk, but you should not work in a small room. This is because the airbrush produces fine paint particles, which circulate in the air and cloy the atmosphere in confined spaces. Inhalation of these particles can be harmful; therefore it is advisable to occupy a working area of no less than 4 sq yd (3.6 sq m).

One issue which is currently surrounded by a fair amount of controversy is whether or not airbrush artists should wear masks. Professionals are divided on this topic, even though in more than one instance artists have been stretchered out of their studios having been overcome by paint mist. It is certainly advisable to wear a mask when spraying large backgrounds; ideally, after such work you should open all the windows and leave the room while the mist clears. Probably the best course of action is to wear a mask at all times. It may be uncomfortable at first, but after a week or two you'll grow accustomed to it. For the light or occasional user a surgical mask should suffice; prolonged use of the airbrush calls for a more sophisticated filter respirator.

Light
There is no substitute for natural light. However, it is unrealistic to assume that you will only work during daylight hours, so good artificial lighting is also essential. This book was written in a room with a fluorescent ceiling light for general brightness, at a desk with an angled lamp directed to the work. These conditions are ideal for airbrushing, too.

Temperature
Always work in a cool room, because the hotter the air, the more moisture in the atmosphere. This can overload the moisture trap, causing the airbrush to spit. Good ventilation is of paramount importance to overcome the problem of a paint-filled atmosphere, so it's a good idea to keep a window open at all times.

The working surface
Whether you work on a slanted or flat surface is completely a matter of personal preference. There's no point in going to the expense of a studio drawing board, when the old kitchen table is perfectly adequate. In fact, most professional airbrush artists work on a flat or only slightly raised surface.

The chair
Artists are generally not fidgety, but freedom of movement is important for airbrushing. You need a seat that follows your movement – so, unfortunately, the old kitchen chair isn't ideal in this case. It's worth investing in an adjustable swivel chair.

STUDIO EQUIPMENT AND MATERIALS
The airbrush can be used in such a diverse array of applications that it is impossible to list every piece of peripheral equipment that may be required. This section is primarily designed to cover mainstream uses, and is therefore addressed to those of you who are relatively serious about using the airbrush in the fields of graphic art, illustration and retouching.

Much of the following information is relevant if you intend to use your airbrush in more offbeat applications, such as ceramic or textile decoration, but for purposes of simplicity you are now being pigeon-holed as a specialist. A number of "specialties" are described in Chapter 4, although it would be impossible to tackle every conceivable application of the airbrush in a single volume.

Studio equipment
Before actually putting airbrush to paper, surround yourself with an orderly arrangement of basic equipment. This should include every artist's essentials, such as steel and plastic rulers, set squares, French curves, templates, ellipse guides, pencils and erasers. These are "top-drawer" basics that should always be within arm's length.

Equally important for the airbrush artist is a range of more specific equipment. Top priority should be your cutting tools, most notably a surgical scalpel for mask-cutting. Supplement this flat-handled scalpel with a round-handled swivel type, which gives you added flexibility for cutting around curves, and also with a compass cutter for describing perfect circles. Scalpel blades are blunted quite easily and should never be sharpened, so always keep a good supply of replacement blades handy.

It's useful to have a selection of paintbrushes as well, for two completely different reasons. Firstly, fine sable-hair brushes are ideal for touching up your artwork with hand-painted detail. Secondly, stiff, coarse brushes serve a different practical purpose in that they are suitable for mixing paint, loading your airbrush and cleaning it after use. Another practical aid for mixing liquid paints is an eye-drop applicator.

Unconventional, but extremely useful, is an ordinary household tile for use as a palette. There is really no need to go to the expense of a professional ceramic palette when an old kitchen or bathroom leftover suffices. Similarly, small glass jars, such as those used in presentation packs of jam and honey, are just the job for mixing and storing liquid paints. Never throw away standard jam jars – like any other artist, the airbrusher needs a constant supply of water-pots. In the same vein, squeezable washing-up liquid bottles filled with water are the perfect tool for flushing the airbrush.

Your checklist of basic equipment is completed by further household items: adhesive tapes (standard, double-sided, masking and drafting), kitchen roll, and absorbent cotton or buds for cleaning a paint cup or recessed reservoir and lifting excess wetness from the artwork. All these items may not be mainstream airbrush materials, but you'll be amazed how useful they are. Don't over-crowd your immediate work area, but equally don't leave yourself under-prepared.

Paints

There is a bewildering array of paints available for use with the airbrush. Some need to be diluted, some don't. Some require special cleaning agents, others don't. There is no single, correct medium exclusive to airbrushing but for the beginner, practical considerations should overrule all others. In other words, start with a paint that needs neither dilution nor a special solvent. Whatever medium you use, the most critical factor is always to clean your airbrush thoroughly and regularly – this point cannot be stressed too often.

Although some paints are more suitable than others, it is true to say that literally anything liquid can be blown through an airbrush. As a general guideline, the right level of consistency is a milky solution that flows rather than drips through a finely-meshed sieve. Provided this consistency is achieved, you can experiment with any substance from food dye to varnish, and create some amazing effects. Do bear in mind, however, that the airbrush is a sensitive piece of equipment that can corrode and clog. Cautious experimentation is healthy, but wild ideas are probably best left to the professional fine artist.

Watercolors

Watercolors are excellent for the beginner, because they are now widely available in liquid form. Whereas some dilution was necessary with tube watercolors, the new liquids can be used as they are when bought. Often the bottle has a dropper fitted to the lid, which makes loading the airbrush extremely simple. This also allows accurate color mixing, as you can log the exact number of drops of each mixed colour, and repeat the dosage for subsequent mixes to ensure that you repeat the color exactly. This is particularly useful for applications such as animation or repeating-pattern fabric painting, where color matching is vital.

Cleaning is easy too, because watercolors rarely cause blockages and are easily flushed away with tap water. A good color range is available, from which you can mix virtually any hue or tone. Watercolors lend a pure transparency to your work, which means you can build up layers of color that do not totally obliterate each other. Some people claim this creates an atmospheric intensity, others regard it as insipid. But the effect required from the medium usually depends on the subject matter.

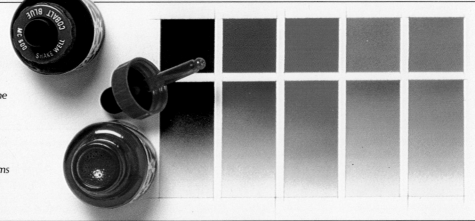

Inks and watercolor

Inks and watercolor can be used either straight from the bottle, to give very bright colors, or diluted with water to allow greater control. The opacity of inks and watercolor allows subtle colors to be made from a very basic palette by spraying one color over another. They come in glass and plastic bottles and often have an eye-dropper attachment fitted to the lid to enable you to fill the color cup directly. They give a brilliance unobtainable from other mediums but lack covering power if the artist needs to lighten a color. Inks are also suitable for tinting over photographs.

Gouache

Gouache, or body color, is the original medium used with the airbrush. It is durable and has very good covering power, enabling colors to be changed easily. It is often mixed with gum arabic or ox gall to improve adhesion and density. It is harder to use than ink because the consistency has to be exact: if it is mixed with water to the approximate consistency of milk it will run through the airbrush smoothly. Gouache is particularly suitable for photo-retouching and gouache manufacturers make a special range of colors for this purpose.

Gouache

The only definition for gouache that the art world can universally agree upon is "opaque watercolor". It is widely used by professionals because it produces good, strong color that dries to a velvety, mat finish and its opacity allows highlights to be sprayed over dark backgrounds. It poses some problems for the less experienced user in that it has more body than watercolor and is quite difficult to dilute to the exact consistency. Gouache also tends to solidify around the airbrush nozzle, which then requires constant cleansing with water.

Inks

Ideal for the beginner, drawing inks are often sold, like liquid watercolors, in handy little bottles with an integral dropper in the lid. They are ready for use and excellent value because you only need a dozen or so colors to cover the complete color spectrum. Inks are enormously popular with commercial illustrators because of their richness and brilliance of color.

With watercolors and gouache, you have to build to a strong hue with several sprays, whereas with ink you can achieve depth and clarity with a single pass. The clean, shiny finish is also well suited to the traditional subject matter of airbrushing, such as automobiles and other machines, chrome lettering and technical cutaways. The only drawback with ink is a minor one – it dries extremely hard so it is essential to flush your airbrush with water the moment you stop work.

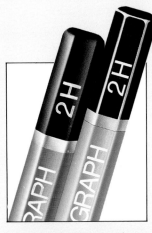

What medium to use?
Subject matter often influences the choice of medium. Gouache was used to create the left of these two pencils, which meant that the lettering had to be painted with a fine brush. The other pencil was illustrated with ink, which enabled the artist to draw the lettering out with a technical pen in black ink (Letraset could also be used) and then spray over, so that the lettering showed through.

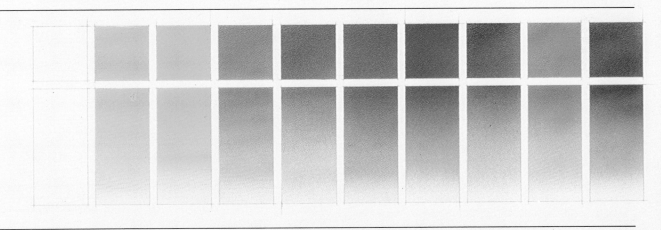

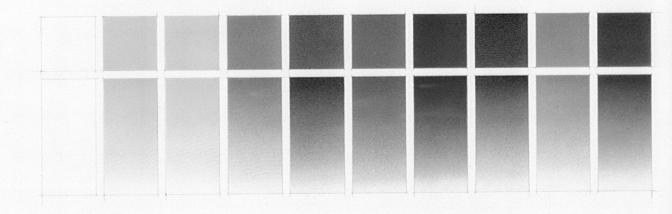

When laying a mask, it is advisable to cut a rough from scrap paper, slightly larger than the area to be sprayed. This not only saves expensive materials but also reduces the chance of either transferring grease or paint to the surface or pulling up paint already laid down (1). Cut the film roughly to size, still on its backing paper, using either a pair of scissors or a scalpel (2). Then carefully remove the film from the backing (3). Be careful not to touch the sticky surface, as greasy fingermarks can easily be transferred onto the board and will be noticeable in the finished illustration.

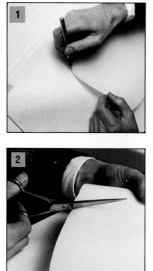

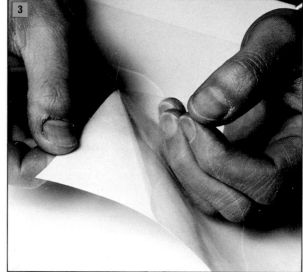

Acrylics

Not so long ago, these quick-drying, plastic-based paints were unfavorably regarded because they clogged up airbrushes. More recently formulated acrylics have a liquid consistency well suited to use with the airbrush. They can generally be thinned, mixed and cleansed with water, but there is a snag. When the paint dries, it is tough, plastic and waterproof, whether in the form of lumps or a thin skin of color. So, if the airbrush is not fully flushed through immediately after use, the results can be disastrous. Dried acrylics may have to be treated with a special solvent: follow the advice of the manufacturer of either paint or airbrush. However, the adhesive and drying properties of these paints are excellent with regard to the quality of the sprayed surface on paper or board.

On a cautionary note, it is sensible always to wear a mask when spraying, as acrylic particles can be more harmful when inhaled than those of more simply constituted water-based paints.

Oils, lacquers and cellulose paints

By all means experiment, but it is probably best to steer clear of these hard-to-handle media until you're fully acclimatized to the more ''user friendly'' paints listed above. special solvents and have a particular tendency to clogging. Unless you're extremely careful, you could inadvertently cause serious damage to your airbrush by trying to force down its throat a volatile medium that it doesn't want to swallow and can't digest.

Papers and boards

Just as you can spray virtually any liquid through an airbrush, so you can spray onto virtually any surface. This avenue is explored further in Chapter 4. For the graphic artist, however, it is an unfortunate fact of life that with surfaces you get what

you pay for. It just so happens the best surfaces for airbrushing are among the more expensive.

Ideally, you should choose a smooth, hard, white artist's board. The surface is designed to withstand dampness and will not peel away from its mounting when wet. Avoid the temptation to buy inexpensive mounting board; the paper layers will separate and buckle, and ruin your artwork.

Some papers provide a passable, inexpensive alternative to artist's board. Avoid thin or textured paper which curls and bubbles up when damp. A strong, white cartridge paper is perfectly acceptable for the beginner, but be warned that it will buckle if you are spraying large areas. Unless you're looking for a specific effect, fibrous papers are not recommended – the airbrush spray highlights the texture and grain and produces a disjointed, mottled effect. When using paper, always try to keep it as flat as possible by stretching it over the work surface and taping down the edges.

Masking materials

Masking is critical to the art of airbrushing and is simply defined as covering up one part of your artwork while another is being sprayed. More positively, it is better described as ''drawing by scalpel,'' whereby you cut the shape you wish to spray out of a blanket mask. Masking techniques are explained fully in Chapter 2.

Materials you will need at the outset are a good supply of clear, low-tack masking film, either in roll or sheet form, plus a further selection of card, paper and acetate – for the most part old scrap paper will suffice. It's a good idea to assemble a drawerful of masking aids, ranging from tissue paper to thick card. As your masking expertise grows, you'll find yourself improvising with all sorts of bits and bobs as masks, from leaves to postage stamps.

MAINTENANCE

The airbrush is a highly-strung, thoroughbred animal that quickly becomes temperamental unless you lavish care and attention on it. Unfortunately, there are no short-cuts when it comes to looking after your instrument and you just cannot afford to be anything less than meticulous. The good news is that, tedious though it most certainly is, routine airbrush maintenance doesn't require any special skills or expensive tools.

There are three golden rules that you ignore at your peril:

☐ Always, but always, clean your airbrush after every use – even if you've only made a 30 second amendment.

☐ Always ensure that the paint you spray through your airbrush is mixed to the right milky consistency. Just as you would have difficulty in swallowing a piece of candy whole, so the airbrush is incapable of digesting a lump of gouache.

☐ Never push up the air pressure beyond 40 psi (2.6 bar). Lowering it to around 10 psi (0.6 bar) to create a stippling effect will not cause any grief to the airbrush, but operating at too high a pressure not only induces an erratic response, but also can wreak havoc with the air valve seals and washers.

Cleaning your airbrush

It is critical to clean your airbrush both before every color change and after every working session.

Before color changes Cleaning between colors is essential, firstly, for the obvious reason that any paint residue left in the airbrush will taint the new color and secondly, to prevent stray particles of pigment from drying hard on the nozzle, causing clogging. The procedure is straightforward:

☐ Spray off any paint remaining in the fluid chamber onto scrap paper or into an absorbent cloth or tissue. Keep spraying until you have a clear air jet.

☐ Fill the fluid chamber with water (or the appropriate cleaning fluid if you are using one of the more stubborn paints) and again spray through onto scrap paper or cloth.

☐ Repeat the process until you are sure all traces of color are absent.

After every working session At the end of a session, never leave the airbrush hanging around on your desk or table. Put it to bed, thoroughly cleaned, in its box. Unless you clean it properly immediately after use, you will get yourself into a "morning-after-the-night-before" situation, and have to spend twice as long unblocking it before you can settle down to work. Nothing is more irritating, and an irritated airbrush artist is unlikely to produce an effective piece of artwork. So on closedown, follow the steps outlined above, and continue with these further steps:

☐ Unscrew the handle and very carefully remove the needle.

☐ Place the needle gently on the fleshy part of the palm of your hand, just beneath your thumb, and gently rotate it whilst drawing it over your skin. It is inadvisable to use a cloth or tissue, as the needle can pick up traces of lint or fiber that may then find their way into the nozzle.

☐ Replace the needle by resting the shaft on the end of a fingertip and softly guiding it into place. Ensure that the lever is in the forward and down position, so the two do not make contact.

In general, these six steps should be sufficient as a day-to-day cleaning routine. However, there is one further trouble spot that requires frequent cleansing – the nozzle. Many professionals do, in fact, leave nozzles to soak in water overnight, but this is unnecessary and can be harmful, as will be explained. The best method of removing paint build-up on the nozzle is quite simply to blast an approved cleaning solvent through the airbrush at full pressure. Not very subtle, maybe, but usually it does the trick. However, if this method doesn't succeed, a failsafe alternative is as follows:

Cleaning procedure: basic clean

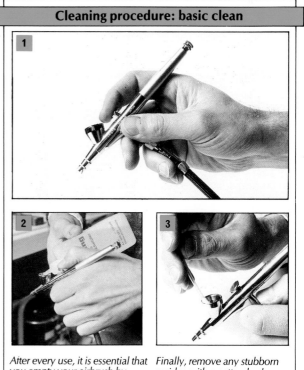

After every use, it is essential that you empty your airbrush by continuous spraying, until you have a jet of clean air (1). Next, fill the fluid chamber with either water or the appropriate cleaning fluid and spray it through (2).

Finally, remove any stubborn residue with a cotton bud or tissue (3); soaking often helps in persistent cases.

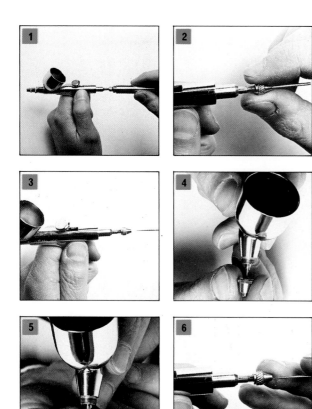

Maintaining and cleaning an airbrush with a fixed nozzle system

First unscrew and remove the airbrush handle (1). Loosen the needle-locking nut (2), and carefully remove the needle (3). Remove the needle cap (4). Now, use a small wrench (usually supplied with the airbrush) to loosen the nozzle and unscrew (5). After cleaning, replace the nozzle and reverse the procedure. Take extreme care when repositioning the needle, guiding it gently with your finger as shown here (6). After tightening the nozzle with a spanner, the needle can be carefully replaced (7).

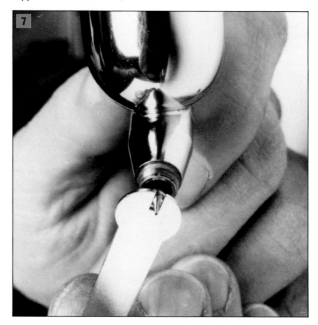

☐ Take out the needle and remove the head assembly/nozzle set.

☐ Immerse the nozzle set in cleaning fluid – for a few minutes only – to soften up any hardened paint deposits on the nozzle.

☐ Using a small sable paintbrush, sweep away any traces of paint.

☐ If the inside of the nozzle remains blocked, take an old but straight airbrush needle and very gently rotate it inside the nozzle, intermittently cleaning the needle as described earlier.

Having completed this process, take the opportunity to check that the component parts of the nozzle are in good condition. Using a powerful magnifying glass or jeweler's eyepiece, inspect the color tip to make sure it is centrally aligned within the air cap orifice. If not, or if parts of the head assembly are showing signs of wear and tear, you have little alternative but to replace the entire assembly from air cap guard to 'O' ring washer. This is because many manufacturers actually match up the constituent parts for complete accuracy in performance, and merely substituting one new part in an existing assembly will result in a severe deterioration in quality.

Repairs

Airbrushes are highly sensitive pieces of equipment. Often special tools are required to assemble and dis-assemble them; they are precision built with great expertise. It is therefore unwise to tackle any major repair job yourself, as it is all too easy to get yourself deeper into the mire. Should your airbrush present a problem that routine maintenance procedures cannot solve, the sensible course of action is to telephone or write to either the manufacturer – who is generally only too pleased to help you out – or the distributor, who should be able to put you in touch with a local servicing agent.

However, it is not all bad news. The vast majority of airbrush problems are caused by either a faulty needle or defective nozzle, and it is easy enough for you to replace both of these parts yourself. Certain points should be borne in mind, nevertheless.

Needle replacement

The most obvious symptoms of a bent needle are over-large droplets or splattered spray. Sometimes it is possible to straighten out the bend by rolling the needle tip with your finger along an ultra-smooth surface. Avoid, though, attempting to remedy a damaged needle by sharpening it on a stone,

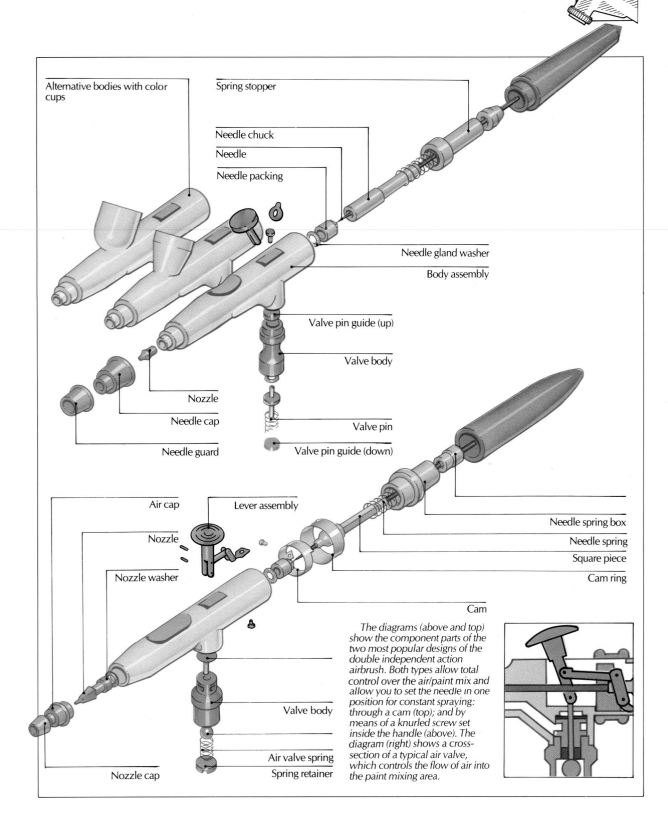

Alternative bodies with color cups

Spring stopper

Needle chuck

Needle

Needle packing

Needle gland washer

Body assembly

Nozzle

Needle cap

Needle guard

Valve pin guide (up)

Valve body

Valve pin

Valve pin guide (down)

Air cap

Lever assembly

Nozzle

Nozzle washer

Needle spring box

Needle spring

Square piece

Cam ring

Cam

Valve body

Nozzle cap

Air valve spring

Spring retainer

The diagrams (above and top) show the component parts of the two most popular designs of the double independent action airbrush. Both types allow total control over the air/paint mix and allow you to set the needle in one position for constant spraying: through a cam (top); and by means of a knurled screw set inside the handle (above). The diagram (right) shows a cross-section of a typical air valve, which controls the flow of air into the paint mixing area.

Maintaining and cleaning an airbrush with a "floating" nozzle

Hold the airbrush as shown (1), unscrew the handle (2), and loosen the needle-locking nut (3). Now, carefully remove the needle (4), unscrew and detach the air cap (5) and separate the guard from the air cap (6 and 7). Next, extract the floating nozzle complete with the small black rubber 'O' ring that acts as a washer (8). Pull the washer off and set it aside in a safe place (9 and 10). Cleanse the nozzle by soaking in water or an appropriate cleaning fluid (11).

If the nozzle remains blocked, however, take an old, straight airbrush needle and very gently rotate it inside the nozzle until all traces of paint have disappeared (12).

Make a habit of checking the nozzle for signs of damage. If necessary, replace it. Otherwise, replace the washer and firmly seat the nozzle back in the airbrush (13). Replace the complete air cap, again making sure it is clean and undamaged (14) and inspect the front of the airbrush for signs of damage or dried paint (15). Before replacing the needle, rest it gently on the fleshy part of your palm and gently rotate it whilst drawing it over your skin (16). Replace the needle, guiding it into position with your fingertip (17). Once the needle is seated correctly in the nozzle, twist it gently before tightening the locking nut. Then replace the handle (18).

If your airbrush is fitted with a cam control, it too needs an occasional check-up. Loosen the fixing screw with a small screwdriver and turn the cam ring. Make sure you can alter and pre-set the lever assembly. Re-set for normal use with the lever as far forward as possible (19 and 20).

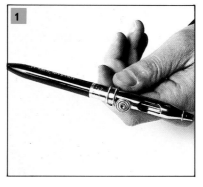
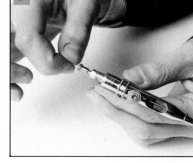
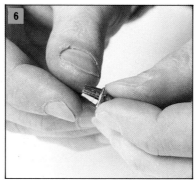
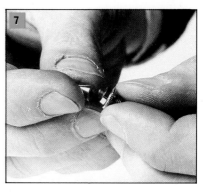

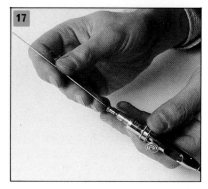

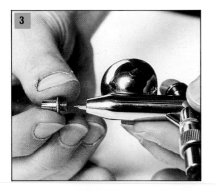

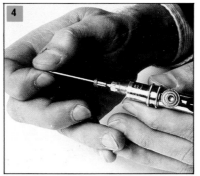

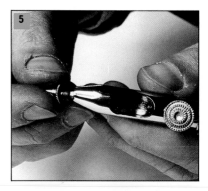

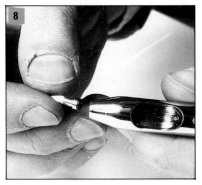

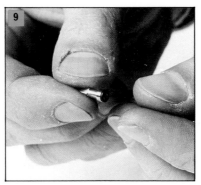

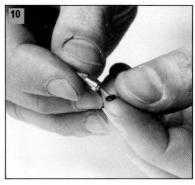

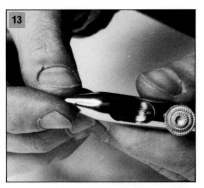

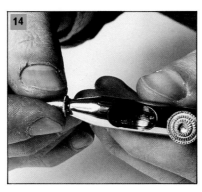

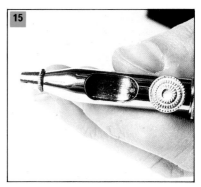

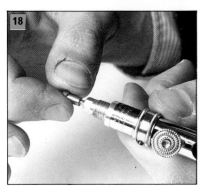

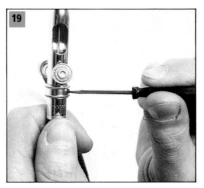

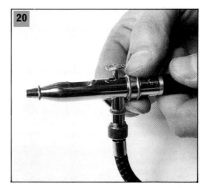

as this can create flat spots that will distort the color tip.

There is nothing you can do about a needle when the tip has bent over backward to form a crochet-style hook, or the needle itself is cracked. You must throw them out immediately, to prevent further damage within the delicate sprayhead. You will find that replacement needles are generally readily available, although you must be on your guard when purchasing them. Different manufacturers make needles of varying diameters and points, and it is crucial that you buy exactly the right needle for your airbrush make, model and sprayhead assembly.

Replacing the nozzle

After the needle, the nozzle is the most vulnerable part of your airbrush. Nozzles do wear, crack and split, but it is usually the result of careless handling.

Different airbrushes have different types of nozzle assembly, but these can be categorized into two groups: floating-tip or screw-in. In both cases, a leaking head signifies that all is not well, and remedial procedures are similar for both groups. You will need to dismantle the nozzle assembly to get to the root cause of the problem and, depending on nozzle construction, this may call for a pair of pliers or a small wrench. With a magnifying glass, you can inspect the various parts to identify the culprit component; look for a worn washer, a tired thread or any cracks or warping elsewhere on the assembly. Nine times out of ten you will get away with renewing just the defective part, although some airbrushes are designed with matching nozzle sets and one small fault necessitates a completely new set. This is frustrating, especially if the fault lies with the small 'O' ring or washer—a fiddly little component that is easily distorted and is also peculiarly fond of doing a disappearing act when your airbrush is in bits for thorough cleaning.

Once you have diagnosed and cured the problem, take extra care when re-assembling the nozzle. You need to tighten it enough to create an airtight seal on screw-in types, but over-zealousness can lead to complications with the screw-threads on the head, body or tip. If you damage these, of course, you're back to square one.

Whilst undertaking nozzle repairs, remove the needle altogether. However, if you decide to replace the nozzle with the needle still in position, make sure that the needle is pulled back. Then screw in the replacement part and slowly ease the needle forwards. Loosen the needle lock-nut, check that the needle is centrally seated, then tighten the nut.

Guidelines on care and maintenance

Experienced professionals with long-established knowledge of their airbrushing equipment will admit to breaking the rules as they are outlined in this section. As with any creative skill, it is virtually impossible to say definitively, "this is the way to do it." Each practitioner finds his or her own ways of dealing with tools and materials. But until you get to know your airbrush, treat it with due respect and follow the basic guidelines for keeping it in good condition.

Tip-on-head assembly
The following airbrushes use this type of head assembly:
■ *Badger*
■ *Thayer & Chandler*

Floating-tip assembly
The two major manufacturers that employ this assembly are:
■ *DeVilbiss*
■ *Paasche*

Tip-on-body assembly
Some airbrushes have the tip fitting directly onto the body. Manufacturers using this system are:
■ *Sata*
■ *Iwata*
■ *Efbe*
■ *Wold*
■ *Binks*

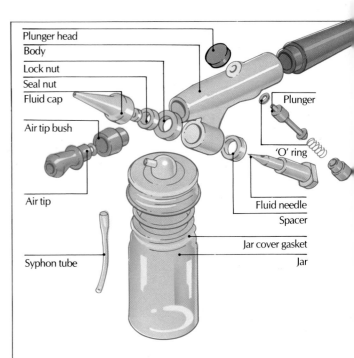

Plunger head
Body
Lock nut
Seal nut
Fluid cap
Air tip bush
Air tip
Syphon tube
Plunger
'O' ring
Fluid needle
Spacer
Jar cover gasket
Jar

The diagram above shows the component parts of a typical single-action airbrush. In this simple design, both the air and the paint are mixed externally. This results in a relatively poor quality spray and the only control is over the width of spray. However, it is a perfectly adequate airbrush for modeling or for simple tasks.

Do occasionally smear a very small amount of petroleum jelly on the needle. It helps to keep the needle packings supple, thereby allowing the needle itself to move more freely. Be careful, though, not to get any between the needle point and the position where the fluid is introduced.

Don't immerse your airbrush totally in either water or cleaning fluid when it's fully assembled. There are three reasons: a) it can cause corrosion, b) it can destroy needle packings and the 'O' ring washer, and c) it can carry dissolved paint into the airways and other working parts, leaving a deposit that causes blocked air passages and stiff mechanisms.

Do study manufacturer's literature and instructions, because what's healthy for one type of airbrush may be crippling for another. For instance, some airbrushes react favorably to an occasional drop of lubricant on the lever mechanism, while others would seize up, requiring expensive remedial treatment.

Don't plough on regardless if there seems to be something wrong with your equipment. Chances are, you'll saddle yourself with a much bigger repair bill than is really necessary.

A spatter cap can be fitted to most brands of airbrush and is used to create a coarse, textured effect. Once mastered, fitting a spatter cap is a simple process. First, unscrew the complete air cap, leaving the nozzle and washer in place (1 and 2). Then screw in the spatter cap (3). With the cap in place, you are ready to start spattering (4).

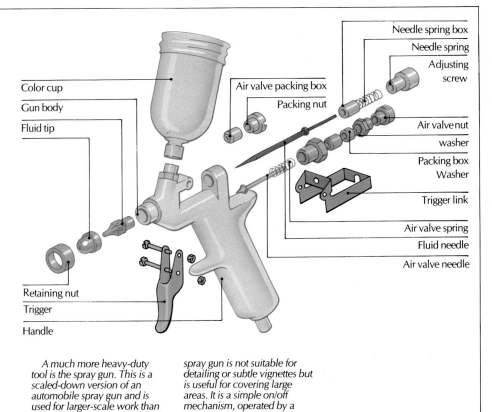

Color cup
Gun body
Fluid tip
Retaining nut
Trigger
Handle

Air valve packing box
Packing nut

Needle spring box
Needle spring
Adjusting screw

Air valve nut
washer
Packing box
Washer
Trigger link
Air valve spring
Fluid needle
Air valve needle

A much more heavy-duty tool is the spray gun. This is a scaled-down version of an automobile spray gun and is used for larger-scale work than the single-action airbrush. The spray gun is not suitable for detailing or subtle vignettes but is useful for covering large areas. It is a simple on/off mechanism, operated by a trigger.

CHAPTER

2

-BASIC ART TECHNIQUES-

Spend as long on this chapter as you need. It may be that you're a natural with the airbrush and will complete all the exercises successfully in a weekend. On the other hand, don't be disheartened if achieving the right result takes weeks or even months. It's practice that makes perfect, with a large helping of patience along the way.

Starting with the premise that you've probably never picked up an airbrush in your life before, those of you who have must either be patient or skip a few pages and come in when you feel there's something new to learn. The exercises are geared to using an independent double-action airbrush and, preferably, ink on a fairly heavy, smooth cartridge paper.

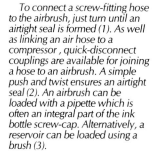

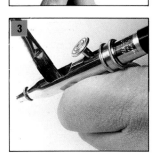

To connect a screw-fitting hose to the airbrush, just turn until an airtight seal is formed (1). As well as linking an air hose to a compressor , quick-disconnect couplings are available for joining a hose to an airbrush. A simple push and twist ensures an airtight seal (2). An airbrush can be loaded with a pipette which is often an integral part of the ink bottle screw-cap. Alternatively, a reservoir can be loaded using a brush (3).

BASIC EXERCISES

First, some general instructions. Attach your airbrush to the air supply and check that there are no leaks at either connection or along the length of the hose. If your compressor has a pressure regulator, set it at the standard operating pressure of 30 psi (2 bar). Now pick up your airbrush and if it has a cam ring or lever adjusting screw, make sure this is set in a position where it won't interfere with the full operational extent of the lever. Silly as it may sound, check to see if your airbrush has a protective cap over the spray head assembly – if it has, remove it! How you hold your airbrush is entirely a matter of personal preference – most users hold it like a pen between thumb and second finger, with the forefinger on top to control the lever. If that feels uncomfortable, experiment until you find a position that feels right for you.

Acclimatize yourself with the lever action before filling the paint reservoir. Down for air, back for (non-existent) paint. Practice just pushing the lever down, then pulling back while keeping it depressed. Finally, pull the lever all the way back, without releasing any air. Basic stuff, of course, but unless you get to know your airbrush, you'll have quite a struggle to master it.

Exercise 1:
Airbrush control

This most basic of exercises will give you a first feel for the airbrush and acquaint you with the relative proportions of air and paint controlled through the lever action.

Requirements: *Blue or black drawing ink, a large sheet of smooth white paper, eye drop applicator if no dropper is supplied with the ink.*

Load your airbrush, using the dropper. Carefully ensure that all the ink goes into the fluid chamber and wipe any stray drops off the airbrush body or tip with a clean tissue. Err on the side of caution and underload rather than overload with ink, so that when you hold your airbrush at a working angle there is no spillage from the fluid chamber.

Press down the lever to release the air. Gently pull it back, releasing the paint, and make a wandering line over the paper, varying the ratios of air and paint. If there is a 'splat', it's the result of too much paint and not enough air, which is easily corrected. Next, vary the distance of the airbrush from the paper, first closing in for a fine controlled

spray then widening the gap for a broader cover (see right).
To stop spraying, do not release the lever abruptly so that it flies forward; maintain downward pressure while bringing the lever forward. This clears the needle of any residue of paint that might blow out next time you use your airbrush. The golden rule to remember here is "air on first, air off last."

Exercise 2: Continuous lines

This exercise should be repeated a few times until you feel confident that you have established control over the lever action.

REQUIREMENTS: Blue or black drawing ink, smooth white paper, dropper.

Start by freehand spraying a straight line, attempting to achieve as clean a start and finish as possible – no circular blobs at beginning and end. You should use a smooth, constant hand motion rather than a hesitant start-stop-start action. Start the motion, too, before you release either air or paint, and continue it through after breaking contact with the lever. The three most common problems you'll encounter are:

☐ "Freezing," or forgetting to release the lever at the end of the stroke.
☐ Holding the airbrush still, or moving too slowly.
☐ Holding the airbrush either too near or too far from the paper.

Once you've stopped making all three mistakes, you've attained a level of coordination that puts you firmly in charge.

Exercise 3: Dot patterns

This exercise will give you a good understanding of the relationship between the spraying distance and spray patterns. Again, you will need plenty of practice before you get a correct result.

REQUIREMENTS: Blue or black drawing ink, smooth white paper, dropper, pencil and ruler.

Quite simply, try spraying a small, clean dot. This requires three harmonious elements – the right amount of ink, the right amount of air and the right distance between airbrush and paper. The main obstacle is the likely "splat," a result of too much ink and too little air. Once your dots are looking consistently clean, pencil in a number of ½in (1.2cm) squares (graph-paper style) on your paper, hold your airbrush about ½in (1.2cm) from the surface, and spray dots at the intersections of lines. When you've reached a level of consistent accuracy on this grid, try enlarging the dots. Increase the ratio of ink, and lift your airbrush away from the surface. Work at this until you have established a good degree of long-distance accuracy.

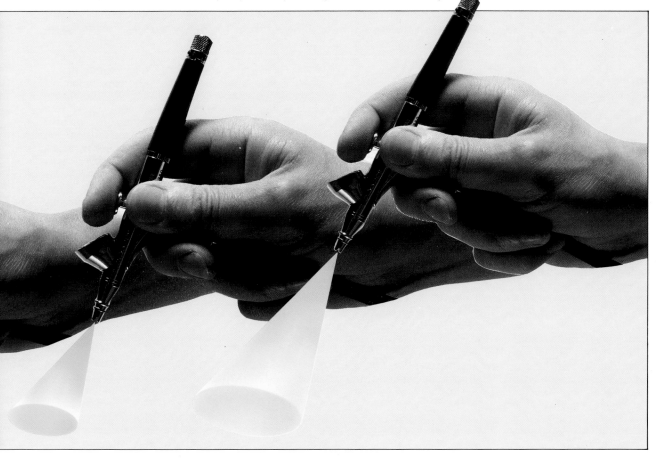

Another standard airbrush exercise is to spray continuous parallel lines (1). Once you have mastered this, draw a grid pattern on the paper. Then, with the airbrush, spray a regular dot on each crossing grid line (2). Finally, join up the dots to make straight lines or a 'Z' pattern (3).

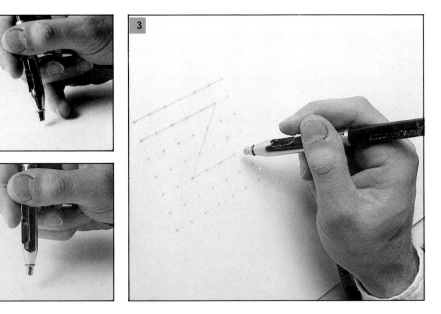

Exercise 4: Joining the dots

This is the classic airbrush exercise and even if it's been plain sailing so far, you'll need all your powers of concentration and perseverance to master this one.

REQUIREMENTS: Blue or black drawing ink, smooth white paper, dropper.

Basically this is a combination of Exercises 2 and 3 – except that it's five times more tricky. Lightly pencil a number of ½in (1.2cm) squares on your paper and airbrush small dots at the intersections. Now try to connect the dots with straight diagonal lines in an even tone.

Exercise 5: Working freehand

This is just a mind-opener and confidence-builder.

REQUIREMENTS: Various inks; large, smooth white paper.

Attempt some freehand drawing. An old favorite is to write your own name but we would suggest you try something more adventurous like copying a simple picture from a book or magazine. Don't worry if the result is awful; the experience you gain in this trial-and-error fashion is extremely valuable.

Exercise 6: Even tone

This exercise is the best way of learning how to achieve a flat, even tone. You will have to repeat it many times – preferably using different colors and varying the scale – before you see a good result. Some simple masking is involved – if you are unsure about this read the masking section that follows.

REQUIREMENTS: Various inks, artist's board, masking tape, scrap paper.

Because some elementary masking is involved here, it is best to work on board rather than on paper. Start by masking a 3in (7.5cm) square with the tape – in other words, a square whose sides are made up of four strips of tape. Cover up the area outside the tape with scrap paper tacked down with tape.

Spray the ink finely from left to right at the top of the masked area, holding your airbrush approximately 4in (10cm) from the surface. Then, spray from right to left, overlapping your previous stroke, and continue this alternation until you have filled the square. Try to achieve an overall tonal fusion. You may need to cover the square three or four times to attain a smooth effect; indeed the only way to create a flat tone is by building it up gradually. Do not be afraid to overspray the masked area – after all, that's what the mask is there for. When you are satisfied with the tone, leave the ink to dry thoroughly before removing the mask. Then lift it slowly and carefully.

Exercise 7: Tonal gradation

Faded or gradated tones are one of the hallmarks of airbrushed work. This exercise will add the ability to produce a faded tone to your rapidly expanding airbrush repertoire.

REQUIREMENTS: Various inks, artist's board, masking tape, scrap paper.

Mask up a 3in (7.5cm) square with tape, as in Exercise 6. This time, instead of spraying from left to right and vice versa, work from bottom to top only, grading the tone as you spray. Start at the bottom of the square and gradually fade your tone into white by decreasing the amount of ink released. Do not fade abruptly, but do not carry the tone further than two-thirds of the area. It is important to remember that as you spray up into the white area, the overspray travels ahead of you and contributes to the gradation of the tone.

The starburst

To make the starburst on the right, first cut the star shape out of a piece of thick paper with a sharp scalpel to form a loose mask. Then, tape the mask down onto a black background with masking tape. Now, spray white paint through the mask (1). To create the blurred edges, very slightly lift and move the mask as you spray through it (2). Once you have a strong white star, remove the mask altogether (3). Now "flare" the center of the star: it is advisable to practice on some scrap paper first. Hold the airbrush over the center of the star, some distance above, and spray lightly (4).

In the simple "starscape" below the effect of distant stars was created with a spatter cap. The stars in the foreground were formed by using the method described above. The glow visible at the bottom of the picture was made by spraying freehand with white gouache.

TRANSFERRING A DRAWING

Having built up the skill to produce basic airbrush effects through the preceding seven exercises, the next stage is obviously to put those effects to good use within some simple illustrations. We have now arrived at the problem of how to get the outlines of an illustration onto the artboard, to be filled in and brought to life by the airbrush.

There are two good questions you may well now ask. Why do I need guidelines in the first place, and given that they are necessary, why not draw them directly onto the artboard? In both cases, the answer is simple.

Firstly, you will need lines of reference because without them, and without a brilliant command of the airbrush, you will end up with an unholy mess. You cannot just pick up an airbrush and spray – planning is vital to ensure a worthwhile result. Some would argue that spontaneity has its place, but before you reach that stage, the basic disciplines must be observed. In short, rough sketches should be followed by an accurate trace, leading to a finished rendering.

Secondly, drawing directly onto the board interferes too much with the surface. The airbrush is such a clean and precise instrument that to spray onto anything other than virgin territory is to detract from the ultimate quality of the finished work. Make your mistakes, and erase them, on a separate piece of paper so that the drawing you transfer to the artboard is accurate and final, although it should not be fully-detailed. Allow yourself room for interpretation with the airbrush, within the reference lines.

At this stage, another basic fact of life cannot be concealed: good airbrushing won't improve a bad drawing. It's exactly the same as trying to make a good film from a poor script, a predicament best summed up by a prominent British director of television commercials in a phrase probably borrowed from Hollywood: "If it ain't on the page, it ain't on the stage." In case alarm bells are ringing because your drawing skills are limited, there is no undue cause for concern. Your base material can be culled from the never-ending source of photographs and illustrations published in their thousands every day. Any subject that can be accurately traced is usable material.

Using a transfer paper

There are several different ways of transferring a drawing onto artboard, some involving expensive machinery for projection and enlargement. The simplest method is, however, a manual transfer involving an inexpensive type of paper known as jeweler's rouge, often referred to as tracing-down paper. It is an excellent transfer medium, obscured by spraying yet undisturbed by the adhesive of masking film. Unfortunately, it is not always easy to track down and you may have to phone

a thin paper with a fine film of dust on one side (the darker side), and it can be used many times over. In fact, the more you use it, the better, because the dust wears off and the lines transferred to the board become fainter. Therefore, there is less interference with the surface to be airbrushed. To "age" new jeweler's rouge, wipe it with a soft tissue to remove excess dust.

Transferring techniques *Using jewelers' rouge*

1 Using an HB pencil, draw the outlines of your design onto white paper. If you are working from a photographic reference, you can skip this stage and trace the image directly on tracing paper.

2 Lay tracing paper over the white paper and trace off the design. At this stage, you can add a little more detail if required.

3 Position the trace on the artboard, leaving a good margin of board all around. Secure the trace to the board with drafting tape.

4 Take a sheet of jeweler's rouge and insert it dust side down between trace and board.

5 With a hard pencil, such as a 6H, simply run over the lines on the tracing paper.

6 Remove both the tracing paper and jeweler's rouge. You will see that your design is now reproduced on the artboard in very faint orange lines. You are ready to commence spraying.

Tracing with graphite

If you fail to obtain any jeweler's rouge, you can employ the trusty old standby of the graphite transfer method. It's comparatively messy and tedious, but it does the job:

1 Follow steps 1 and 2 as above.

2 Turn the trace over and rub an HB pencil over the reverse side of the design, following the outlines of the drawing.

3 Turn the trace over again, and place it right side up on the artboard.

4 Trace over the original lines with a 6H pencil, then remove the tracing paper.

You can enlarge a traced drawing by first dividing it into a grid of small squares (below left). To achieve this, use the dissecting diagonals method (4 diagrams above). Draw two diagonals through the shape and a horizontal and a vertical line through the intersecting point to divide the original shape into four equal-sized shapes. Continue until the desired number of smaller squares is obtained. Next, draw one diagonal through the original, extending beyond it; choose the point along this diagonal that you wish to enlarge to, and then strike lines back to form a shape of the same proportion as the original. This shape can now be divided in exactly the same way as the original.

A highly detailed area on the drawing can be further subdivided (below).

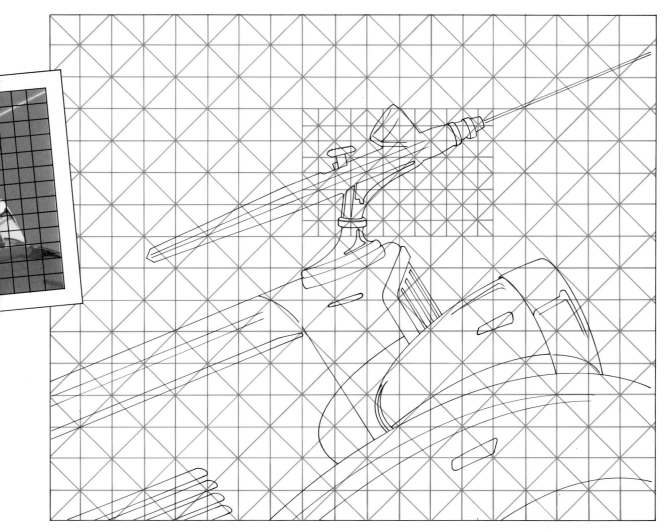

MASKING

We have now arrived at the highly-skilled technique that either makes or breaks the airbrush artist – masking. Essentially, a mask is used either to conceal an area from your spray – here referred to as negative masking – or to expose a shape to it – positive masking. It is not our intention here to delve into the full intricacies of this complex subject; merely to explain the ground rules and basic techniques thereby giving you a springboard for experimentation. As any airbrush artist can tell you, there is no hard-and-fast procedure for acquiring masking skills. Nothing is written in tablets of stone and there is no real substitute for experience.

Although it would seem that the logical headings for discussion of masking should be "Positive masking" and "Negative masking," that is in fact not the case. The techniques of masking are more commonly determined by the type of materials used, and for this reason the subject is better discussed in terms of "hard" and "loose" masking. The two are by no means mutually exclusive and in fact the majority of airbrushed works are executed using a combination of both methods.

Hard masking

A hard mask can be simply defined as one that is physically attached to the working surface. Far and away the best material for hard masking is the product generically known as masking film. Specially developed for use with the airbrush, this self-adhesive low-tack transparent film is supplied in both roll and sheet form. The adhesive side is protected by a sheet of removable backing paper, which should be gradually peeled away as the film is positioned over the artboard. The properties which make masking film so suitable for the task are considerably affected by direct sunlight or heat, so you should always be careful where you store your supply of film.

There are a number of reasons why masking film has rocketed in popularity over a relatively short period of time. Firstly, it fulfills the most basic requirement of all hard masks with failsafe reliability: it blocks out the spray completely. When in position, no painting medium can creep underneath it or seep through it. Secondly, because static electricity makes a major contribution to the sticking power of the film, the adhesive itself is low tack; this means that you can easily raise the film from the artboard and should not lift off any paint with it. Thirdly, most brands of film are extremely thin, thus preventing excessive build-up of paint at the edges of the mask; this, in turn, means that the resultant sprayed edge is pin-sharp. Fourthly, being transparent, the film does not obscure either your transferred lines of reference or any previously sprayed areas; so you need never spray "blind" as you can simply renew the film if it becomes clouded by overspray. Finally, film is extremely workable; with a sharp scalpel and sleight of hand you can cut the most intricate shapes.

Scalpels must be razor sharp at all times for cutting film. A blunt instrument will cut ragged lines in the film, which are the precursors of ragged lines on your artwork. Do not be discouraged if in your early attempts at cutting film, you apply too much pressure and score the artboard below. Determining the right cutting pressure is rather like finding the biting point of the clutch of an automobile: no one can tell you about it, you will get it wrong initially, but after a few troubled moments, it becomes second nature.

Hard masking procedure

Hard masking is equally suitable for positive and negative masking, although it is probably more often associated with the former. There are various ways of approaching hard masking, but the following is perhaps the most widely accepted.

Masking can commence once you have transferred your reference lines onto the artboard. If you are working on a small to medium scale, your initial step is to cover the entire image area on the artboard with masking film. If you're working on a large scale, it is best to break down the image into sections and tackle each segment in turn: therefore you only need apply film to the portion you are working on at any one time, with the remainder isolated and masked off with taped-down, scrap paper. The reason for this is that masking film should not be left in position for any longer than is necessary, as it may destabilize.

To position the film on the board, do not peel away all the backing paper at once; roll back one corner and attach the exposed piece of the adhesive side of the film to the board. Then, gradually stroke the film onto the board with a ruler or by hand, peeling away the backing as you go. This way there is less risk of the film settling with bubbles and wrinkles.

The next step is the subject of some debate. Should you cut all the mask lines in one fell swoop now, or should you cut just the first shape, then spray, cut the second and spray, and so on? As usual, there is no definitive answer one way or the other, and professionals continue to argue the relative merits. Our recommendation is that your should cut all the masks at the outset, removing and replacing them as you progress with the illustration. This saves time and trouble later, when the drawing outlines on the artboard may well be obscured by the overspray on the masking film. If you can't see what you're meant to be cutting, you can't cut it.

To remove a cut mask, hold your scalpel flat to the surface and very lightly pick at the edge of the area you wish to lift. It should part from the board quite willingly, and then you can slowly peel off the remainder. At this point, we are once again faced with a dilemma that would make for interesting listening if you assembled a dozen professionals around the debating table. The motion: should removed masks be kept, and replaced in position once the exposed area has been airbrushed, or should the whole area be re-covered with a fresh mask? The argument for, is why go to the trouble of making a new mask when you've already got one. The argument against, is that once removed, a mask can stretch and lose its tack, plus the fact that unless you re-site the original absolutely perfectly, you will end up with unwanted white lines or sprayed lines. This time, we're sitting on the

Spraying a flat tone

To cut a hard mask, first draw the design onto the base board or the masking film and then peel the masking film off its backing. Now cut round the square design with a scalpel (1). Next lift a corner of the square mask with the tip of the scalpel and remove it (2 & 3). Using broad, even strokes, a flat tone is sprayed on (4). It is better to build up the tone with several light applications, carefully drying off between each spray (5). Remove the mask to look at the result (6). Any underspray or marks can be carefully nicked out with a blade (7). A vignette is just as easily achieved with the same method.

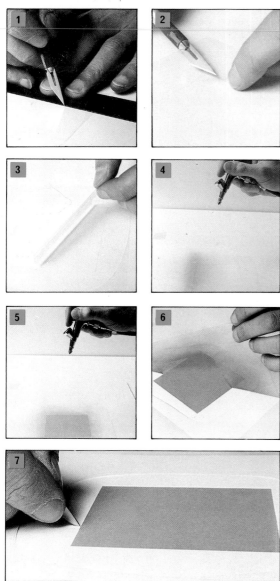

fence, because it is a "self education" issue. Try it both ways. If you decide to keep the original cutout, a good tip is to house it temporarily on a piece of backing paper, ensuring that dust doesn't infiltrate the adhesive side.

With the mask removed, you have reached the moment of truth. It is time to pick up your airbrush. You can either build up the image freehand, use loose masking (see next section) or, if fine detail is required within the exposed area, you can opt for a "mask within a mask." In other words, you can position a negative mask within the existing positive mask. Paint build-up at the mask's edge can be avoided by holding your airbrush at a steep angle to the surface. On completion of spraying, it is absolutely critical to let the paint dry thoroughly before repositioning either the original or a new mask. Premature replacement spells disaster, because when the time comes to peel away the masking film in its entirety, you will not be unveiling a masterpiece: you'll find that half the paint stays on the artboard, the other half lifts with the masking film. It is at such moments that your sanity and the well-being of your airbrush are at risk.

A simple cube can be created by the subtractive mask method. First draw a cube, lay on masking film and cut along the drawn lines with a sharp scalpel. Now remove the mask for the darkest side. Spray a flat tone, then, leaving this area open, remove the middle-tone mask. Spray across both. Finally, by removing the mask from the third surface, and blowing over a light spray, a simple 3-dimensional effect is achieved.

Liquid masking

Waning in popularity, liquid masking is perhaps best avoided unless you revel in the challenge of doing things the hard way. Liquid masks are formed by rubber compound solution that is painted on the surface and then dries to form a protective skin. It is not stubborn when dry, so removal is quite easy either by peeling or rubbing with an ordinary eraser. This process can be quite untidy and on top of that, there are further drawbacks: some liquid masks discolour the board, others lift the paper surface, none is really suitable for use with acrylic paints; this last because the paint tends to glue the mask to the surface.

Despite these headaches, there are occasions when you may find that this somewhat unfashionable method comes into its own. For example, neither hard nor loose masking can properly cope with tiny detail. Liquid masking can, since it is flexible enough to be painted on with a fine sable brush. For general use, however, it is probably more trouble than it is worth.

Loose masking

A loose mask can be a feather, paper clip, comb, piece of chicken wire or any one of thousands of everyday objects. More traditional materials are paper, card, acetate and ready-made plastic French curves and ellipse guides.

The most accurate way to describe a loose mask is with a negative definition: it is any object placed in the firing line between the airbrush and artboard that is not fixed at all points to the board. A loose mask may rest on the surface of the board or can be held some distance above it: in some cases, loose masks may be weighted or taped to the board but, as with loosely taped paper, the air jet from the airbrush lifts the edges and paint is allowed to trespass under the mask. The effect is an uneven, soft-edged line that could represent anything from a distant mountain range to an aircraft vapor trail.

There is only one way to discover the kaleidoscope of effects that can be created by materials of different textures and thicknesses, positioned at varying distances from the surface; that is to experiment. Tear up an old newspaper and spray over the pieces; spray through blotting paper; around absorbent cotton; through stencils and templates. Very soon you'll get a feel for how effects can be achieved and used, and you'll build up a stock of reusable home-made loose masks. With a little ingenuity, you should be able to design and cut an all-in-one loose mask that incorporates a straight line, right angle, convex and concave curves. Use acetate rather than paper because, although it costs a little more, it should last a lot longer under repeated use.

This photo-realistic approach to depicting the human eye (top right) was executed using only one hard mask which formed the basic shape of the eye. The pupil was created by spraying through a plastic circle template, giving it a soft edge. The white highlight was applied in the same way. All other detail was carried out freehand, occasionally replacing the hard mask. The blood vessels were executed using a particularly fine spray with a Paasche turbo. A small amount of brushwork is evident in the eye corners and lower lid.

A monochrome version of the eye (center right) demonstrates a graphic approach to the eye. The same basic method was used but a coarse spray was used for effect and a highlight reflecting the light source from a window is shown.

Photo-realist and graphic techniques are combined in this representation (below right).

This example of photo-realism (far right) by the illustrator, Chris Moore (see page 143), is a highly finished example featuring the human eye. The carefully observed highlights make the eye totally believable. The treatment of the various skin textures are particularly effective, from the fine sensitive skin of the top lid, to the stretched coarser skin below the eye. Even the fine eyelash shadows were executed with an airbrush.

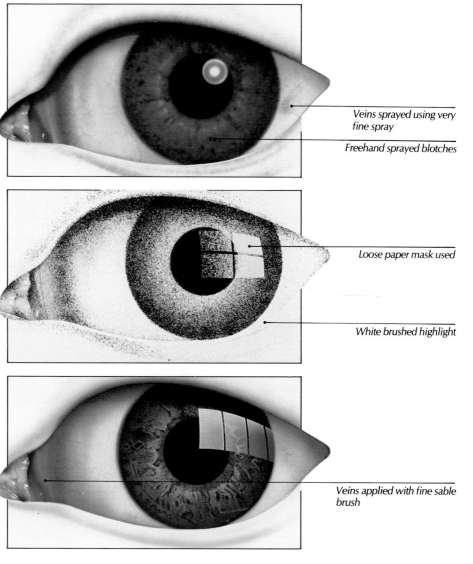

Veins sprayed using very fine spray

Freehand sprayed blotches

Loose paper mask used

White brushed highlight

Veins applied with fine sable brush

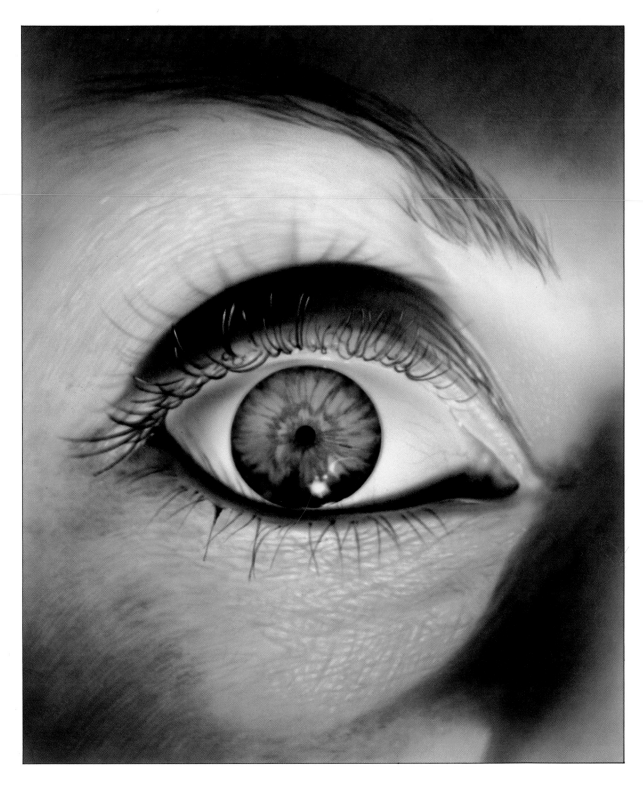

Exercises in shape

Exercise 8 Cube
Cut the outline of the entire cube in the masking film, and then the three inner dividing lines. Now lift the mask from the section of the cube furthest from the light source, in this case the righthand side. Gradually airbrush a tone from the upper left corner to the bottom right, building up the color intensity slowly. When the paint has dried, replace the mask and tackle the lefthand side in the same way. Using your judgment, vary the intensity of the tone to create a three-dimensional effect. Finish by lightly fading the color across the top surface of the cube.

Exercise 9 Cone
Cut the outline and remove the mask. Start airbrushing from the top, flaring the spray slightly towards the curved base. Repeat this action until you have recreated the tapered appearance as shown.

Exercise 10 Cylinder
Note how the light varies on a cylinder, making the flat surface different in tonal quality from the curved area. First, cut the outline and the top dividing line. Remove the mask for the curved area, and imitate the spray pattern used here. Replace that mask, and lift the one covering the flat section. Again, follow the effect of spraying shown here.

Exercise 11 Sphere
Cut the outline, using either a compass knife or circle cutter, and lift the mask. Airbrush lightly around the entire edge of the circle in a curved motion, rocking the airbrush back and forth. Starting from the bottom righthand segment of the circle, airbrush upwards and inwards, stopping just short of the center of the circle. Leave a white circular area in the upper lefthand portion to highlight the form. Continue a slow build up until your sphere takes on a three-dimensional appearance as shown.

Three dimensions
The three-dimensional effect is not difficult to achieve with the airbrush. The airbrush artist must, however, have a fundamental understanding of the distribution of light and shade over any given shape and must learn the art of rendering material textures such as the examples below.

Mat steel
Matt steel has a fairly dull surface and therefore does not reflect well. The inner shading can be achieved with soft masking only.

Chrome
Chrome is highly reflective, and the contrast between shadows and highlights is particularly marked. Note the use of hard masking to achieve this effect, as opposed to the soft mask for matt steel.

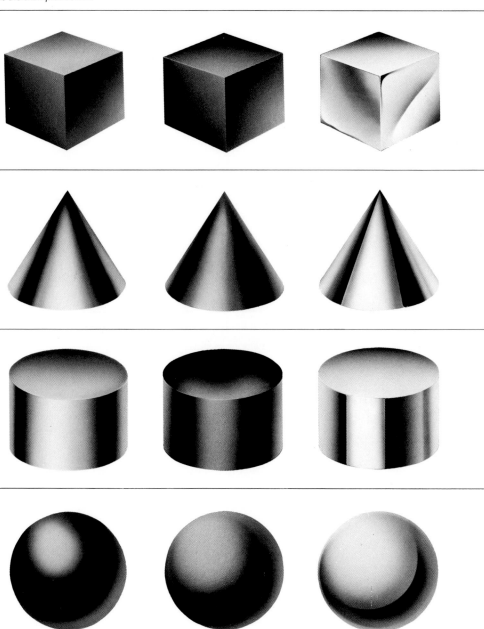

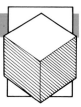

Glass

Although glass appears simple at first glance, the fact that one can see through it presents the problem of having to show the back edges without losing the form. Spraying these lightly can achieve the distancing effect necessary to "knock" the edges back.

Rubber

Rubber generally has a dark, matt finish that picks up few reflections. The difficulty is not so much in the shading but in matching the texture of the material. A spatter cap is useful in this case.

Stone

Like rubber, stone is normally fairly dull and non-reflective. The most effective way to achieve the pitted texture is, again, to employ a spatter cap.

Wood

Wood has a variety of textures, from fine light-grained boxwood to the coarser, heavy hardwoods; experimentation is the key word. Employ combinations of movable hard masks, torn paper masks, brushwork, and techniques such as those described on pages 62-5.

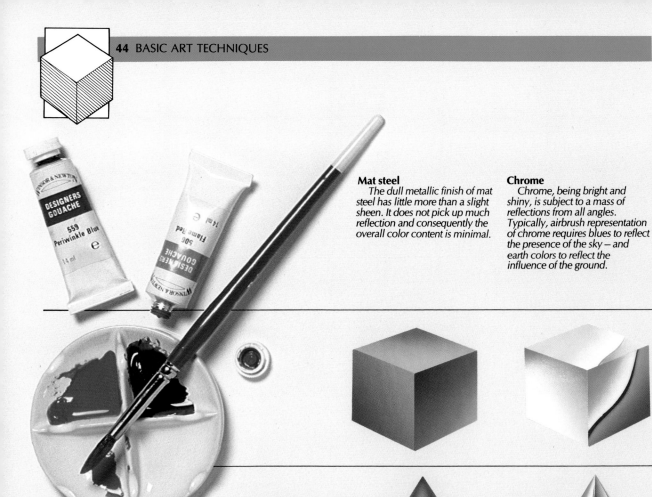

Mat steel
The dull metallic finish of mat steel has little more than a slight sheen. It does not pick up much reflection and consequently the overall color content is minimal.

Chrome
Chrome, being bright and shiny, is subject to a mass of reflections from all angles. Typically, airbrush representation of chrome requires blues to reflect the presence of the sky – and earth colors to reflect the influence of the ground.

Using color

Many professional airbrush artists rely on just a dozen stock colors. From this base supply they are able to mix any number of hues. However, for the inexperienced artist, mixing colors can present problems: paint sometimes behaves in a most unpredictable manner. It will take time and trial and error experimentation to familiarize yourself with the mixed reactions of certain colors but with practice you will start to find that you instinctively mix colors to the desired hue with the minimum of wastage.

It is useful, when you are illustrating an image that features particular materials, surfaces or textures, such as steel, glass or rubber, to get hold of an example of it beforehand and study it. Colors and reflections are often surprising.

Glass

Glass attracts a myriad reflections. A glass object, in limbo, does not present too many problems for the airbrush artist, as the predominant colors are blues and greens. If you wish to emphasize the reflective qualities of glass, then the illustration becomes much more complicated.

Rubber

A prime example of how a tinge of color – in this case scarlet – can enhance the three-dimensional effect of an illustration. Notice how the addition of scarlet brings the illustration out from the page unlike the flat black-and-white rendering on the previous spread.

Stone

It is much simpler to show the various types and textures of stone when using color. Simply spray a spatter of yellow ocher and overlay a spatter of gray to achieve a passable stone effect. To obtain a higher degree of realism spray back a white spatter to give the highlighted effect often found in many varieties of stone.

Wood

Using exactly the same technique as described on the previous page for monochrome wood, color can be used effectively to show the many varieties of wood. It is, however, advisable to avoid the darker browns, keeping instead to lighter shades of color in the yellow/gray range. Avoid the temptation of adding every line of grain.

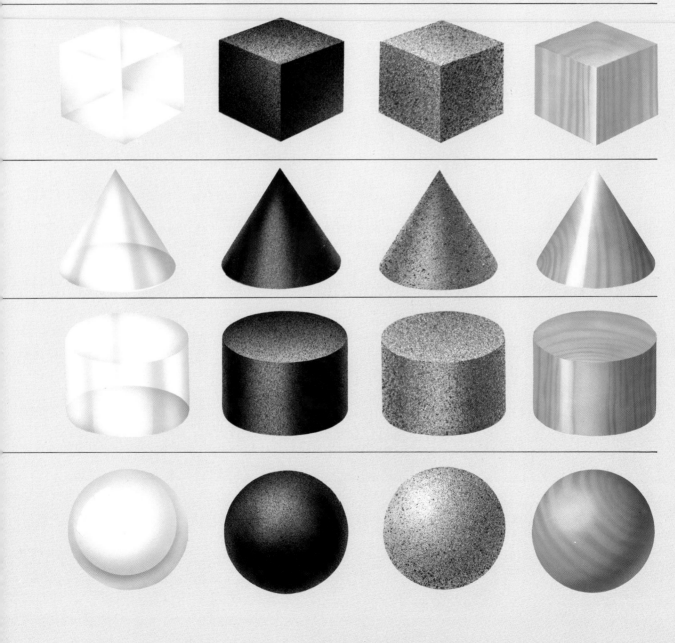

As can be seen (left), cast shadows help to ''ground'' objects. Achieving realistic shadows requires either particular drafting skills or careful observation from life. In natural conditions light and reflected light come from all directions but for the purposes of illustration it is wise to adhere to one light source. Everyday objects and a drawing board light can often be used for experimentation. Shown below are four permutations of varying light sources: (1) low light source from left; (2) high light source from behind left; (3) low light source from behind; (4) low light source from right.

1

2

3

4

Form and texture

Once you have mastered the basic forms – cubes, spheres, cylinders and cones – you can combine them to create coherent images. Most forms are made up of combinations of these basic shapes and most highly complicated shapes can be built up slowly, using the basic ''forms.'' This, together with a mastery of texture, will enable you to describe any surface.

The still life shown above uses the basic forms described on the previous four pages with the addition of an egg, a particularly difficult texture to emulate. These shapes are made to sit on a surface by ''grounding'' them with cast shadows. It is obvious that some grasp of perspective is required to draw such a still life. However, there are available on the market pre-drawn perspective grids.

PROJECT: Lettering

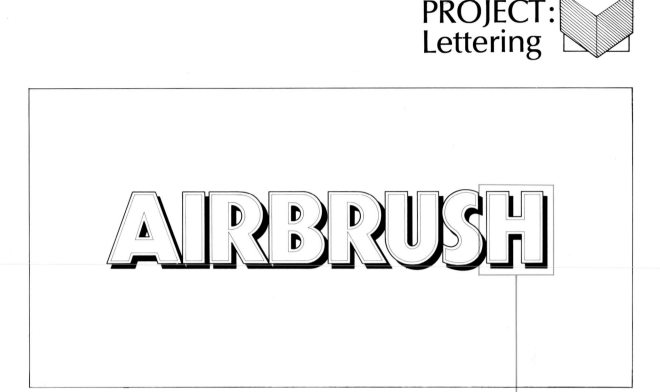

PLANNING BEFORE PAINTING

The hardest part of airbrushing is planning the painting – deciding on a logical sequence of both masking and spraying that takes you from a blank sheet of board to a finished illustration. Airbrushing is not essentially a spontaneous process and precise planning will save you confusion and crises of confidence midway through a job.

Needless to say, the only rules that govern planning are rules of thumb; they exist to be bent and broken, not religiously obeyed. It is a matter of logic and personal preferences, but the following points make sense:

☐ Work from background to foreground. The focal point of an illustration is generally to the fore, thus it should be sprayed over the background.

☐ Spray dark areas first, then light. This is because with transparent media such as inks or watercolors, lighter colors are more prone to contamination by darker colors than vice versa. They may be smudged or fingerprinted as you lift and replace masks, therefore get your dark colors down first.

Remember different people work in different ways, and no one can claim a "correct" method. Some artists, for example, prefer to start by spraying all the elements of the same color in one burst – all the blue areas, followed by all the green areas and so on. Others see complexity as the criterion for planning, so tackle the most detailed and difficult areas first, while others again choose to warm up by spraying the larger, easier areas. Rest assured, with practice you'll arrive at an order that seems logical to you. And that will be the right way for you.

Convincing lettering relies on careful construction or tracing. Instant lettering catalogs, such as Letraset or type books, are a good source. This lettering can be traced and enlarged or reduced to suit. The lettering for this project is straightforward, comprising straight lines and halfcircles. The shadow is drawn in with an outline, using a technical pen and black ink (above).

A First, find a model for your lettering or use the example in this exercise. Transfer this onto artboard by tracing it and then enlarging to a suitable size. Enlarging can be done using the grid method, explained on page 37, or freehand, guided by a diagonal, as shown on the preceding page, or with the aid of an enlarging machine. Then ink in the initial line-work with pen, ruler and templates, as shown below.

B Next, tackle the background by masking the whole area with masking film and with a sharp scalpel cut round the letter(s) and picture border to lift off the background mask. Now charge your airbrush with black ink and spray from the outside edge inwards (1), slowly changing to blue and finally to scarlet to create the glow round the letter(s) (2).

C Now, to create the bevelled border round the letter(s), lay mat masking film over the letter(s) and draw the outline of the border with a pencil (3). Cut (4) and lift out the inner part of

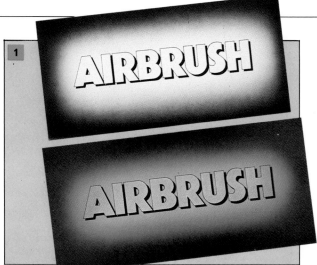

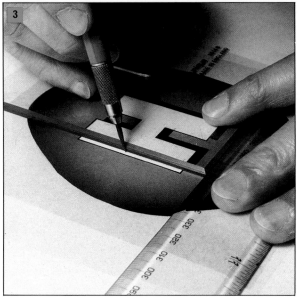

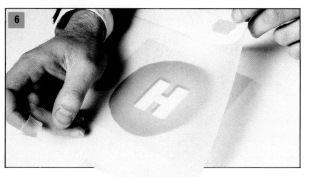

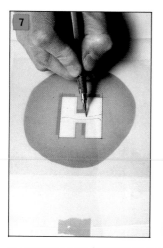

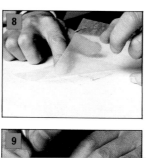

the letter(s) with a sharp scalpel (5). Store the masks for later use.

D The next stage is the creation of the wavy line across the center of the letter(s). Lay a sheet of tracing paper over the work and tape down with masking tape (6). Then, with a pencil, draw in the wave-like reflection (7). Take off the tracing paper and reinforce with masking film (8). Using a French curve, cut out a mask for the central dark wave (9). Next, spray over the wave with black. The edges will be soft because of the loose mask.

E Following this, the inner face of the letter(s) is completed. First the mask is roughly cut away below the wave (10) and vignetted down with violet and blue inks. As inks are transparent it does not matter if the black wave is recovered. Complete these steps (11 and 12), leaving the background mask in position.

AIRBRUSH

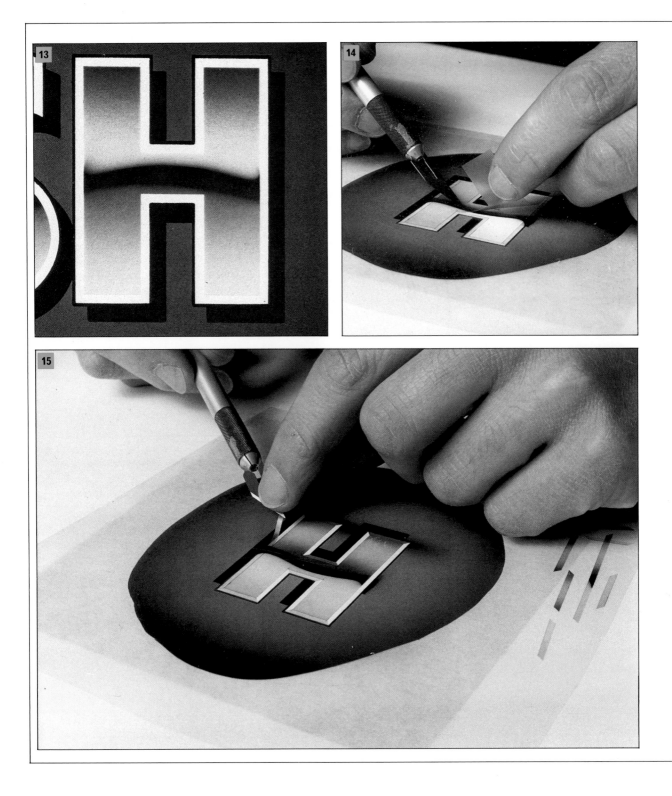

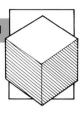

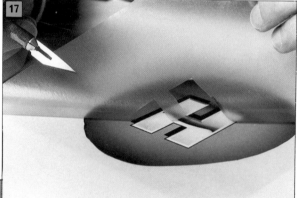

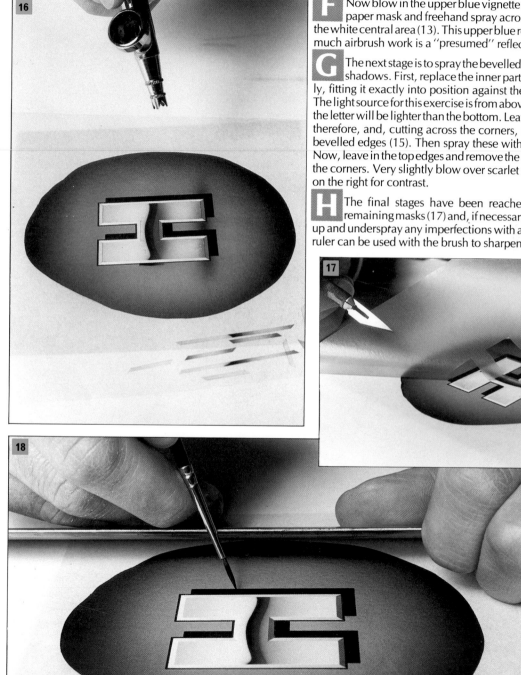

F Now blow in the upper blue vignette. Take off the tracing paper mask and freehand spray across, carefully leaving the white central area (13). This upper blue reflection as found in much airbrush work is a "presumed" reflection of the sky.

G The next stage is to spray the bevelled letter border(s) with shadows. First, replace the inner part of the letter careful-ly, fitting it exactly into position against the border mask (14). The light source for this exercise is from above, so the top edge of the letter will be lighter than the bottom. Leave in the side edges, therefore, and, cutting across the corners, remove the bottom bevelled edges (15). Then spray these with dark shadow (16). Now, leave in the top edges and remove the side ones, cutting at the corners. Very slightly blow over scarlet on the left and blue on the right for contrast.

H The final stages have been reached. Peel off all the remaining masks (17) and, if necessary, touch up and tidy up and underspray any imperfections with a fine sable brush. A ruler can be used with the brush to sharpen the edges (18).

19

After removing the final mask, the overall effect can be viewed (19). Consistency across the letters should be checked at this point and only essential changes made, since remasking at this stage could lead to small areas of the artwork lifting. It is often a good idea to protect the surface of the final illustration with a sheet of clear acetate. This prevents droplets of water from falling onto the surface, or greasy fingerprints being applied. Often, the moisture in the pores of the fingertips will lift off the surface and leave the fingerprints showing in white. This is virtually impossible to repair and it will invariably show through, especially when ink has been used.

After you have completed a simple example, you might wish to try a complicated logo, such as the one shown on the right, which was designed and executed for a book jacket. It is often worth collecting examples of various logos and examples of typography from magazine advertisements and filing them for future reference.

Using special masks

Masks can be either "positive" or "negative;" in other words, they can be used to expose areas to the spray or conceal areas from it. Almost any material or object can be usefully employed as a mask. Solid objects, such as circle templates and French curves, can be used to create interesting effects, and it is worth experimenting with items that can be sprayed through or which have interesting textures. Absorbent cotton, for example, is excellent for creating the soft edges around clouds. Hand-torn heavy card or blotting paper gives an interesting soft, cloud-edged texture. It is worth experimenting — loosely tear various types of paper and board. Paint can often be cleaned from the surfaces of masks and the masks reused. It is often worth cutting masks out of a durable material, such as some of the thicker grades of clear acetate or plexiglass. Both materials can be cut with a sharp craft knife and plexiglass can be drilled and filed. Emery boards are often very useful for shaping such templates. Pre-cut lettering or pattern stencils can be bought from specialist art supply stores. These are often extremely useful and can also be reused.

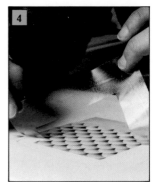

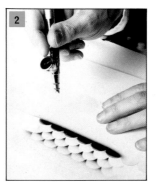

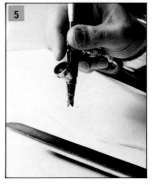

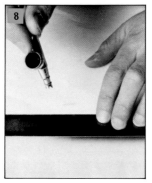

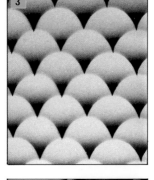

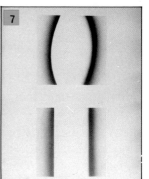

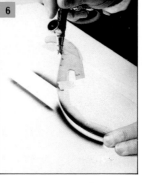

This sequence of pictures shows a repeating pattern, produced using a hand-cut acetate mask (1). After the first row has been sprayed, the mask is moved down another row and sprayed again (2). This process is repeated until the bottom of the work is reached. Care must be taken to ensure that the ink or paint is fully dry before moving the template down (4), or smudging will occur. The completed pattern (3) gives a graphic fish-scale appearance. The technique of spraying across a ruler (5) and French curve (6) can give an interesting effect (7). The closer the edge of the ruler to the surface of the board, the harder the line; a fairly hard line is achieved when just the thickness of a steel ruler is used (8).

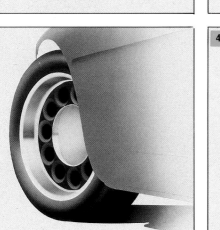

This typical example of a car stylist's visual shows slick graphic representation taken to an extreme. The wheels are executed using a combination of hard-cut masks for the hard edges (1), sprayed back using white gouache. A cut mask is moved around the perimeter to produce the apertures in the aluminum wheel (2). After the shapes of the tire have been cut using a hard mask, the modeling on the tire is produced by spraying through an ellipsed template (3); scrap paper masks off the surrounding ellipses (see above). The fine finishing touches on the bodywork of the car are created by spraying across a torn paper mask (4).

In the field of professional illustration, a major consideration in deciding the amount of finished detail to give a piece is the size at which the artwork will be used. It is obviously pointless to spend valuable hours finishing an artwork to an extremely high standard if it is to be used on a matchbox. The client would also object to paying for unusable detail.

The larger example of a telephone receiver (left) took twice the time of the smaller inset version (below), but when used at this size, the difference in the finishing is barely noticeable.

Cutting and re-using circular masks

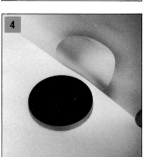

Cutting masking film for a hard mask is very simple if you require only straight lines; even curves can be simply executed, using a French curve. Circles, however, present a problem. By hand they are never perfect. You can cut around the inside of a circle template, but you risk nicking the template, so that it is no longer circular. Alternatively, a scalpel blade can be attached to one leg of a compass by using tape or gripping the pen attachment, but this method is not entirely satisfactory. A purpose-built cutting jig is the best answer (1). Once mastered, effects are simple and clean. A flat tone is sprayed through the mask (2). Then, by replacing the cut-out section (3), and moving the original mask down by 1/8in and spraying a light tone through it (4), a flat disk is easily created.

An almost photographic quality is achieved in this illustration of pool balls (above). The very particular high gloss but waxy surface of pool balls is captured and the subtle reflection of the number 11 is most effective. By using this technique only once, the artist reveals a restrained approach. The numbers were drawn on in ink with a technical pen before spraying was started. Soft highlights were sprayed through a circle template to contrast with the hard-cut mask effect used elsewhere. The illustration is not based on a black line drawing with ink sprayed over (a technique known as "holding line") but is totally self-supporting. This technique is known as "fully realized" and demands much greater accuracy of mask cutting. Careful observation from life and a fairly large-scale drawing, allowing greater flexibility, combine to make this an excellent illustration.

PROJECT:
Plastic and chrome

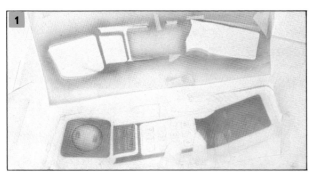

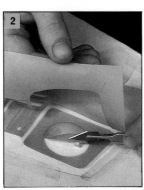

The airbrush is particularly suited to the representation of reflective surfaces – chrome, gloss paints and plastics. The image achieved can be so real that it creates a vibrant feeling of tension between the reality and the artifice employed in it.

A The outline of the telephone is film masked (1) using jewelers' rouge to trace through on top of the film. This avoids marking the board's surface. The darker green areas were removed first and sprayed across in a flat tone. Then the pale green areas were removed and the lighter color blown across.

B The masking of the earpiece disk is held just above the surface by loops of tape (2), ensuring a softer spray edge. Carefully remove the mask with the blunt edge of the scalpel; if carefully removed, the mask can be stored and reused.

C The shadow down the side of the telephone is then remasked. The darker tone is sprayed over, graduating it up to the top edge by spraying across a raised card.

D A template is used for the circle of the earpiece. The plastic is thick enough to affect the outline, which is softened by oblique spraying. The angle of the spray can greatly vary the outline and emphasis (3).

E First, the black button panel and the slots of the ear and mouthpiece are film-masked and sprayed. Then the original film mask is carefully replaced for the modeling of the casing. The outside edges are darkened by carefully spraying a fine vignette along a ruler. The molding below the earpiece is achieved with two simply cut masks and freehand spraying.

F Now the telephone is virtually complete and the masks are removed. The apparent tonal contrast between (4) and (5) is interesting. It is difficult to judge the depth of tone with masks which are no longer transparent in position, so it is worth checking frequently by lifting a corner.

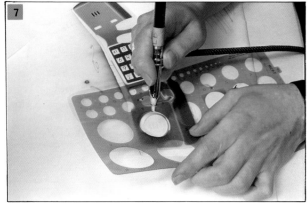

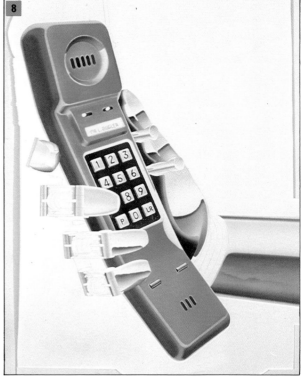

G Brush and finishing work is usually left until last. Here, though, the telephone and hand are treated separately. Details such as the button numbers are added with a fine sable brush, held steady with a ruler's edge (6).

H The basic foundation for the highly reflective metal of the robotic hand is airbrushed with a single film mask. Working from dark to light, the reflections in the metal are added with loose masking. The hand reflects the green of the telephone, acquiring a blue tinge on the metal. At the bottom of the palm reflection, the hard edge is knocked back by blowing across white gouache, thereby foreshortening the hand. Finishing touches to the receiver are blown through a template (7).

I Detailing of the joints and finger mechanisms are sprayed and brushed in. You can see how the outline of the illustration has been lightened to contrast with the intended darker background (8 and 9).

J The finished illustration shows how the final touches can strengthen the image. First, highlight areas are hand-painted around the earpiece and then pale gray across the keys. Then finger shadows on the casing and the reflection of the metal are added. Finally, the third major texture of the rubber boot wrist joint is detailed with careful hand-spraying.

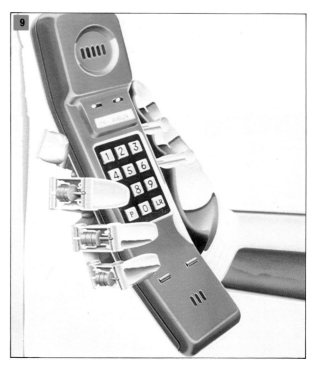

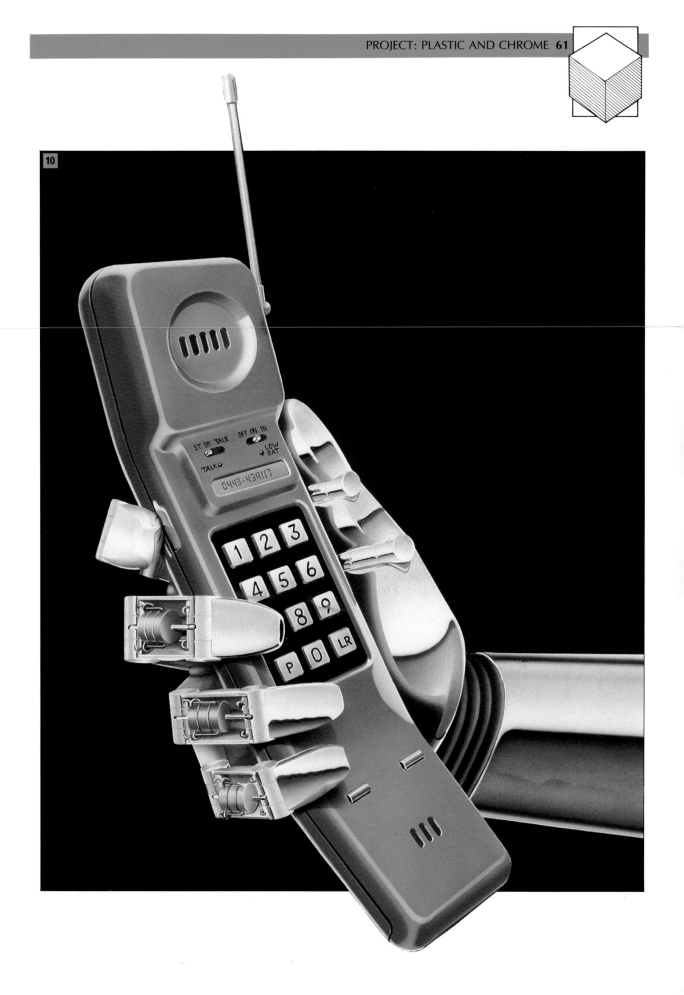

PROJECT:
Wood

Any form or object is made up from a combination of basic shapes—cubes, cylinders, cones and spheres; it is just a matter of scale and texture. As discussed in the last two projects, the airbrush is naturally suited to representing shiny and glossy surfaces – chrome and shiny paints. With less reflective textures, such as wood, the airbrush has to be used in a different way with more freehand brushwork.

The wooden texture of the artist's mannequin in this project is achieved by first spraying on full tone but flat color. Then a layer of fine spatter is added in a lighter tone by using either a spatter cap or a small amount of air to cause the paint to blob. The spatter is then drawn across the flat surface with absorbent cotton while still wet.

A After drawing the design onto the base board, the whole area is covered with a film which is progressively cut to carry out the various stages of spraying. The film is cut and areas lifted off for the first mask (1). Each individual component is sprayed separately while the other elements are covered with scrap paper. Close examination of the head will reveal the smearing of fine spatter technique employed here to emulate fine-grain wood, such as boxwood. Some shading is added to the head and outstretched arm after the execution of the texture technique. At this stage, a hard pencil eraser is employed to produce soft highlights on the head and the sphere representing the football.

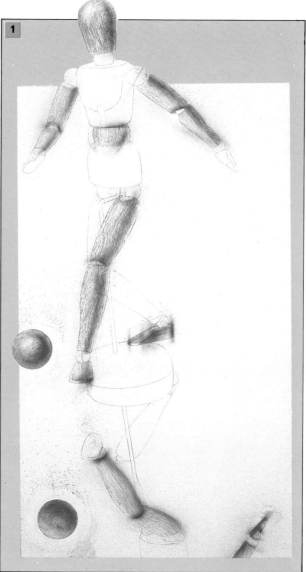

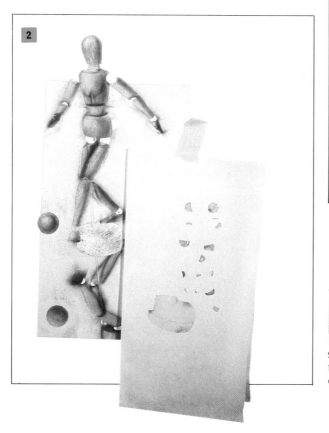

B The mid-point in the second mask is shown (2) when the torso areas have been completely modeled and the masks replaced, after ensuring that the ink in far corners of the mask was completely dry. Now the joint areas of the mannequin are removed and carefully stored on a sheet of clean white paper.

C The technique used by the artist to represent fine, closely grained wood is clearly shown (3). Fine spatter is applied to the plinth, which is then smeared across, using a small piece of absorbent cotton. The cotton must be renewed frequently so that it is dry. The fineness of the spray can be seen on the piece of scrap paper next to the artist's hand.

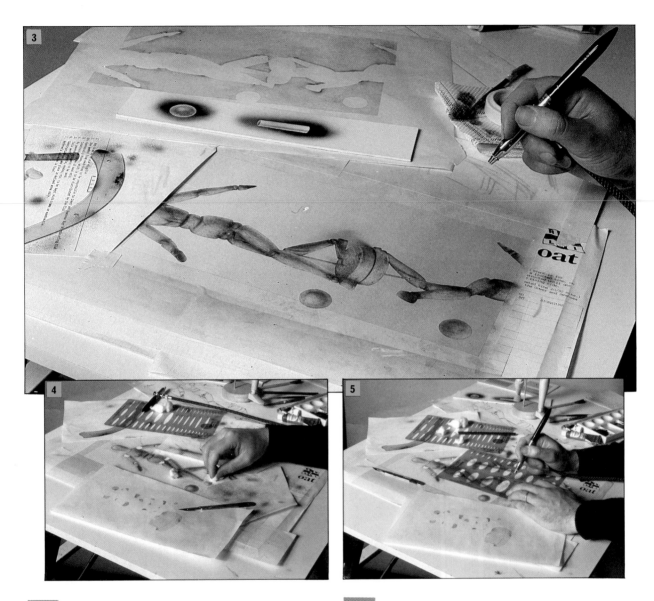

D After the texture on top of the plinth has been applied, some modeling can be added. Instead of cutting a Frisk or paper mask, a found object is used (4); in this case an ellipse template. These are made from durable plastic, which can be cleaned easily after use in warm soapy water.

E The paint is dried using air from the airbrush (5). Before drying paint in this way, it is essential to check that the needle is seated fully forward. The tiniest droplet of paint or water might ruin your careful work.

F The wire stand for the mannequin is so fine that a colored pencil is used for shadowing (6). It is often necessary to resort to other techniques, such as pencil- and brushwork, when the detailing is so fine, although professionals tend to use brush or ruling pens and gouache because of their permanency. When using pencil, there is always a risk of smudging, so care must be taken not to load too much color onto the surface.

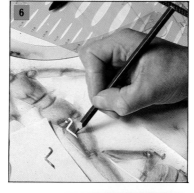

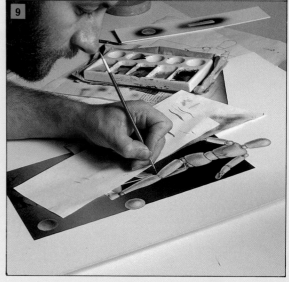

G The final highlight is applied using a fine '0' size brush. Here, it is run along a firmly held ruler (7). A smooth, fluid action is essential and it is advisable to practice on scrap paper before committing yourself to your artwork. The gouache should be at the consistency of milk: if it is too dry, the brush will drag; if too wet, it will flood. In addition, some would use a ruling pen to ensure perfectly parallel straight lines.

H It is worth noting that, with masks in place and when large amounts of overspraying are necessary as for this dark background, it is easy to make the tone too dark. It is wise, therefore, to lift a corner of the mask and check the background against the subject – it is impossible to judge with the mask in place. The final mask is removed (8). Care must be taken at this stage not to drag damp areas of film across your artwork, as masking film often holds small droplets on the surface.

I Finally, the fine sable brush is taken up. Cutmarks are painted out and fine details are added, such as the modeling of the screw heads and the fine shadows on the ball joints (9). A fine dark line is added to the underside of the sphere to strengthen it and make it stand out. Last of all, do not forget to sign it.

10

Wood textures

Textures such as wood rely on the artist formulating his own techniques through experimentation. There is no correct method as such but freehand striations can produce an effect that resembles darker hardwood such as teak. Ash is clearly grained and can be simulated with a fine brush. Pine is coarse-grained and can be sprayed along torn paper to produce the desired effect.

PROJECT:
Realism

A First the helmet is tackled (1). The black outline and helmet transfer are executed in ink on the board with a technical pen. Then, using this as a guide, a Frisk is cut and the areas to be red lifted off first and sprayed with watercolor. When this is quite dry, the mask is replaced and the blue areas exposed and sprayed. The highlights are created using strips of Frisk, left in position for the first few passes of white gouache spray and then removed to give a lighter tone. Details are finally added with watercolor pencils and the spot highlight sprayed freehand. The attempt at the highlight on the visor is later altered – part of the process of creating an image.

B Next the leather-clad body is film masked and the red and blue base colors sprayed on. The shadows and highlights, for example those suggesting the folds in the leather, are applied, using a combination of loose paper masking and freehand spraying. For the highlights on the shiny leather on the upper back, liquid mask is applied as a resist (2).

C These highlights are then softened using a pencil eraser. Some fine touching-in is completed at this stage with a blue pencil (3).

D Now, all but the rider's lower back and leg are complete. Highlights and shadows and number stitching details are added with a fine sable brush and watercolor pencils (4).

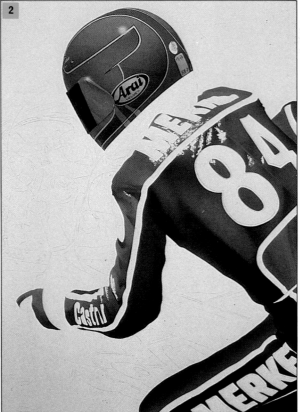

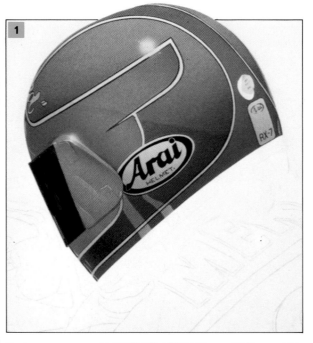

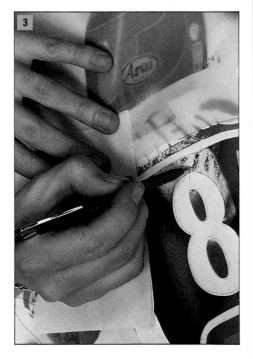

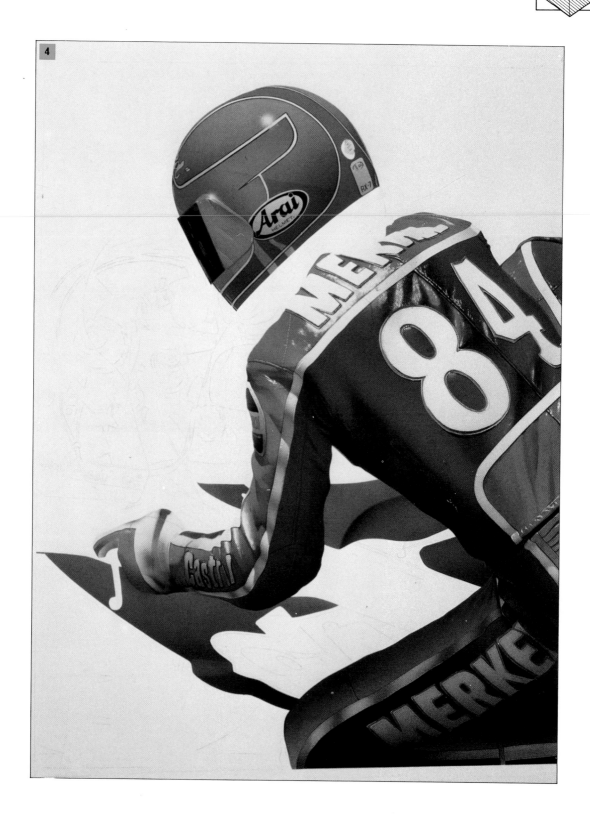

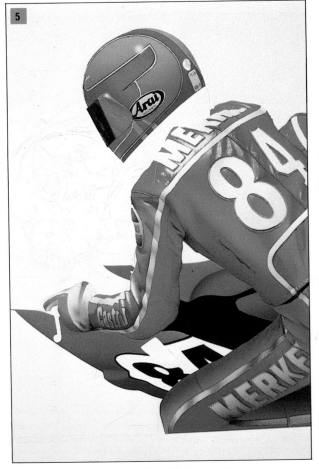

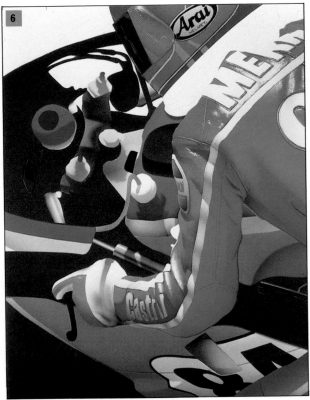

E Now to concentrate on the glass-fiber and steel elements of the composition: after the red base color is masked and sprayed (5), the shadows are blown over in black. Then, the numbers are carefully drawn and blocked in.

F Form is given to the lower fairing with further over-spraying of dark shadows and white highlights. Then the basic forms of the handlebar section are masked and sprayed. Finally, some simple cast shadows are blown over, using a variety of loose paper masks (6).

G Much of the technical detail of the handlebars and yoke is completed using watercolor pencils and a fine sable brush for the highlights (7). Loose edges can also be cleaned up at this stage with a brush.

H The completed illustration shows how the focus in this picture emulates that produced by a telephoto lens. There is a central area of tight focus, which tapers off towards the edges of the composition. After final details are completed, such as hair and face, the highly effective wheel is very simply modeled with a spot highlight from pure white to light blue. The background color is airbrushed in before the plexiglass canopy is film masked and sprayed over to complete the illustration.

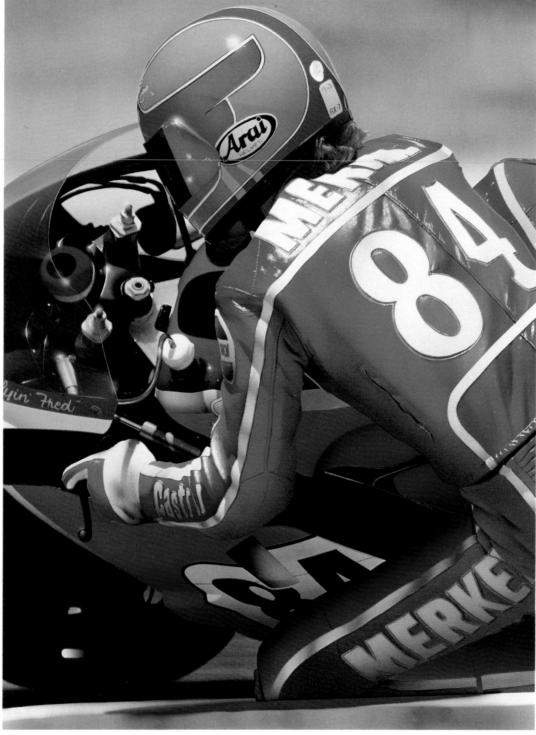

Figurative techniques

Even for the most skilled technician, there are still some subjects which present problems for the airbrush artist. The human figure certainly falls into this category, for the hard, smooth, metallic finish so easily achieved with the airbrush is somewhat alien to the delicate translucence of human skin tones. The airbrush can, however, be highly effective when used to create stylized representations of figures. By flattening out tones, for example, an excellent art deco feel can be contrived. Such stylized pieces are currently enjoying a revival, inspired by the successful poster artists of the 1930s and 1940s.

Otis Shepard's graphic style is evident in the Wrigley's chewing gum advertisement (above). A more realistic style was used by George Petty; the swimstar drawings (right) were prepared for *Jantzen* in 1937 and used for a nationwide advertising campaign. His work was also featured prominently in *Esquire* magazine. Alberto Vargas's work was later featured in *Esquire* and was similar in style to Petty's, but Vargas's remains the better known.

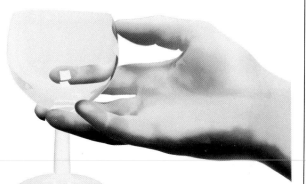

Achieving a visually acceptable hand image is difficult and calls for precise mask work. The translucent appearance of the skin is created by using a light touch and a hard pencil eraser for fine adjustments. The example here was derived from a photograph and executed on a large scale so that the final artwork could be reduced and therefore tightened up. The insets show loose tracing paper masks being used on the palm of the hand. In the first two stages (above), the hand lacks realism through lack of detail, which requires fine brushwork. The final stage (left) appears unfinished but when reduced the image will become crisper and more intense.

PROJECT:
Stylized treatments

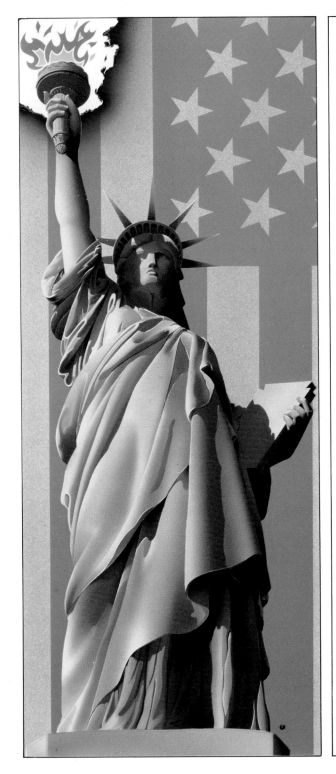

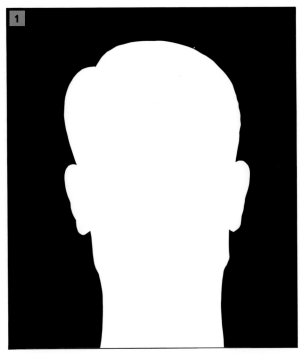

After mastering realistic treatment of form, many illustrators simplify their styles and produce graphic images like those seen in the 1930s and in the pop art boom of the late 1960s. The popular image (left) was treated with flat, subtle color and given a fine spatter texture, and is typical of this style.

The following "face" project, influenced by the American illustrator J C Leyendecker, is a good example of the same technique.

A The order in which an illustration is completed is dependent on the style of the illustrator and the particular problems arising from the composition. In this case it was decided to spray the flat black background first (1).

B The first loose mask, cut from tracing paper reinforced with film, is for the shadowed areas of the face and hair (2). The background is partially covered with paper to protect it when the black paint is blown in. When the mask is removed, the basic structure of the face is already apparent (3).

C Using the same method, the next five masks (4 to 8) are cut and sprayed. You will see that the masks have not all been sprayed with flat color, but that sometimes the color, for example in the forehead shadow, is vignetted across.

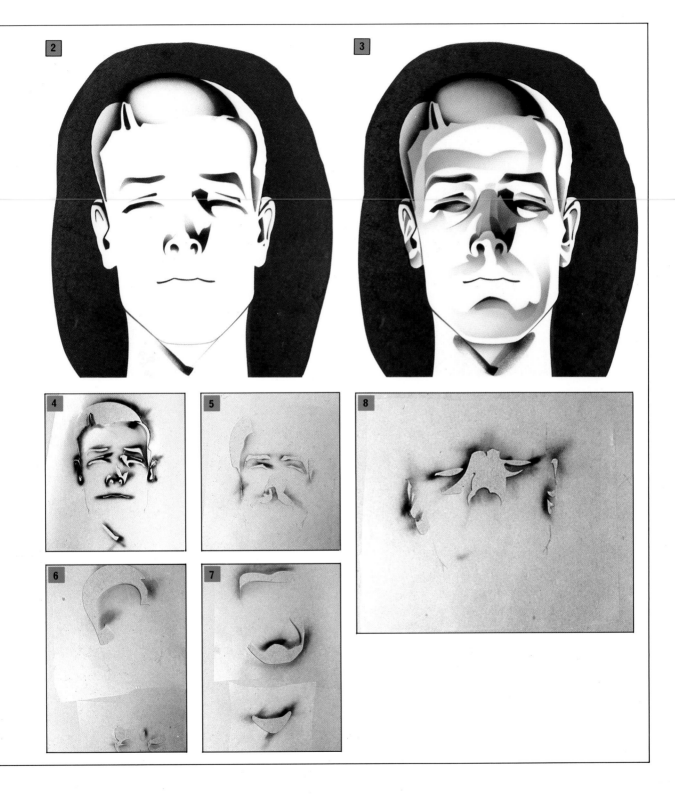

D Next, the skin tone is sprayed in over the shadows with the eyes and background masked (9). Always wear a face mask when spraying (10) as the fine spray is easily inhaled and can be damaging to the lungs. The eyebrows are then scratched with a scalpel to make highlights.

E The lips are now treated separately, working from dark to light. The mouth is traced onto tracing paper (11), reinforced, and then a mask cut for the lower lip, using a French curve (12). The lower lip is then sprayed (13) and finished with a fine brush (14).

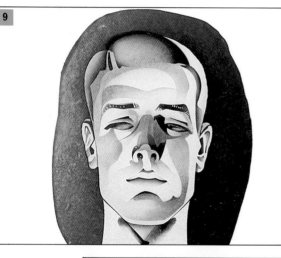

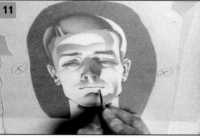

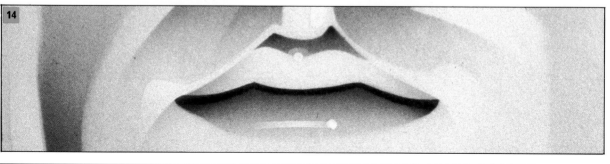

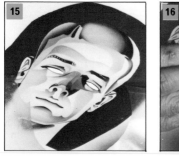

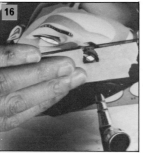

F The eyes are tackled next. The background mask is lifted off and the eye masks removed (15). Then, the whole face is masked, apart from the eyes, and the irises sprayed, using a circle template as a mask (16): the other circles in the template are closed off with masking tape. Then the pupil is sprayed through a smaller circle on the template. The finished eyes can be seen in detail below (19).

G Next, a mask for the hair highlights and for highlights down the right-hand side of the face is cut, positioned and sprayed with white (17). Blurred edges are achieved by lifting and moving the mask slightly while spraying (18).

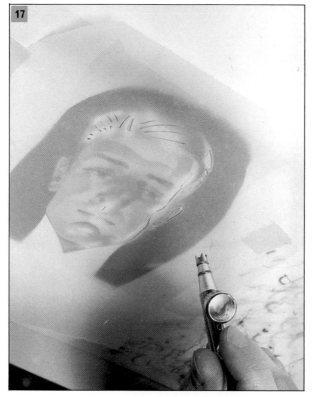

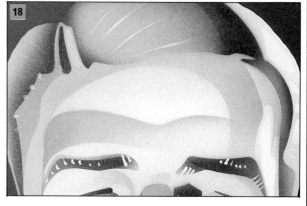

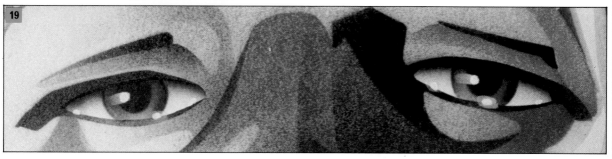

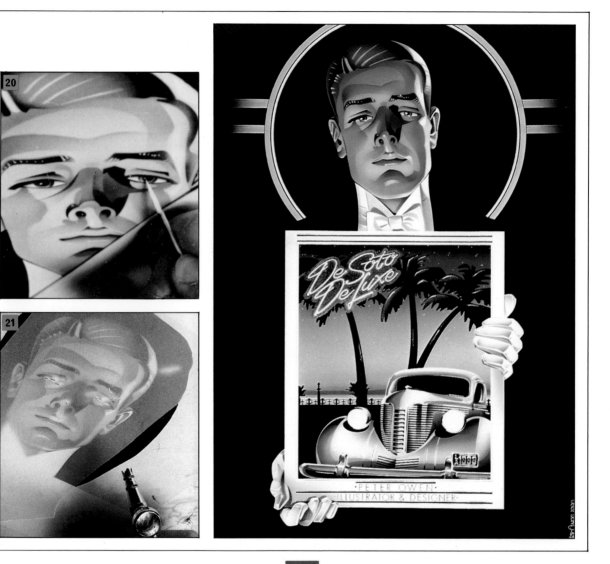

H Some of the highlights are added by hand, using a fine brush (20), but most are added by cutting a mask for the eyes, nose and lips and then spraying with white (21). These highlights are also given blurred edges by slightly lifting and moving the masks while spraying. The centers of the highlights are then strengthened with some white paint using a fine sable brush.

The finished piece of artwork featuring the face can be seen above . Opposite, the face is shown enlarged.

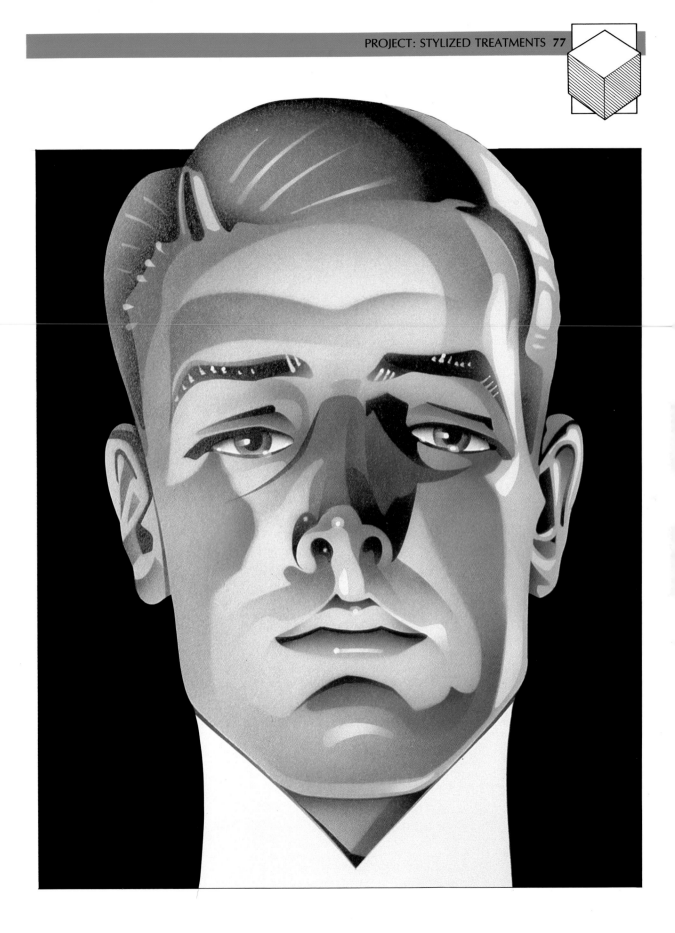

PROJECT:
Graphic techniques

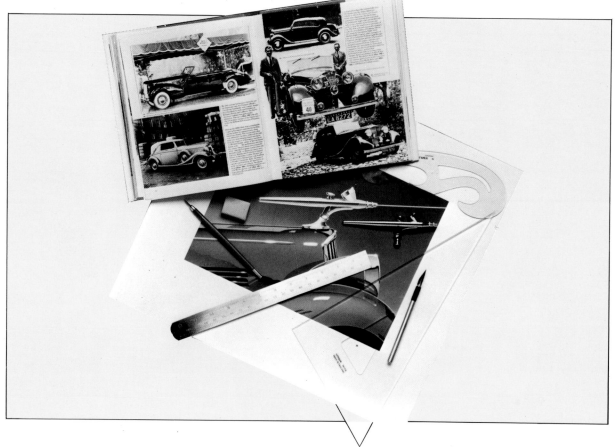

If you have methodically worked through, and successfully completed, the preceding exercises, you will now be ready to put your skills to the test with a major work. If you are confident, you can invent your own subject matter and wade in. Alternatively, you may prefer to begin cautiously by following the step-by-step guidelines given here. These will eventually lead you to a copy of our cover illustration. It is, in fact, an excellent "first masterpiece" subject, lending itself particularly well to the airbrush style.

Materials required: HB, 2H and 6H pencils, felt-tip markers, technical pen, layout paper, tracing paper, tracing down paper (jewelers' rouge), white art-board, scalpel, ruler, curves, templates, fine sable brush, good supply of clear, low-tack, mat masking film, black drawing ink, white gouache, assorted inks (black, blue, scarlet, red, dark gray, sienna).

A As with any work of art, the first step is to produce a very rough sketch, or series of sketches, with a pencil (preferably HB) on layout paper (1). This gives you the chance to play around with different shapes and sizes, helping you to formulate ideas (2). If you are aiming to recreate our finished illustration, this step is very straightforward. Perhaps you might like to

change the color of the car, in which case you can use the felt-tip markers to assess the effect of various shades (3).

B Once you are happy with the basic composition for your illustration, you should proceed to a full color visual (4). Again, complete accuracy is not vital as you are merely putting down your formalized ideas onto paper to gain a good idea of its overall effect. However, you will find a well-worked visual invaluable in helping to plan the order of work. For example, if you choose to work the darkest areas first, you will need to refer to your visual constantly to decide on an order of spraying.

C Using a 2H pencil on tracing paper, you can now produce a detailed pencil trace of the proposed illustration from your color visual. At this stage fill in all the fine detailing, such as the radiator grille and the airbrush plinth.

D Next, take a sheet of tracing down paper (jewelers' rouge) and transfer your drawing onto a hard, smooth, white art-board, (5 and 6). Use a 6H or hard pencil and make sure you leave a wide border around your illustration. You can always trim the art-board when the work is completed.

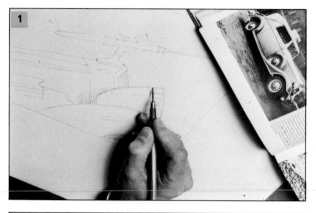

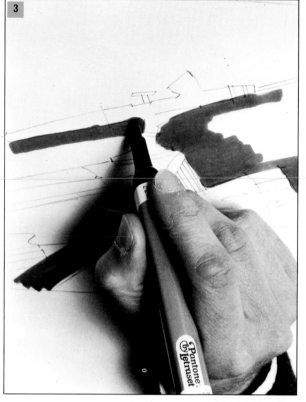

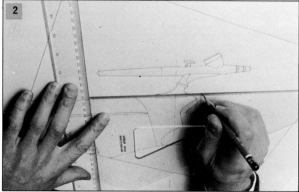

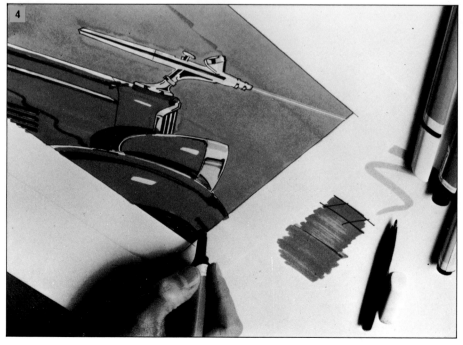

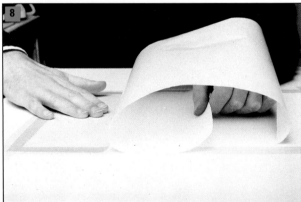

E You will need a clean white border for your image, so cover the area outside the image area with scrap paper, taping it down well at the inner edge. Now, cut a piece of clear, low-tack masking film to size, sufficient to cover the whole image (7). Tack down one side first, then slowly pull away the backing sheet, smoothing the film over the board as you go (8).

F You can now expose the first area to be sprayed – in this case, the complete upper background (9). Use a sharp scalpel and straight and curved edges (10). Then just peel away the film covering the background.

G Spray in the background (11). Start at the top with black, then – using your own judgment – fade from black to blue. The effect to aim for is an indistinguishable fusion between the two colors, with the fade progressively weakening from black to blue. To create a soft scarlet glow immediately above the car, the blue should in turn fade into scarlet. Once you are satisfied that you have achieved a smooth background, remove the remaining masking film.

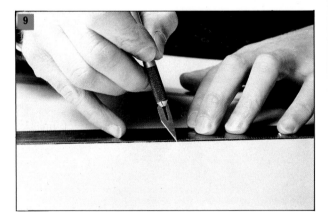

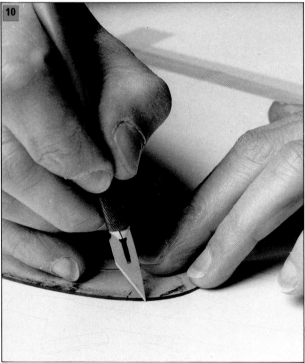

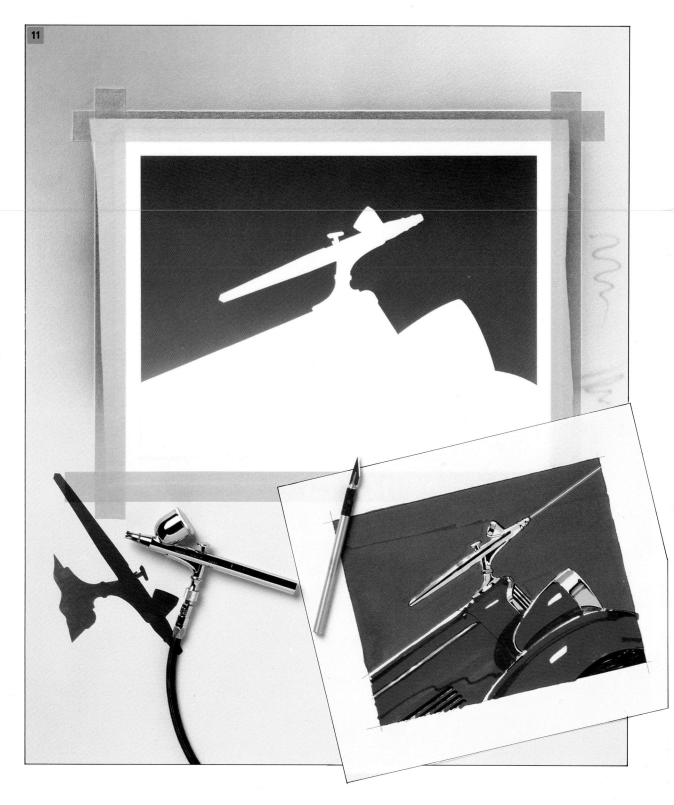

11

H With the illustration fully exposed, draw in all the flat black areas, such as the side grille and wheel arch in the bottom right-hand corner. Using a technical pen with rulers, curves and templates, first delineate the outlines in drawing ink, then fill in the black areas with either the pen or a fine sable brush.

I Next, mask off the whole red area with a mat finish masking film which enables you to overdraw the detail on to the film with an HB pencil. Instead of having to look through the film when removing masks, overdrawing gives you a much clearer view of the underlying detail. Now you can start spraying the car. Cut and remove the masks covering the darker areas first, such as the shadow at the bottom of the headlamp casing (12). These can be sprayed with a very dark gray. Follow a logical sequence from dark to light, progressing from dark gray to gray, red, scarlet and ending up with the white areas which require no spraying at this stage (13). Now, again, remove all the masks.

12

13

J Now you can tackle the chrome areas on both the airbrush ornament and the car. First re-cover the whole illustration with mat masking film and then draw out all the relevant areas with a pencil on the film. Next, cut the masks, starting with the darkest areas again. Do not worry about the detail at this stage as it will be added at a later stage. Instead concentrate on the main blocks of color. Spray black first, then dark gray, followed by sienna mixed with a touch of scarlet and finally the blue. The reflections in the airbrush can be observed in your own airbrush. Often objective observation is the only way to achieve a convincing image, although it is necessary to simplify what you see. On completion, remove the entire mask.

K Now is the time to add the fine detail, using a brush and a ruling pen (14). Masking is not essential, but you may prefer to mask some areas and spray them as opposed to using the pen. The aim now is to bring the drawing to life by highlighting certain areas and picking out reflections (15). The white highlights can be brushed in with gouache. Keep a piece of scrap paper under your hand to protect the illustration. It is impossible to explain all the detail in this illustration but it should be possible to imitate the results through experimentation. The strong white highlight on the airbrush was created using a ruling pen. Use a sharp scalpel to nick out any excess ink (16).

L You are now ready to add the ray from the airbrush model using an airbrush. Pick and choose your whites, test spraying onto a piece of scrap paper with a similarly colored background. This will help you determine the "whiteness" of the result. Then mask the ray area and spray with a hard white. Now, with a slightly bigger mask, soften the edges with white, before adding a blue tint to the outer limits of the ray.

M It is quite likely that during earlier spraying, ink may have seeped under the masking film. Now is the time for corrective action. Also, if there are any areas where masks were slightly out of position, the "gaps" can now be colored in by hand. Make sure when using gouache with a brush that you keep the consistency of the paint like milk. If you allow gouache to become too dry it will clog; if too wet, it will run into blobs on the surface.

N Stand back and take a long look at your illustration. Check the tonal equality – is any area of feature too light or too dark? Is any reflection or shape slightly off target? If so, amend accordingly (17).

O Once this is done, the finishing touches can be added. First the highlights have to be knocked up or "flared" to make them stand out. This can be done freehand by applying white gouache (18) or by scratching the highlight with a scalpel. Edges may need to be softened and this can be done with an ordinary soft eraser.

P Finally, check again to ensure your illustration is as close to perfection as possible and use a fine sable brush to touch up the edges. A brush and rule can be used to clean up the straight edges and conceal any cut marks still visible. The temptation may well be to overlook minor flaws in the excitement of these final stages. But correcting such flaws will improve your work considerably.

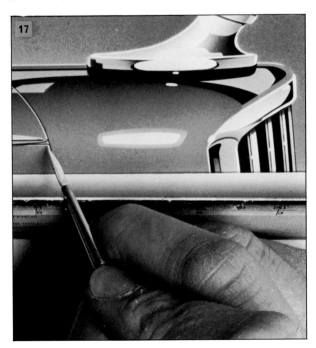

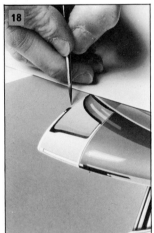

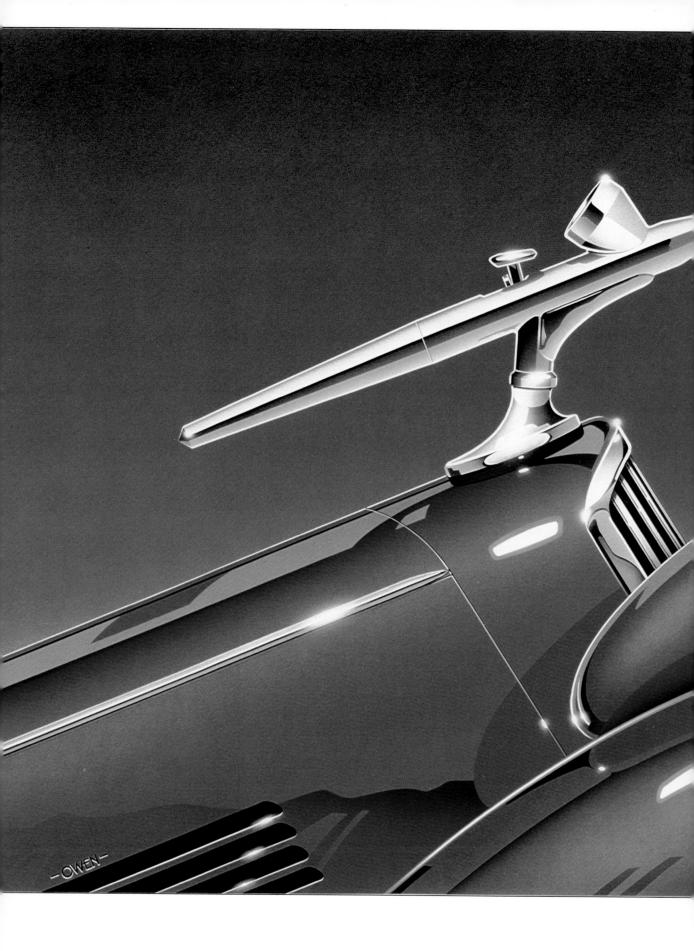

Now for the delicious moment when all scrap paper is removed from around the board. Immediately you will notice how much stronger your work looks. Trim the board, leaving a pristine white margin around the illustration. Then give it some protection with a clear acetate overlay taped onto the back. This will save your work from the ravages of oily fingerprints, which are very difficult to cover up. Finally, photograph your work. Then, in the case of loss or damage, at least you will have a record of your masterpiece.

This section contains some examples of other techniques commonly used by exponents of the airbrush. They offer an alternative method of displaying or portraying an image and are useful in a general portfolio of work. Of course, there are further techniques not illustrated here – and the airbrush artist will invent many of his own, often by mistake. The two main areas open to diversification involve masking agents – anything which can be removed after spraying can be used – and materials to spray through to achieve an effect – from gauze to perforated metal.

Image on colored paper

The illustration below of an all-welded compressor was based on general assembly drawings. The design was drawn on tracing paper and was then transferred onto blue paper using white transtrace. Areas, such as the pistons and liners, to receive detailed treatment, were exposed first. Coeruleum blue watercolor and then peacock blue gouache was sprayed on and then lamp black and permanent white gouache added to indicate form. Secondary features were then completed to a lesser finish with more economical use of gouache; white and the coeruleum blue were omitted and shadows faded from gray to blue. Emphasis was then given to the edges of the section with white gouache applied with a brush. Other selective lining-in was completed by brush and colored pencil. The annotations were hand-written with white ink with a technical pen. Finally, the graphics were added onto an overlay.

Reverse-image illustration

The Opel suspension unit illustrated opposite was produced with a white line on a black background using a combination of transparent watercolor and opaque gouache. The order of application is very important: if you spray gouache on top of watercolor the Frisk film mask will pull the gouache up. Since you are using a reverse image, first spray on the highlights, creating a monochrome image. Next, add the watercolors. Finally, the highlights must be knocked up by spraying with white ink to increase the contrast.

The Grasso. Modular Construction. All Welded Compressor

Key-line on acetate

Below is a traditionally rendered "ghosted" airbrush drawing of a racing car. With this type of illustration, every detail has been applied to the base surface, including all the finished line-work. But, if care is not taken, deep cut marks will appear in the base board which even intricate brush and ruling-pen line-work will not disguise. This problem can be overcome by the method illustrated at right. Here, the color work for this Porsche 934 turbo was sprayed onto one sheet of clear photographic film. Then, to facilitate mask-cutting, a line drawing of the subject was made and printed onto a second sheet of clear film as a film positive. With the positive under the clear film, masks are cut but, when the color work has been completed, the situation is reversed with the positive on top acting as a key-line for the illustration. This line covers up any cut marks and gives a crisp quality to the finished piece.

Method: first, using Frisk masks, the engine and gearbox were sprayed with gouache, followed by the other internal components. The positive is replaced on top at various stages to check the finished look. With the internal details completed, the body is added around them, "ghosting over" with a fine spray where necessary. Finally, the sponsored advertisements and ground shadow were added.

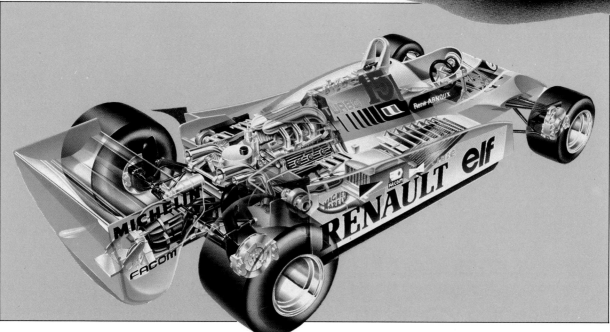

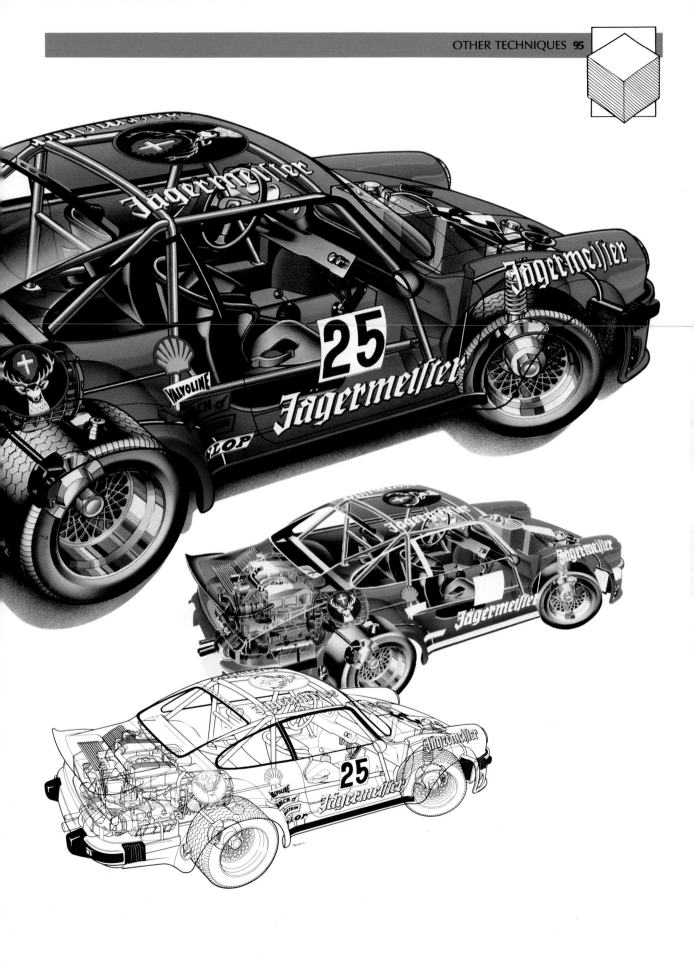

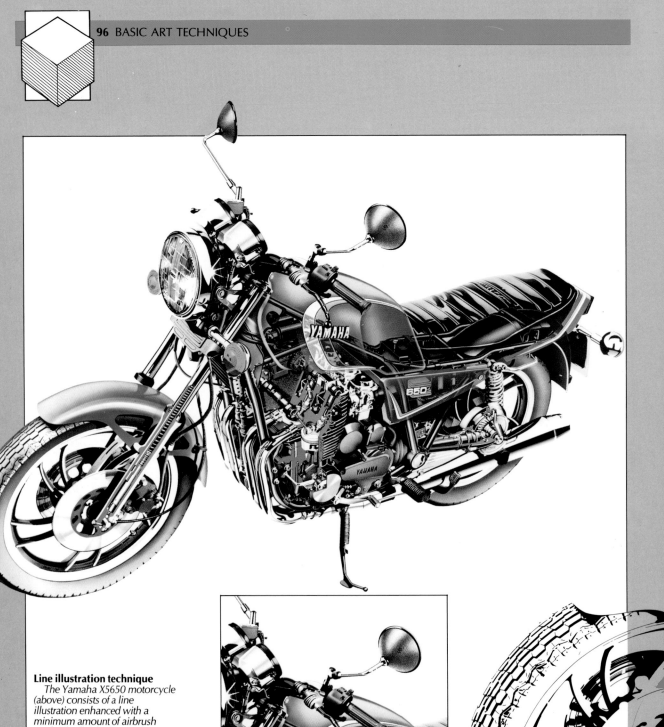

Line illustration technique

The Yamaha X5650 motorcycle (above) consists of a line illustration enhanced with a minimum amount of airbrush work. The finished image has much of the appeal of a full airbrush painting yet the skill required is minimal.

Essentially the technique involves a rationalization of the drawing into dark (black) shadow areas and light (white) highlight areas similar to a tone elimination photograph. Colored drawing inks are then sprayed on the drawing to produce a full-color image.

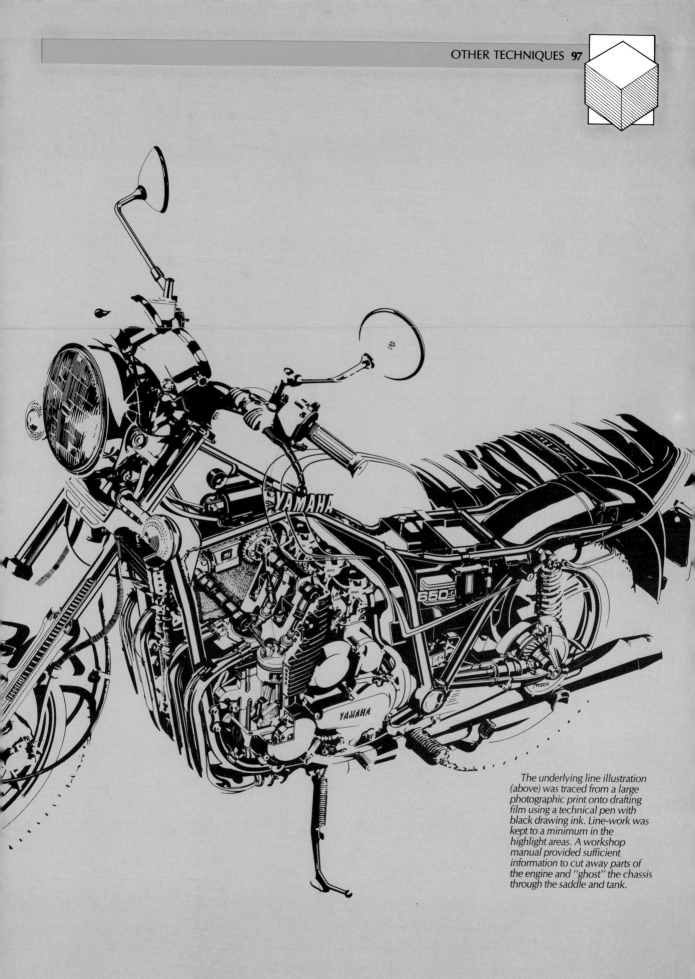

The underlying line illustration (above) was traced from a large photographic print onto drafting film using a technical pen with black drawing ink. Line-work was kept to a minimum in the highlight areas. A workshop manual provided sufficient information to cut away parts of the engine and "ghost" the chassis through the saddle and tank.

CHAPTER

3

– BASIC PHOTO-RETOUCHING –

Photo-retouching is one of those behind-the-scenes activities that appears far less glamorous than creating your own original artwork. In fact, it is a highly skilled process that demands from the airbrush operator a level of control generally much greater than that needed for illustration. In addition, to progress beyond the basics, you need a keen visual sense that defies the pigeon-holing of retouchers as merely technical craftsmen.

If your first reaction is to skip this chapter to concentrate further on mainstream illustration, resist the urge. Nothing we are going to attempt is beyond your powers with the airbrush, as the photo-retouching exercises involve many of the skills you've acquired from the exercises in the last chapter. True, retouching is primarily the preserve of the professional, but it is as well to be aware that those professionals are extremely highly paid. While this book is not intended as a career guide, if it acts as a stimulant for you to take a closer interest in the techniques and uses of retouching, that is all to the good.

THE USES OF PHOTO-RETOUCHING

Pick up any newspaper or magazine and almost without exception it will contain a retouched photograph. You may not be able to see which shots have been retouched, but that is testament to the retoucher's art.

Retouching is not normally employed to improve a poor photograph, but to sharpen the impression of the subject of the shot. This could involve taking something out of the photograph, putting something in, or a combination of both. Advertisers, for instance, are always keen to portray their product in its best light. If that product happens to be, say, a bottle of gin or sherry, it is difficult to photograph it without capturing some unwanted reflections on film, and these must be eliminated in the retouching. Similarly, if a company wishes to produce a brochure showing shots of machines at work on its factory floor, it is both easier and cheaper to photograph the machines as they are and then ask a retoucher to brighten up the paintwork and remove any blemishes. Furthermore, even the best-laid plans of mice and men can go awry. In one case involving the photography of a white horse for a certain brand of whisky, the shot considered best by the advertising agency was marred by the fact that the horse had, a minute earlier, fouled the studio floor. Instead of settling for the

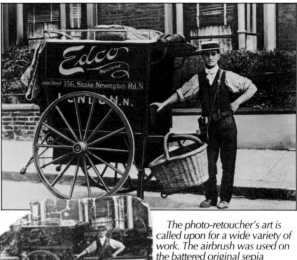

The photo-retoucher's art is called upon for a wide variety of work. The airbrush was used on the battered original sepia photograph (left) to create the immaculate print (above). The airbrush was also used to produce the amusing image (below).

second best pose, retouching was used literally to clean up the photograph! In another case, an agency specified a female model for a facial shot, who arrived at the studio looking immaculate apart from the fact that she was cross-eyed. Again, instead of incurring expensive cancellation fees, the solution lay with the retoucher.

As well as advertisements, newspaper editorial photographs are often retouched. Frequently, the purpose is not to add or subtract from the composition, but merely to clarify the image so that it reproduces better in newsprint. Less subtlety may be required if this is the case, because the retoucher's brief is probably to heighten the differentiation between gray tones – in other words, to make the photograph more black and white. It is true to say, too, that unlike advertising photographers, photojournalists often have only one chance to get their shot – drama such as a man leaping from a blazing building happens only once, and it happens very quickly. If the shot is of poor quality, deft retouching skills can make it printable.

On a more sinister note, retouching can disprove the theory that the camera never lies. Retouching can be and has been used to alter photographs radically, so that their basic truth is violently distorted. Not recommended!

Here, the photo-retoucher has been asked to eliminate the works in the background, clean up the work platform and clarify the logo.

Starting with an enlarged print, the work platform was masked with low-tack film for a hard, crisp outline. Then it was sprayed from the top with light gray paint down to the tarmac. Next, from there, tarmac-colored black was sprayed on from side to side, gradually lifting the airbrush. The shadows were blown in and finally the machinery "cleaned up" with an airbrush and the outline and logo reinforced with a brush.

THE AIRBRUSH IN RETOUCHING

The airbrush can be used for retouching black and white prints or negatives and color prints or transparencies. Throughout this century, airbrushing has been the backbone of the retoucher's art and it remains a vital ability in the repertoire today, despite the fact that modern photographic and processing techniques can be exploited to create effects only previously attainable with the airbrush.

The term "retouching" covers a much broader range of activities than just airbrushing. Top color laboratories house a frighteningly expensive battery of materials and equipment, ranging from chemicals for the blanket removal of photographic emulsion to electronic-based hardware for color separations and photocomping. Needless to say, this complex world does not belong in these pages.

Though the airbrush may seem humble by comparison, its inherent facility of affording the retoucher fine and total control guarantees its future in this field. Photo-retouching is a creative process that relies on human expertise and the human eye for its ultimate effectiveness. It is our aim here to introduce you gently and at little expense to this fascinating subject.

The airbrush is invaluable to the photo-retoucher for a variety of effects. It has been used to soften the cutting edge in photomontage (above) and to cover up undesirable details (far right).

In the 1923 photograph above, Jack Nicholson has been superimposed into the gathering. Such work is very delicate and is described in detail on pages 112-16.

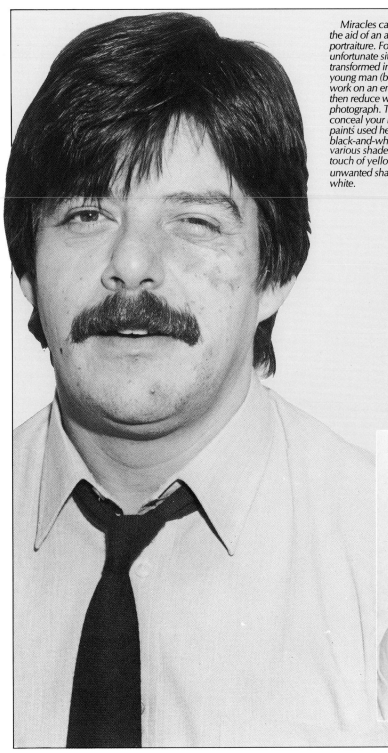

Miracles can be achieved with the aid of an airbrush in photo-portraiture. For example, the unfortunate sitter (left) has been transformed into the dapper young man (below). If possible, work on an enlargement (x 2) and then reduce when you re-photograph. This will help to conceal your retouching. The paints used here are process black-and-white mixed to form various shades of gray with a touch of yellow ocher. Gray kills unwanted shadows better than white.

Hair: first mask off sitter and spray background with light gray. This will leave an unnaturally smooth hair outline, so soften it with a fine brush using dry paint.

Eye: to open up the black eye, use a very sharp scalpel to knife the emulsion and remove the dark shadows. As you work on the emulsion it will gradually lighten. Take care not to go through to the backing paper. Soften the scalpel-work with an airbrush and then finish details with a fine sable brush.

Blemishes: these are treated using the same method as that used for the eye.

Chin: mask off the background with Frisk over tracing paper so that the outline is not too hard. Then, using very dilute mid-gray, spray over so that the skin texture shows through.

Collar and tie: use photographic reference of the replacement. Use light gray to map out basic shapes, then build up with a fine sable brush. Finally airbrush out the remains of the former collar and tie by masking off the replacement.

MATERIALS AND PAINTS

Just as the techniques for retouching are essentially the same as those for mainstream airbrush illustration, so are the materials. Naturally, professional color retouching demands specialized, expensive equipment, much of which is unrelated to airbrush technology. However, as we are primarily concerned with providing a practical introduction to retouching of black and white prints, there is little you need add to your existing stock of materials.

For the exercises, firstly you'll need a good supply of clear masking film. Many retouchers of the old school still champion liquid masking, although this trusty method now seems unnecessarily laborious and messy. Quality masking film does not pull emulsion off the print when raised, and it has the added advantage, being transparent, of revealing the entire print when in position. In retouching this is crucial, as the whole object is to spray in blended tones that exactly match those of the original photograph.

Secondly, you will have to invest in some new blades for your scalpel. The best blades for this work are not the long-pointed type that cut at a shallow angle, but the flatter blades that give you more contact with the surface you are cutting. A blunt blade should be avoided at all costs, because the less incisive it is, the greater the risk of inflicting irremediable white score marks on the print underneath.

Thirdly, you will almost certainly need to supplement your paint range because your existing supply probably will not include the right colors for black and white exercises. A word of warning here: if your graphic supply store sells the special range of graded retouching grays, don't let the shop assistant talk you into buying them. You don't need them. You're much better off following the example of many professionals, who use just four basic colors. These are lamp black, Vandyke brown and process white in watercolor tubes – for spraying through the airbrush – plus one tube of white gouache, which you will apply with a paintbrush to create highlights and fine detail. You'll find that a mixture of black and white in whatever proportion produces a bluish gray when sprayed onto the print, so the brown is added to counteract this. The basic rule to remember is that the lighter the gray, the less brown is needed.

The reasons for avoiding the premixed retouching grays are twofold. You don't need to go to the expense of the full set of grays when all tones can be mixed from the four colors listed above, and the only way you'll get a real feel for retouching is by understanding the various effects of different grays – which you can only acquire by gaining experience in mixing your own tones.

PREPARATION
Stage one: acquiring prints

For the exercises that follow, you will need to take your own black and white photographs, reproducing as faithfully as possible the composition of the examples given. When you feel reasonably confident that you've mastered the exercises, the only way to further your education in retouching is to attempt some more testing challenges of your own. Unless you are a keen photographer as well as a budding airbrush artist, this means tracking down a friendly and generous source of prints. A local professional photographer is the best bet. Any source will be better than none, but try to avoid wedding photographers whose subject matter is poor fodder for the retoucher, and look instead in the Yellow Pages for those listed as advertising, commercial or industrial photographers. These types of people will be more sympathetic to your aims, as they will be fully conversant with the retoucher's art and are more likely to have spare and scrap prints lying around. Bear in mind that prints are not cheaply produced in the first place, so show willing by offering to contribute toward costs. It is worthwhile cultivating goodwill, and with luck this will turn out to be a token gesture on your part.

The easiest way to start is by retouching out from a shot rather than reconstructing the image. Work on a large print, if possible, because a reduced print can then be taken from your retouched version which will to some extent disguise your workings, whereas an enlarged print will accentuate any minor flaws. Photographers will generally oblige with 8in x 10in (20cm x 25cm) prints, or one of the larger standard photographic sizes. Without pushing your luck too far, explain that your ideal is really two identical prints with a mat finish. The second print is invaluable for reference, so that you can see at all stages of retouching where you've been and where you're going. A mat finish is preferable to a glossy surface, although by no means essential, because retouching colors contrast quite sharply with the shine of gloss and during the early stages this will make your efforts look discouragingly clumsy. Also, retouched areas on a glossy print tend to lose their sheen over a period of time.

It is conceivable that a photographer might offer you old black and white negatives instead of prints. If that is the case, resist the temptation to retouch directly onto the negative. It can be done and some professionals work solely in this way, but the majority prefer to make life easy for themselves and do things the right way – where black is black and white is white. Accept negatives if offered, especially if the subject matter is good retouching material, such as a simple metal object, and have a couple of prints processed from them.

Stage two: preparing prints

Photographic papers, like art boards, are not the easiest materials to deal with. They will disfigure if stored in the wrong climate, so always keep your prints in a cool, dry place. Similarly, if improperly mounted, they will curl away from the work surface when wetted, possibly causing cracks in the retouched area on drying.

It is extremely important to mount the print firmly on a hard, flat surface. The usual method involves a triple-decker format, with the print mounted on a piece of rigid board already sturdily taped to your desk or table. There are various non-permanent adhesives suitable for attaching the print to the board, notably an aerosol can of spray adhesive or a double-bonding rubber cement. The former is usually more

expensive, but is is quicker and cleaner.

When the print is smoothly fixed, with no creases or bubbles, the next step is to clean the surface to remove any fingerprints, dirt or dust. A gentle once-over with an absorbent cotton swab dosed with a little lighter fuel is one way, but equally effective is a readily available method – just spit on the print and wipe it clean with absorbent cotton. You may need to dry the print after this; a quick blast of air from your airbrush – totally clean and empty of color – does the trick.

Stage three: mixing paints

It is only by experience and intuition that you will acquire the knack of accurately mixing the correct shade of gray to match a tone on the print. Trial and error is the name of the game for the beginner. For this reason, it is best to pre-mix your paints in a container, not in the airbrush. Mixing in the airbrush color cup is not advisable because it is difficult to fuse the colors

thoroughly, and if you need to add a fair amount of black, there is the distinct possibility of overloading the cup. An ordinary paintbrush can be used to transfer the paint from container to airbrush. To arrive at the gray tone you require, use white as your base and add black gradually for lighter tones, vice versa for darker tones. This helps avoid both wastage and overloading of the color cup.

Predictably, there is no getting away from the fact that you must unstintingly clean your airbrush between every color change. You will no doubt be tempted to adjust the gray you have just finished using by adding an extra drop of black or a hint of white, but this is false economy. Paint dries quickly and airbrushes clog easily. Constant cleaning of the color cup ensures that no foreign bodies enter the paint mix and exit onto the print. A cotton bud is better than absorbent cotton for cleaning the cup, being more tightly bound and less prone to shedding woolly fibers.

Changing the background can sometimes enhance a portrait and also be used to cover up errors in composition or lighting.
 White background: mask figure with a loose mask (Frisk laid on tracing paper) to soften edges. Spray background using process white, working from side to side.
 Vignetted background: kill the background with mid-gray to produce an even tone. Turn print upside down then vignette from top to bottom gradually lifting the brush to produce an even gradation of tone.
 Halo: cut out halo from cardboard, smoothing edges with your finger. Mask figure with low-tack film and spray background. Remove mask and place oval over subject, held above surface on coins. Spray from center of oval to achieve even, soft edge.

RETOUCHING TECHNIQUES

Essentially, if you have successfully completed the step-by-step exercises in Chapter Two, there is little more basic written instruction that will help you to proficiency in retouching by airbrush. The principles for retouching differ only slightly from those of illustration and, as with any skilled process, it is practice that makes the perfect retoucher. However, here are some simple techniques frequently encountered in black and white retouching.

Total blocks

This technique is demanded mainly by advertising agencies, where the advertisement comprises a photograph over which the text must be superimposed. It is really very simple: put down masking film to protect the area to remain unaltered and spray the exposed part of the print. This is usually defined by the agency on an acetate overlay. Resist the urge to spray

incessantly until you have achieved an opaque block, as a thick, wet layer will accumulate, which in all probability will fracture on drying. Instead, build up the layers one by one, pausing in between to allow sufficient time for the paint to dry.

Washes

A wash is a partial or transparent block, often employed to dim a background, thereby emphasizing the frontal and focal point of a photograph. The objective here is to spray a fine mist, so you should extend the distance between airbrush and print to about 12in (30cm). Masking is not necessary, as any excess paint or overspray can be easily wiped away with a moist cotton bud, to create either a sharp or progressive edge.

Halos and vignettes

These common techniques are frequently used to compensate for a photographer's deficiency in lighting, or as an inexpen-

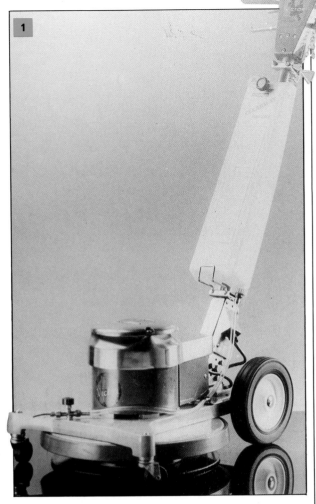

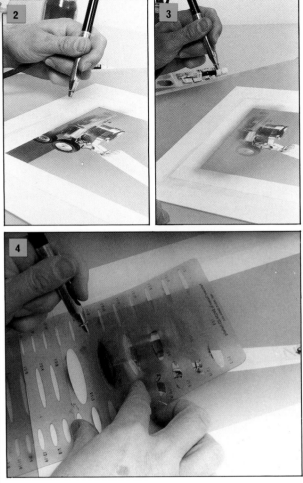

sive means of transforming a location shot of an automobile, for example, into a studio-style shot. The latter exercise would involve a total block of the location background, then vignetting under the automobile to add a realistic shadow that counters the impression that it is floating in mid-air. Vignetting involves lightening the background as it recedes away from the subject, whereas haloing, as the title suggests, is a light tone around the subject, gradually darkening towards the edges of the print. Both effects are easily achieved and both require the subject to be masked. Masking film can be used, although when you are masking the central subject of the print, you may encounter a problem. If you lift the mask and then wish to replace it to alter the airbrush work in some way, you may find that the mask has stretched and no longer covers the image accurately. There is a way around this problem: in place of film, you can use a cutout of the subject, carefully carved from an identical spare print, to mask the image being retouched. Weight this down in position.

The brief for this black-and-white retouch for a brochure was to remove the background, including the reflection of the machine on the shiny flooring. The aim was to replace this with a smooth, graduated background with only the gentlest of shadows to confirm the impression that the machine was grounded rather than floating in the air.

A The original print (1) is masked with low-tack masking film, leaving only the background exposed. A mid-gray paint is now sprayed on with the airbrush, starting at the bottom (2). Slowly the very dark area and reflection begins to disappear (3). Then, gradually work up from the base into the existing gray of the background so that a smooth, gradated tone is achieved.

B Next, the soft shadowing is applied with a darker gray paint using an ellipse template as a mask (4). The thickness of the acetate template ensures a soft edge to the

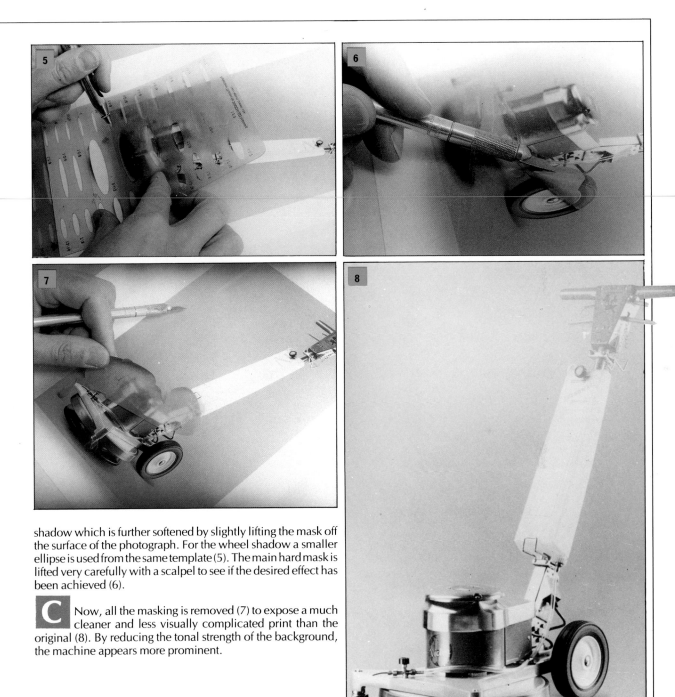

shadow which is further softened by slightly lifting the mask off the surface of the photograph. For the wheel shadow a smaller ellipse is used from the same template (5). The main hard mask is lifted very carefully with a scalpel to see if the desired effect has been achieved (6).

C Now, all the masking is removed (7) to expose a much cleaner and less visually complicated print than the original (8). By reducing the tonal strength of the background, the machine appears more prominent.

Print restoration

In almost every home, an attic or closet contains a box of treasured family photographs, often torn and tattered after years of handling. With skillful airbrush work, these aged snapshots can be restored – if not quite to their former glory, at least to a standard that comes close.

First and foremost, it must be stressed that you should not work on the original unless you are utterly confident of your ability. In your eagerness you might risk desecrating an heirloom of untold sentimental value. Take a copy print from the original, work on the print, then re-photograph your repaired version.

Techniques are identical to those used in reconstruction on modern black and white prints. Almost exclusively, this means freehand airbrushing to a high level of competence. Where restoration work can differ is in the necessity to create paint textures that reflect the fine grain of early photographic papers. Even when the old print is copied, the texture of the original paper still shows through in the image. Once again, there is no substitute for experience in identifying how to achieve that texture.

Like so many old photographic prints, the one shown here has suffered some battering. Before you tackle such restoration work, spend some time studying your subject to decide on a course of action. First, take a photograph of your print and have it enlarged. Next, remove any blemishes, scratches or dark shadows. This can be done by knifing with a scalpel or by using commercially available photographic bleach. Next, carefully airbrush over knife-work. Now, with a fine sable brush, fill in the gaps created by the tears and cracks in the original print. The face is best tackled with a brush and photographic dyes, with the aid of a magnifying glass. The eyes are important, so take care to match the damaged one with the other. Finally, re-photograph (far right) and sepia or hand color if required.

Photomontage

Photomontage in its most basic form, involves cutting out any number of parts from different prints and combining them to create a single image. Often, this image is deliberately disjointed, with the component images juxtaposed for maximum shock effect or to communicate a visual message: a baby astride a bomb, for example. Even a relatively inexperienced airbrush user should be able to create an effective photomontage, since the role of the airbrush is often confined to smoothing the borders between photographic cut-outs.

This calls for simple spraying and a fine paintbrush for coloring the thin, white edges of the cut-outs.

On a professional or commercial level, photomontage is more akin to retouching, in that normally two or more images are combined to create a coherent, realistic end result. A shot of a female model, for instance, may need to be inserted next to an automobile. In this case, the artist will mount two or more prints on board, then cover them with a clear acetate cell. Airbrushing then takes place on the cell, and the final step is simply to re-photograph the cell and the underlying prints.

These two examples (left and far right) show how deceptive photomontage can be. President Lyndon Johnson shakes hands with a little girl whilst her father stands proudly behind (left). The girl and father have been superimposed onto a photograph of the President and a boy. First a dummy photograph is taken of the girl and her father. Then, with a sharp scalpel, the outline is cut through the emulsion, not the backing paper. The print is turned over and the required section pushed out so that the backing paper tears away from the cut emulsion, leaving a thin layer of backing paper around the edge, thicker in the center. The edges are chamfered cautiously with very fine sandpaper to avoid rubbing through to the emulsion. Next, with a fine sable brush, the tones are reinforced round the water-thin edge. Absorbent cotton is used to dampen the back of the print to stretch the emulsion, after which it is sprayed with glue and, when tacky, carefully lowered into position. Dry for 3 hours under a weight. Once dry, the emulsion will tighten to form a taut covering. The cutting line can then be softly integrated with the background using an airbrush.

The dummy photograph (inset above right) shows the trouble that has been taken to match the lighting with the original photograph (inset below right). The girl is standing on a box so that she is positioned at the right height. The two photographs are then matched up and treated, as explained above. In this case, some retouching of the girl's dress above the clasped hands was necessary and Chairman Mao's eyes were raised to meet those of the taller man.

PROJECT:
Color retouching

The color retoucher can use an airbrush to create a variety of styles, ranging from that associated with the first hand-colored daguerrotypes executed by the Victorians to modern special-effects color retouching. There will also always be work offered by publications wanting color photographs when they only have black-and-white to hand. This necessitates a totally naturalistic style which is indistinguishable from a color print.

There are commercially available sets of colors for color retouching. The oil-based colors can only be applied with a brush, but the water-based dyes, which come in strong, intense, bright colors, can be used with an airbrush. Inks and water-colors can also be used with an airbrush but are not recommended for brushwork. The airbrush is particularly useful for

larger areas of soft or flat color and vignetted backgrounds. It is also suited to coloring those materials which are traditionally associated with airbrushing, such as glossy paints and chrome. In color retouching, detailing with a fine brush is carried out before spraying, otherwise the sprayed film of paint can be damaged.

The beginner will need a pile of prints to practice on. Try out various styles on the same print copy and assess the effects achieved. Your coloring must be delicate, working up from light to dark — it is easy to increase tone but not to reduce it. For flat areas of color, start the airbrush stroke outside the border of the print so that you can check the airbrush is operating efficiently.

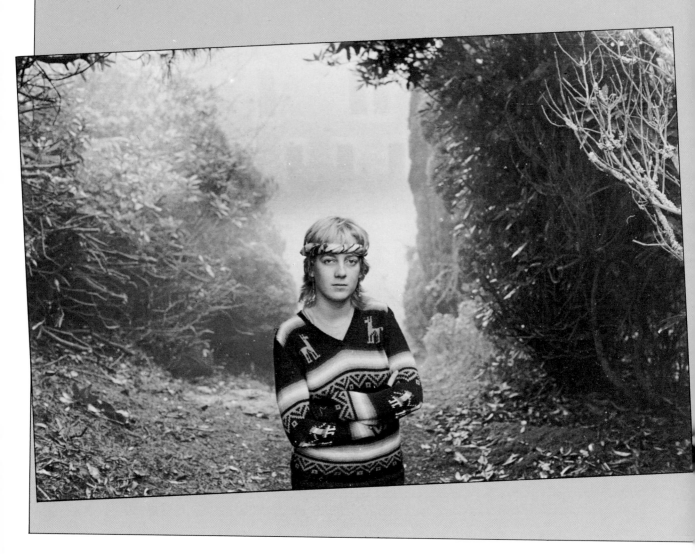

This portrait (bottom) has been retouched with color in a recognized "arty" style, with no attempt to be naturalistic. Certain elements of the composition are picked out for detailing with a brush (left and below). The figure is then masked with low-tack film and the background blown over with dilute sepia dye. Then the central background is vignetted (bottom).

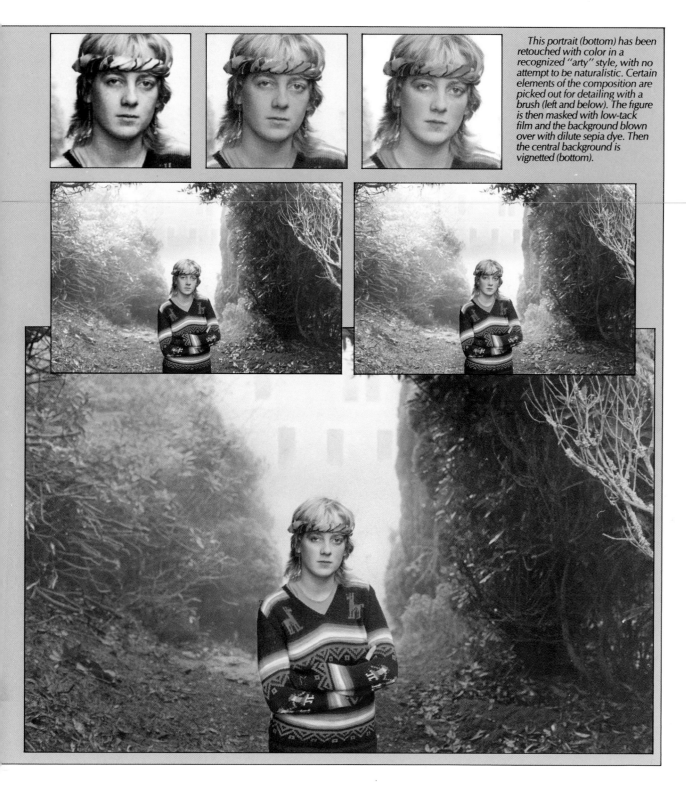

Photomontage can be used to reposition elements (right and far right). To reposition the small boy in the foreground behind the cat (far right), first a photograph of the original (right) must be taken. Have it printed on thin paper to ease the chamfering of the edges. Next, cut out round the boy with a sharp scalpel. There are problems with scale and focus when moving objects from back- to foreground – here the boy appears smaller. On a second print, the image of the boy is removed, using a color to match the grays of the road. Do not forget to remove the shadow, too. Then airbrush over to soften the hand-work. Now, cut round the back and tail of the cat, chamfer the edges, and slip in the boy with ready-prepared edges. Affix the boy to the background and the cat to the boy. Finally, airbrush out the cutting line and spray on the boy's new shadow.

Photomontage can also be used to remove an unwanted detail. The friendly canine (above) was removed to produce the print (right). First, the print was cut in two along prominent lines in the composition, such as the side of the door. The two sides were then joined together by overlapping one side on top of the other. The edge of the superimposed part was chamfered down and then glued into position. Next, the cutting line was softened with an airbrush and the remaining parts of the dog filled in to match the background. Finally, the children were masked and the whole area ghosted over with process white to reduce the tone and make the figures stand out.

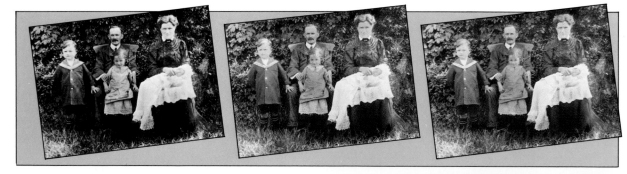

COLOR RETOUCHING

Color retouching is very much a commercial enterprise, supported mainly by the advertising industry. Often, the retoucher is working against tight deadlines, and manufac-turers have developed a variety of aids that can perform some of the functions that were previously the province of the airbrush. These include chemicals that can reduce color intensity and photographic processes that can strip in a num-ber of images without showing any seams.

Needless to say, the airbrush is still unrivaled as a tool for cleaning up color images — removing unwanted reflections on glass or metal, or wrinkles and blemishes from a model's face. Retouching can be carried out on either transparency or print, with the profession divided as to which is the best.

If you feel you have successfully mastered the art of black and white retouching, the next step is to tackle some color work — but be warned, it is not easy. Far and away the best method is to start by working on prints, because you will be able to see what you are doing much more clearly than on a transparency. Transparency retouching requires an enlarger, light box and other items of darkroom equipment.

Various paints can be used, but strongly recommended for their compatibility with both airbrush and surface are color dyes for glossy finishes and tube watercolors for mat. Unless you are correcting only a minor flaw on the print image, work not on the print itself but on an acetate overlay, then rephotograph to produce a finished combination print.

The real art of color retouching is mixing color accur-ately and quickly. Paint manufacturers supply color reference charts with their products, and it will pay you to study such a chart long, hard and often. Again, actual mixing should be done on a palette, not in the color cup, and paint transferred to the airbrush cup with a paintbrush.

Spraying techniques are basically no different from those of black and white retouching, your major challenge being the creation of textures to match the qualities of the photographic image. For example, an essential feature of the professional's range of skills is the ability to spray realistic flesh tones. After administering cosmetic surgery such as the removal of a blemish, the retoucher must graft in its place a true skin texture. Familiarity with the airbrush will tell you that one way of achieving this is to lower the air pressure from the compressor, to get a stippled effect from the spray.

Deciding on what to complete with a brush and what can be better executed with an airbrush takes practice. Some projects involving color retouching are more suitably carried out with a brush, such as the Victorian family (left), executed in the style of their time. The photograph of a 1960s Chevrolet (1) cries out for airbrush treatment. To demonstrate some possible effects, three prints have been airbrushed. In (2), to make the car stand out, the background is blown over with dark blue dye to reduce the tone. Then the car is lightly sprayed with very dilute colors and the details filled in with a brush. Alternatively, the car can be emphasized (3 and 4) with bright colors. Here, the background and windows are masked off and the car sprayed in dazzling pink and yellow. Shadows are applied using loose masks. The effect achieved is very much in keeping with the pop-art image of the photograph.

SUMMARY

You'll need a good deal of practice and a steady supply of prints before you become adept with the airbrush as a retouching tool. As with so many other applications of the airbrush, the most worthwhile advice is that you should experiment. If instinct suggests you try a different material or technique, then try it. Finally, do not rely on your airbrush to the exclusion of other methods of applying retouching paint: in fact, perhaps the most useful exercise you can undertake during your early days is to take two identical prints and retouch the first one using only the airbrush, the second with just a paintbrush. It's an unbeatable way to determine how a retouching job is best approached, the kind of experience for which there can be no substitute.

CHAPTER 4

- OTHER APPLICATIONS -

The airbrush is an ingenious tool and in imaginative hands there is no limit to its capability. It is young, too, so there are many avenues still unexplored, which is why our repeated advice to any airbrush artist is to experiment. Don't be bound by convention buck it by spraying unlikely solutions onto unlikely surfaces. Stop short of anything that clearly invites disaster, but do grant yourself the enjoyment of trailblazing in a tempered way.

This chapter is a practical introduction to just some of the many and varied applications of the airbrush. It is instructive, but the greatest lesson you can learn from it is that in each of the applications described, somebody somewhere originally picked up an airbrush and said "Let's try it."

MODELING

After the illustrator, the modelmaker is the second most prolific user of the airbrush. The reason is simple: the modeler's ultimate goal is authenticity, and frequently the subject is a machine such as an automobile or aeroplane that is spray-painted in its full-scale original version.

The airbrush is ideal for finishing almost every kind of model, from plastic kit to metal casting, because its fine spray will not obscure the intricate and realistic detail found on most models. By the same token, it cannot disguise flaws, either in the model itself or in the modelmaker's faulty workmanship, so careful preparation is of paramount importance.

Firstly, you should make sure that your airbrush is absolutely clean so that no rogue elements are introduced into the paint. If there is dirt or dust in the paint, there will be dirt and dust on the model. Secondly, you must attend to any faults in the model before you start spraying. Gaps can be filled with either specialist modeling putty or the more workable glazing putty. Don't just plug a hole with a single lump of putty — gradually build up the shortfall with several layers, sanding between applications. If the problem is the opposite, with over-sized parts protruding out of line, you should either sandpaper them down or very carefully amputate them with a hobby knife. Finally, it is imperative to remove any grease or fingerprints on the model's surface by wiping it all over with a weak detergent solution.

A basic airbrush is an excellent tool for camouflaging plastic model kits, such as the fighter plane (right and below). The smooth finish is much easier to achieve by spraying than, say, by painting with a brush.

Model-maker, Terry Webster, (see page 152) uses an airbrush to highlight features of his resin/plaster creations. He is shown spraying the skin tones of his "Tiger Man" (above and right) to create the finished result (below).

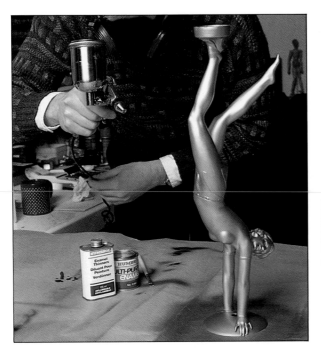

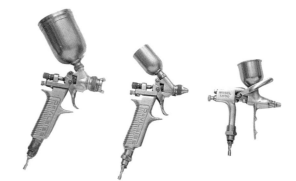

Spraying metallics
This art deco figure was purchased in a deteriorated condition and restored to its former glory using an airbrush. Gold enamel paint and a spray gun, such as those popular with model makers and ceramists (above) proved to be an effective combination.

There is a wide choice of paints available that will successfully adhere to any material from plastic to clay. As long as you observe the golden rule and dilute your medium to milky consistency, there is no reason why you shouldn't experiment with the airbrush to achieve various effects and finishes. The specialist enamel paints for scale models are perfectly adequate for airbrush spraying when used with a suitable thinner, such as turpentine.

Similarly, the various masking methods discussed in Chapter 2 can all be usefully employed by the modelmaker. Masking film is relatively easy to use, but masking tapes are often preferred because of their extra flexibility in a three-dimensional format. You can save yourself some scalpel work, too, by assembling a selection of tapes in widths ranging from ⅓₂in (2mm) to 2in (5cm).

In modeling, airbrushing is sometimes used merely as a quick and effective method of coating the finished article with flat color overall, but equally often, true authenticity demands that the model should have a "weathered" appearance. A battle-weary tank, for example, looks infinitely more effective than a showroom condition model, and likewise a camouflaged Spitfire has a more realistic appeal than a plane with a fresh blanket coating of color. Creation of these special effects requires fine control on behalf of the modelmakers, and some techniques are revealed in the exercises included here.

Additionally, the airbrush is an excellent means of coloring the dioramas or landscape settings which more adventurous modelmakers build for their models. A high degree of realism can be achieved, whether the object is a grassy bank for a model railway track or a sand-duned desert battlefield.

CERAMICS

Airbrushing of ceramic objects, be they clay sculptures or dinner plates, is a fast-developing home industry in the United States, where many innovative designers are exploring new avenues in airbrush techniques. The beginner need not attempt anything elaborate. There are no problems in tackling some simple ceramic decoration of your own. The advantage of hand-painting with an airbrush is that you will end up with a much smoother, slicker glaze.

For ceramic work, you need not go to the expense of an independent double-action airbrush: a large-nozzle single-action model suffices, because ceramic paints are generally slightly thicker than artist's paints.

It is wise at first to restrict your choice of paints to the simplest colorants specially made for ceramic use. Enamels, oxides and slips (dense liquid clay) are best left alone until you have gained enough experience to determine the consistency that successfully withstands the kiln-firing process. Too thin a finish and the contraction of the clay during firing outweighs the adhesive properties of the paint – and instead of a masterpiece, you're faced with a flaky mess.

Masking techniques are relatively straightforward. Card, hand-held in position, does the job effectively, without mottling the clay surface when lifted off. Let your imagination run riot, too, by using leaves or petals as positive masks. If you encounter problems in masking an awkwardly shaped article – a coffee mug, for example – a good idea is to cut a negative mask in a wide piece of card, which can be stretched fully over the mug and taped at either end to your drawing board or work surface.

CAR CUSTOMIZING

More than any other application, it is probably car customizing that has brought airbrushing to the attention of a wider public. It is true to say that customizing has declined in popularity since its "hippy" heyday in the late 60s and early 70s, although many fine examples of automobile art are still in good running order on the roads today.

The procedures for spraying automobiles differ slightly from standard airbrushing techniques. It is wholly unwise to tackle any major customizing project without having first read one or two of the many detailed books available on the subject – a car is a costly item, and without proper instruction the inexperienced beginner is bound to make a few glaringly obvious mistakes. Apart from that, the automobile artist needs a different array of equipment that can come with a hefty price tag. If you are serious about car customizing, your best investment at first is a little money and a lot of time spent poring over the specialist books.

GLASS

Airbrushing is a highly successful method of decorating glass, because a smooth, shiny spray ideally complements the flat, hard surface of the material. There are several ways in which you can tackle a project on glass, from a full-scale design for a storefront to an intricate stained-glass pattern or an ornamental treatment on fusible glass.

If you are lucky enough to be asked to decorate a storefront, the procedure is relatively straightforward, although you may have to reverse your normal priorities of painting. You are painting on the inside for the design to be viewed from the outside – normal practice, as the purpose of your illustration will more often than not be to stop passers-by in their tracks. Because your work is being viewed from the "wrong" side, the first layer of paint you spray is, to the viewer, the topcoat. This is the opposite of graphic work on artboard when normally your first spray is the base coat upon which you build your illustration. Working front to back takes a bit of getting used to, but it is an excellent means of self-discipline. Unless you are spraying freehand, it is advisable to draw your design on the outside of the window and mask on the inside. Masking film is ideal, although a large expanse of glass means a big outlay on film. Special glass paints are available, but some dilution may be necessary to achieve the right consistency.

Fusible glass painting is generally executed on a less grand scale. A fusible glass is roughly described as one that withstands being fired in a kiln, and it is not recommended you attempt firing with standard glass: it will probably just break. Also, the only really practical medium to spray is a special glass glaze. General-use artists' media such as inks and watercolors will not survive the firing process.

WOOD

The airbrush artist who likes nothing better than to fill the mantelpiece with three-dimensional curios and ephemera can have a fine time spraying on wood. Interesting effects can be achieved quite simply, and the only vital factor is to prepare the wood properly. Smooth woods, such as those available from any lumberyard or builders' suppliers, should be sanded, sealed with shellac – either brush-applied or sprayed through the airbrush – then fine-sanded to a smooth finish. Enamels adhere to this prepared surface extremely well. Rough woods, such as driftwood collected on the sea shore, should be allowed to dry out and need only to be sealed with shellac.

COMMERCIAL AND PROFESSIONAL USES
Taxidermy

Taxidermy – stuffing animals – is a highly-skilled craft, and airbrushing is just one of many facets that the taxidermist must master before reaching the top of the profession. Use of the airbrush is particularly suitable for simulating the often brilliant colors of prized species of fish. Acrylic lacquers are widely used for re-creating the natural markings which will have severely discolored after the lengthy drying process that a fish must undergo before it can be successfully stuffed.

Technical illustrators often find themselves doing exploded drawings for parts lists and catalogues. Occasionally the opportunity will arise to do full-tone work as in this rendering of a dump-truck. These days, however, much of the prestigious colour brochure work is handled by an agency and not the company drawing office.

Medical illustration

Medical illustrators depend heavily on the airbrush, and the finest exponents of the art deserve to be ranked alongside their leading counterparts in commercial graphics. There are essentially two types of medical illustration: those used for educational purposes, which must be anatomically accurate to the last detail, and those primarily commissioned by journals or drug companies, which are often dramatized to convey a stipulated image. This latter type generally combines scientific accuracy with dramatic enhancement, which makes airbrushing the ideal technique for achieving the desired effect.

Technical illustration

Technical drawing is a huge category that spans everything from cutaway diagrams to graphs and charts. Generally, logic and accuracy are more use than artistic imagination. Rarely, if ever, is the technical illustrator invited to contribute an emotional slant to the work.

What is needed, however, is a mind that is familiar with a vast welter of technical principles – from geometry to mechanics. If you decide that technical illustration is your forté, you've a lot of reading ahead of you! Also, the vast majority of such work is line; what airbrush work there is tends to go to a handful of professionals.

Animation

The airbrush has been used with varying success in film animation – cartoons – since the early days of Walt Disney. The animator can make a choice from every style of graphic art ever invented, but it has to be said that other artistic forms are more appropriate for animation than airbrushing. The fundamental technique of animation depends on creating a series of closely matched static frames that when run sequentially form the movement of the film. At the best of times this is a painstaking process, but the airbrush's limited paint capacity causes extra trouble for animatic illustrators trying to match color tones and densities from one frame to the next. This being said, open-minded animators are producing some refreshing new films using the airbrush and there is reason to hope that the airbrush will find more frequent application.

Architectural renderings

The airbrush is often used to create an "artist's impression" of how a projected building will look when it has been built. Accuracy is of prime importance, not just in the scale and proportion of the structure itself, but also in color and detail. Skill with the airbrush is arguably a lesser prerequisite for the renderer than a thorough knowledge of perspective drawings and the principles of architecture and construction, but when used, it does contribute its own characteristic texture.

The Lee jeans poster by Bob Murdoch (above) works as a strong graphic image, as does the update of 1930s' style (above right). A fine spatter was used for the background chevrons. A stronger use of the airbrush is demonstrated in Connie Jude's illustration for Ms London magazine (right). The illustrations by David Hughes for Working Woman magazine (far right) use mixed media – crayons, wash and minimal airbrushing.

Fashion illustration

Fashion illustrators first turned to the airbrush in the late 1920s. The simple, muted style of the pioneer, Joseph Binder, influenced other artists, such as E McKnight Kauffer, A M Cassandre, Otis Shephard and George Petty. Petty's work is more detailed and relies to a greater extent on draftsmanship, a development taken up by Alberto Vargas, one of the best-known "pin-up" illustrators. The 1960s saw a move towards high realism and a polished style typified by the chrome-plated women of Philip Castle, still popular with some Japanese illustrators, such as Hajime Sorayama.

Modern airbrush fashion illustration falls into two main schools. The first takes its lead from the strong, sophisticated graphic images of the 1930s, using fine spatters and subtle vignettes; the second favours a much looser style, often executed freehand and without a mask. Mixed media – combining airbrushing with collage, crayon, wash or felt-tip pen, for example – is increasing in popularity and a new type of airbrush is now available that blows air across the point of a felt-tip pen. The most recent adaptation of the airbrush in fashion illustration uses animation to produce cartoon-style television advertisements.

going, you're right there with ... season by changing season. ... of the glossy fashion mags ... command. So startling is your ... spend more money than you ... nce you dare not use public ... es you arouse amusement as ... among your less fashionable ... o not realise that Peruvian ... s and floorlength white canvas ... ow IN. Your ability totally to ... earance – hair, makeup, sil- ... lot – makes you a true cham- ... n and so many looks have been ... erimposed on your blank can- ... that no one really knows what ... ou're like. Not even you. Bed- ... ide books: Anything on the ... Booker shortlist, Lace 1, Lace 2, ... Diana Vreeland's autobio- ... graphy. Music: Mozart's Don ... Giovanni, Mahler's 5th, Howard ... Jones, Pointer Sisters. TV: Dyn- ... asty (in secret), Mastermind.

ALL WOMAN

Your palette is a vista of unin-terrupted pastels and you think there's no colour more flattering to a woman than pale pink – unless it's baby blue or just possibly turquoise. Straight hair, straight lines, and strict tailoring are for the (other) birds and you feel your feminine best in 'soft' clothes that emphasise your curves — which may well be more exuberant than you realise. And although you love animals – particularly pussy cats – you do feel that there's nothing like fur to keep out the cold. (You're right.) You 'just adore' jewellery in general and your birthstone in particular. Bedside books: Woman of Substance, Cookery Manuals. Music: Julio Iglesias, Vivaldi, Elaine Page. TV: Dallas, The Mistress.

THE FLAUNTER

The true extrovert you dress for effect and those who denigrate your bold, brash ways are often closet admirers. Your clothes may look haphazard but in fact are chosen with great care – definitely Zandra Rhodes rather than Thrift Shop or local Co-op. Your credo, practised with fer-vour and flair, is that fashion should be fun and if you flip over the edge and it becomes funny, so what? A working girl can have a lot of laughs if she doesn't take herself too seriously and provided she's not in insurance, a building society or a bank she's probably right. Assuming her ability equals her panache. Bedside books: Erica Jong, Sci Fi, fashion mags. Music: King's Love Pride, Fran-kie Goes to Hollywood, Britten's Peter Grimes. TV: Spitting Images, Victoria Wood, The Tube.

THE VAMP

This is how you are described by others rather than how you see yourself. You are merely aware of your 'assets' and are deter-mined to capitalise on them and why not? The trouble is that your role model went out of date with black and white TV and in the age of the video, yours is a deteriorating vintage. You deplore the current trend for baggy clothes, pre-ferring to stick (sic) with satin or jersey and are only just beginning to realise the potential of black leather. You wear black stockings (NOT tights) blouses (NOT shirts) and feel it's a waste not to pull in your waist. Bedside books: Harold Robbins, Jackie Collins, Adrian Mole. Music: Spandau Ballet, Wham!, Best of Pavarotti, Pointer Sisters. TV: Made-for-TV-films, Dallas, Dynasty, The Price is Right.

59

Once again using a chevron background (see page 124), the graphic treatment of the figure is taken a step further (right), and the form entirely defined by the horizontal stripes on the fabric of the dress. The close-fitting nature of the fabric accentuates the shape and planes of the figure, and even the slightest thinning of the horizontal line, for example, on the left thigh, indicates a change in direction of plane. The areas of skin that are revealed by the fashionable apertures in the dress are left completely unsprayed and yet the shape appears continuous. Such subtlety of form requires either a specific reference or very careful drafting; in this case, a photographic reference was carefully traced.

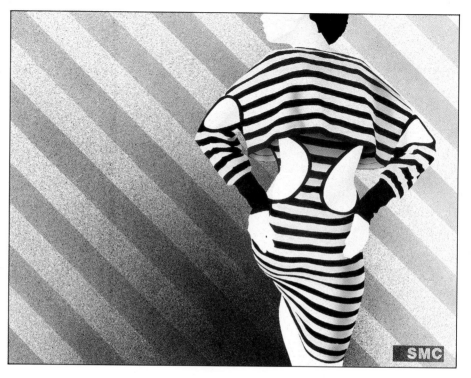

PRINTING FABRICS

Once more, it is the Americans with their uninhibited use of the airbrush who are leading the way in fabric decoration. Particularly big business is the airbrushing of T-shirts, most commonly practiced at coastal vacation spots by artists whose skill ratings can be variously assessed on a scale ranging from minimal to brilliant. Some of these exponents, appreciating that time is money, work with up to a dozen airbrushes at one time, each loaded with a different color. In a ten minute session, they complete vacationers' favorites such as seascapes or simple calligraphic slogans. And, it must be said, some of them have risen to considerable fame and fortune.

As with ceramics, it is easy for the beginner to try some basic fabric painting. Virtually any kind of textile can be sprayed, including more expensive materials such as silk, satin and velvet, so it is possible to create striking patterns for any of your soft furnishings—sofas, curtains or bedding. Before attempting anything too extravagant, it's sensible to cut your teeth on a simple and inexpensive project.

Sometimes this work is done with artists' tube acrylics diluted with water, because they offer a wide, rich color choice. The major drawback here is that acrylics are not entirely colorfast, so acrylic-painted fabrics must be dry-cleaned rather than washed. This can prove prohibitively expensive and it is best to plump for a more practical choice of paint from the many specialist fabric colors available. These include textile inks, liquid dyes, bleaches and fabric paints, all of which can be thinned with water before spraying. All, too,

are colorfast formulations designed to resist fading when washed. When buying fabric paint, always check to make sure that the medium matches the material — it is no use, for instance, spraying nylon dye onto cotton. Also, before you set about spraying in earnest, have a quick test run on a small scrap of fabric, if possible, to monitor the absorbency of the material. Otherwise, what was intended to be elegant calligraphy will become blurred and illegible.

Mounting fabrics in readiness for spraying can be a little problematical. When spraying made-up clothes, most artists prefer to work with the surface vertically positioned, rather than stretched horizontally on a drawing board. Whichever you choose, the critical factor is to ensure that there is a non-absorbent barrier between the front and the back, so the colors do not soak through. In addition, unless you are aiming for an abstract image or special effect by deliberately creasing or wrinkling, the fabric must be stretched taut and taped. One further point to bear in mind is that your design will look far more effective on a light-colored fabric than a darker one, where the sprayed colors will be battling for prominence with the dominant base color.

The method of spraying is simply a matter of personal choice. Some artists are adept and practiced enough to conjure up spectacular freehand images, while others rely on a selection of stencils with which they gradually build up a design. Loose masking with card presents little difficulty, although it is worth the effort to attempt the more complex task of overall masking, as shown in the exercise.

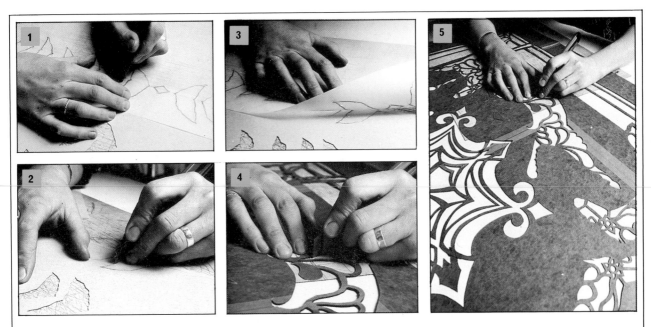

The fundamental skill of all airbrushing – the cutting of masks or stencils – is also the basis of successful fabric painting. This sequence of photography shows Eleanor Allitt (see page 148) preparing stencils and spraying patterns for the silk headsquares and scarves she designs.

A First, the pattern is worked out on layout paper before being traced off onto tracing paper. The pattern is transferred onto Manila stencil card and cut out (1 and 2). It is best to stick to simple repetitive patterns at first. As you will see on page 128, these can be very effective (3). After practice, more complicated designs can be attempted, such as the one being cut here (4 and 5). After cutting, the card is oiled so that it repels paint and then is carefully dried (6).

B Next, the mounted silk is smoothed with an iron in preparation for spraying (7). Specialist fabric dyes are available for use on materials such as silk or cotton, and some of these dyes are specifically formulated for use with an airbrush. Some thinning may be necessary to attain the right consistency. Otherwise, dyes of different colors can be mixed directly in the airbrush jar, transferring them with a syringe (8).

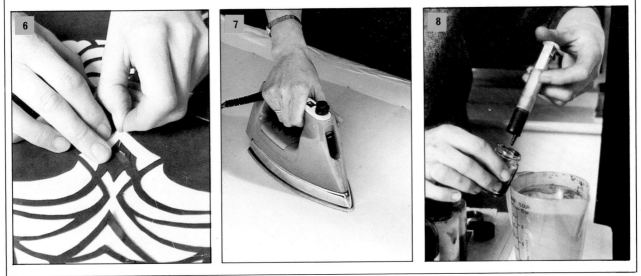

C The stencil is weighted down with small heavy objects ready for the airbrushing to begin (9). From these photographs it is easy to see where the major work lies in such fabric painting: the airbrushing is almost the easy part, and it is in the stencil cutting that the skill lies.

D Try not to spray too much dye in one pass as it may bleed under the stencil (10). You will need to lift the stencil at intervals to check color saturation and tonal equality.

E Finally, the background is sprayed freehand. First of all, however, to create the star pattern, a simple negative (ie concealing) mask is cut and laid in position (11 and 12). It is weighted down with small bits of lead (left over from the artist's studio roof). The star masks are then lifted and the result admired (13). The last photograph shows some further examples of Eleanor Allitt's subtle designs on silk. After spraying, the fabric needs to be hung up to dry to avoid creasing. Fixing the pattern depends on the dyes used. Some manufacturers recommend ironing on the wrong side of the fabric. Some dyes, however, need steaming, which can be done using an ordinary culinary steamer.

FOOD DECORATION

Artistry on the dinner table has received a welcome boost with the comparatively recent development of nouvelle cuisine spearheaded by French master chefs. Whilst we would put food decoration in the "fun" category, it is nevertheless another application that opens up a cheap and individualistic area of experimentation for the airbrush owner.

Two points must be emphasized, both simple but of great importance. Firstly, you must never spray anything other than the prescribed food colorings readily available in larger supermarkets. Secondly, you should always ensure that your airbrush is thoroughly cleared of any toxic paint you may have been using in your last job.

The most suitable foods for spraying are obviously light-colored, hard-coated goodies such as cake icing or meringues. Masking can be used, although you may find it an extremely fiddly, unhygienic process whereby you are constantly poking your fingers into the food.

A The first step, as with any airbrushing, is to work out your intended design (1). The subject to be airbrushed is an iced cake, so the surface is flat, which makes masking possible.

B Next, take some wax paper, reinforced with film, and cut out the mask for the red areas (2).

C With some thick card underneath, the smaller details of the red mask are cut with a scalpel, using a straight edge for guidance (3).

D Now the mask is transferred to the cake and held in position by hand. Using accepted food dyes, commence spraying on the iced surface (4). Each color is built up in the same way as the red until the image is complete. The result can be very effective and can add the professional touch to your cake decoration.

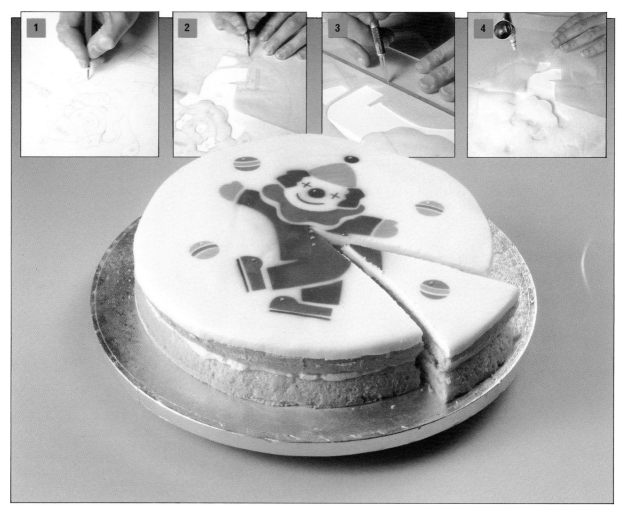

The future

The airbrush has been in existence since 1893. During that time it has repeatedly been denounced as a novelty, phase or fad by critics with little or no knowledge of its capacities. It is an unarguable truth that today more airbrushes are being sold than ever before, and that owners of airbrushes are producing work in an ever-increasing number of different styles. The artists themselves are guaranteeing a tremendous future for the tool, by a natural evolution of images that defy categorization under the standard, "shiny" airbrushed finish. The outlook has never been more healthy.

The future in fine art

Fine art is one area in which the airbrush will surely make a major breakthrough in the coming years. All the signs are that, after years of frowning upon airbrushed works, the fine art fraternity – especially in America – is slowly but surely beginning to recognize the validity of airbrushing as an art form.

There has been one main criticism leveled at the airbrush by the commentators, gallery curators, collectors, academicians, patrons and aesthetes who have been the arbiters of what constitutes fine art: that the tool and techniques associated with it are "too mechanical." Because the brush is not in direct contact with the surface, it has been judged that the artist's touch has exerted little personal influence on the application of paint to that surface. No less a person than Charles Burdick, the inventor of the airbrush, suffered this criticism when the Royal Academy in London rejected his work for inclusion in its influential Annual Exhibition. Furthermore, there is an element of truth in the argument that the airbrush has to some extent been hoist on its own petard: its inherent qualities were quickly recognized and seized upon by commercial artists, who are traditionally held in poor light by their more "purist" counterparts in fine art. What is good for the commercial artist is bad for the fine artist is a dictum that survives today, and the airbrush has been unfairly victimized as a result.

Despite this prejudice it is worth noting that there have been important twentieth-century art movements in which the airbrush has been given a significant role in the work of individual artists: the Bauhaus school, with its origins in Germany in the 1920s; Pop Art, a product of America in the 1960s; and the following trend of Super-realism. Today, wholly-airbrushed works are finding their way onto gallery walls in the United States, Japan and, to a lesser extent, Europe – although as yet no individual work of this kind had been hailed as a masterpiece, nor has any single airbrush artist achieved the status awarded to the major painters of this period.

Time, however, is on the airbrush's side. History reveals many precedents where disdain and even outrage has greeted new artistic departures which were later heralded as historic turning-points by successive artistic establishments. Retrospective acclaim is already being afforded to earlier commercial artists, notably George Petty and Alberto Vargas, whose commissions came largely from pin-up magazines in

the 1930s and 40s: an early indication of pending acceptability. A variety of artists today, though some are still reluctant to admit it, are deploying the airbrush, while many highly successful commercial airbrush artists are seriously endeavoring to cross over into the fine art field. It is perhaps the latter category, with their hard-gained mastery of the tool plus a newly-found, unfettered approach, who will once and for all break down the barriers: encouragement, indeed, for future generations of airbrush artists.

The airbrush and computers

Few commercial activities have escaped the scare-mongering that has accompanied the rise to prominence of the computer: that, sooner or later, the computer will take over from human ability. Airbrushing is no exception. This notion can be instantly dispelled by the fact that, despite the extraordinary advances in computer technology, no electronic process has yet been developed to fulfill satisfactorily the function of human creativity. Neither is any such development on the horizon.

In industrial applications, however, there are instances where the airbrush and computer are already happily coexisting. In ceramics, for example, computer-controlled airbrushes are employed to decorate mass-produced crockery, as part of the production line process. Patterns are relatively simple, such as a blue ring around the rim of a white dinner plate, but no doubt in the future more complex designs – created originally by an artist, of course – will be possible. A more sophisticated industrial use of the airbrush is as a substitute for the printing process in the production of, for example, a one-off billboard poster. Here the airbrush is adapted to accommodate four color cups, housing the four basic printing inks, by means of a spaghetti-like arrangement of feed tubes. The computer "holds" the airbrush in a frame and sprays hundreds of dots to form the image, having been pre-programed to determine the proportions of each color required per dot to arrive at the eventual color image. Again it should be noted that the original image is designed not by the computer but by an artist. The electronic brain is merely acting under instructions.

YOUR FUTURE WITH THE AIRBRUSH

If you have read this far, it is likely that you are going to have — or already have — an immensely enjoyable relationship with the airbrush. For the vast majority of users, airbrushing is simply a fascinating way of occupying leisure hours. There is, however, a small band of people who make a living out of airbrushing. The airbrush is an incredibly versatile instrument which, given a good idea, can be incorporated into any number of money-spinning projects. The difficult part is to find the good idea in the first place. However, most of those who rely on the airbrush for an income are either professional illustrators or retouchers. If you aspire to their ranks, be warned that none of them subscribes to the theory that talent alone is sufficient. All have paid their dues, in working to understand the basics, then spending long hours honing their techniques to near-perfection. It is a chore, but for those of you with the determination and ability to succeed, this section offers practical instructions on how to prepare and present your work to the people who can forward your career.

Acquiring the basics

You cannot live by the airbrush alone. It is essential to gain a good overall art education before specializing in airbrushing; otherwise, sooner or later, your limitations will be cruelly exposed either in your artwork or in conversation with clients, resulting in embarrassment all round.

The traditional way to acquire this education was as an apprentice to a commercial art studio. The apprenticeship system, alas, has more or less collapsed worldwide, a victim of financial belt-tightening within the industry and undermined by the greater capacity of art schools and colleges. The college system provides an excellent springboard to a career in art. Generally, you will have a choice of a Fine Art or Graphic Design course, although some colleges offer airbrush-orientated courses in Technical Illustration. Most courses will be equipped with the basics for airbrushing, even if it is not taught as a formal discipline, so at the least, you will have access to good working equipment.

Your first job

Your initial challenge on leaving college is to find a job that brings you into contact with the airbrush on a regular basis: in other words, a job in an advertising agency, graphic design, retouching or artwork studio. Your title will probably be trainee or junior artist, and you should expect to do everything from pasting-up artwork to making the tea. Your job specification will not include watching the studio's key airbrush artist at work, and picking his or her brain; but demonstrate a willingness to learn and the response will almost certainly be a willingness to teach. While airbrushing will be far from your principal activity, you should seize the opportunity to do as much airbrushed work as possible, both at the studio and in your spare time. Your aim now should be to build a portfolio that will stand you in good stead when the time comes to branch out into a situation where use of the airbrush is a more pivotal activity.

Assembling a portfolio

You may be able to talk the hind legs off a donkey, but if you can't show a prospective agent or employer evidence of your capability, you've wasted the bus fare getting to the interview. The basic guidelines for buying the portfolio itself and then filling it are best summed up by one of Britain's greatest believers in hiring young talent, Dave Trott, Creative Director of advertising agency Gold Greenlees Trott:"The best kind of portfolio to use is about 60cm by 90cm (2ft by 3ft), in zip-up plastic with a spiral binder holding acetate pages. That way your work is kept clean, it can't fall out, it is always neat, it looks nice and simple and not messy. The rule for positioning work in a portfolio is the best work at the front and the back. That way you get people interested as soon as they start and you leave them on a high note at the end. Use every interview to improve your portfolio. When you go to an interview, ask them for constructive criticism of your work. Not only will it give you a chance to improve it, but you will find that people want to hire a junior who is willing to learn, not someone who already thinks he or she knows it all!"

Ideally, your portfolio should contain a dozen or so illustrations covering a good spread of work that you are proud to show. It is of little use showing your most "painterly" or abstract work if you are attempting to gain a foothold in the commercial world. On the other hand, if you have evolved a stylish approach, don't be afraid to let it show through — there are plenty of other candidates who are probably as technically skilled as yourself, but may lack your imagination. Your portfolio should certainly include the following:
☐ An example of lettering.
☐ A rendering of an everday item, such as a beer can or similar packaging.
☐ One piece of black and white work.
☐ A realistic and accurate rendering of a technical item — a set of headphones, car, television etc.
☐ A "concept" piece, that shows a design idea. Invent a theme such as "the freshest lager in the world" and illustrate a beer can ringed by snow-capped mountains. You should show an ability to think, as well as illustrate.
☐ Any airbrushed work that you have executed that was subsequently printed — as long as you are pleased with the result. Everybody's portfolio is full of "brilliant" work that never saw the light of day — you will automatically be one-up if you show good work that did.

Showing your portfolio

At this stage, it is as well to understand the machinations of the commercial illustration industry. Nothing could be worse than to get the wrong reaction to your work because you have approached the wrong people.

Quite often, the illustrator will only have contact with his or her agent, who is well-known in advertising circles and is entrusted to secure a steady supply of work. The advertising agency pays the agent, who takes a cut before paying the illustrator. The illustrator's reference for the work is a rough layout supplied by the Art Director who has conceived the

The chain of command

In advertising, the major source of work for professional illustrators, there is a lengthy chain that leads up to a commission.

CLIENT: manufacturer of product ▶

ADVERTISING AGENCY: appointed by client ▶

ART DIRECTOR: employed by advertising agency ▶

ART BUYER: employed to 'buy' the illustrator ▶

ILLUSTRATORS AGENT: independent ▶

ILLUSTRATOR:

There are variations, as many smaller agencies do not employ art buyers and some illustrators prefer to dispense with an agent and work directly with clients.

advertising idea, usually in tandem with an advertising writer. Publishing houses, another good source of work, also employ Art Directors; often, though, an illustrator is given only a copy of the text of the article which the illustration will accompany. This gives the illustrator much greater freedom to interpret the "message" of the text. Unfortunately, publishing houses as a rule do not normally pay as well as advertising agencies.

So who should you show your portfolio to, assuming that you now want to work freelance, which means you are a self-employed illustrator available for hire at a price? Big advertising agencies operate a Catch 22 principle: they will be reluctant to see you unless you are a big name, but you need them to help you make your name. Agents will offer encouragement, probably hedging their bets by asking you to return after a year or so. Unless they see proof that you can deliver good work, on time, they will be unwilling to lay their reputation on the line. They have everything to lose.

Essentially, to start off with you are on your own. You will have to tout your portfolio around the kind of places where you are more likely to forge a direct link with someone empowered to make the commissioning decisions: smaller advertising agencies, design studios, and especially magazines, publishers and direct clients. The latter category can pay big dividends if you are prepared to wear out your knuckles knocking on doors. Direct clients—the large, medium or small businesses that constitute the client in the chain described above — can say yes or no on the spot, and they are usually delighted to work closely with creative people who can make an everyday product look special.

Being freelance

A freelance illustrator is a hired hand. Some people will hire you because your talent can make an average idea look like a good idea. Others will hire you because they have a brilliant idea, and your talent is required to do it justice. Whichever the

case, one thing you cannot do is behave like a prima donna. You will be working against tight deadlines and if you accept the job, you will be expected to deliver. It is not good enough to be capable of doing the job: you must also be able to do it quickly. Similarly, he who pays the piper calls the tune: people will verbally tear your work apart in front of you and you will have to accept it. Requests for alteration, even outright rejection, are commonplace and if you cannot stomach that, you will not enjoy life as a freelance.

Despite all the pressures and all the hours you must put in, the life of a freelance airbrush artist is not one to be readily exchanged. You have the freedom to develop your own style, and you get the opportunity to contribute ideas of your own. On top of that, once the early struggle is over, you get paid handsomely for your work.

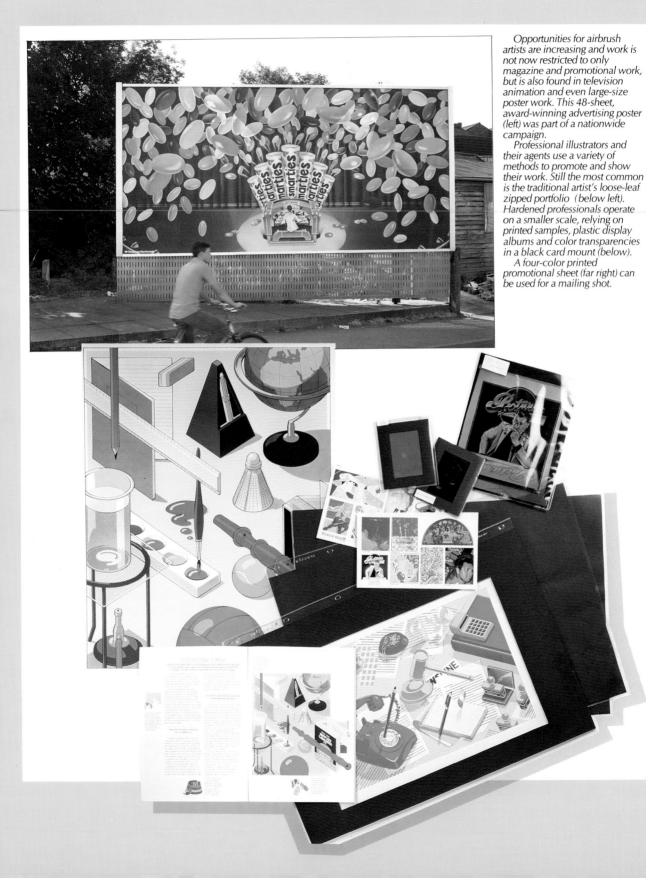

Opportunities for airbrush artists are increasing and work is not now restricted to only magazine and promotional work, but is also found in television animation and even large-size poster work. This 48-sheet, award-winning advertising poster (left) was part of a nationwide campaign.

Professional illustrators and their agents use a variety of methods to promote and show their work. Still the most common is the traditional artist's loose-leaf zipped portfolio (below left). Hardened professionals operate on a smaller scale, relying on printed samples, plastic display albums and color transparencies in a black card mount (below).

A four-color printed promotional sheet (far right) can be used for a mailing shot.

CHAPTER

– THE EXPERTS –

In the following pages, you will meet some of the people who earn a living from airbrushing or airbrush-related work. Some of them swear by the airbrush, others swear at it. All of them, however, have one thing in common: a fund of useful advice that is born of experience with the airbrush and is, therefore, worth its weight in gold. Much of this advice tallies with the practical assistance given in earlier chapters; occasionally it contradicts previously suggested courses of action. No matter. It's just further endorsement of the recurrent themes throughout this book: that no one way is always the right way to do things, and that the only way to learn anything is to experiment and thereby gain experience.

*D*avid Bull got off to an inauspicious start when he was expelled from junior art school for "naughtiness" at the age of 15. This admirably qualified him for a career in advertising, which he duly pursued for five years in an agency studio.

Five years was enough, and there followed a period of extensive travel and a successful, though poverty-stricken, dalliance with fine art. Moving to London, David Bull worked for various publishing houses as a designer until suddenly, in 1970, his fate was determined by two simultaneous events. He "awoke to illustration" while viewing the Pushpin Exhibition, a traveling exhibition of illustration and graphics from the American Pushpin studio, and a friend departed to the United States, leaving behind an airbrush and compressor. Once accustomed to the instrument's weird and temperamental habits, Bull found it could produce the results he had been struggling to achieve with a brush and paint washes. He intends now to market a series of prints.

■David Bull: book jacket artwork for Robert Ludlum novel ■David Bull: album sleeve for Elvis Presley's early hits

Comment

After years of airbrushing with clean, pampered equipment, it still turns on you by spitting blots over the only area it is impossible to cover up, or bleeding under the masking film where it really matters. You just have to accept that mechanical things are a law unto themselves.

I do all my preliminary drawing on a tracing pad, then redraw and retrace until I am happy with the composition. My final trace is a mirror image, so I turn it over and rub down the area I'm going to work on first. I always start by spraying the toughest part: it's no use getting halfway through an illustration only to blow it on the hard bit. I usually work on 4R Hammer paper with inks because, being transparent, they allow me to mix the colors by laying one ink over another. If I can't find the right colors in inks, I use Dr Martin's watercolors. I also always work on a large scale, because that gives me more freedom to introduce textures. I like to stylize my work and I do enjoy tackling the odd bit of creative lettering.

Equipment

Devilbiss airbrush and compressor. He describes both as "geriatric." "The Super 63 occasionally needs a new needle and nozzle set, but the compressor is so well-made it goes on forever."

Areas of work

Mostly advertising and editorial, occasionally TV graphics, packaging and album sleeves.

Tips

■ I can't stand hard edges . I cut stencils out of thin card and adjust the softness by varying the distance between stencil and surface. This adds depth, with sharp foregrounds and soft backgrounds. For very intricate areas, I use masking fluid and a drip pen.

■ Clean needles with wood alcohol, which acts as a solvent to inks. I flush the airbrush with alcohol between colors and soak nozzle sets in alcohol overnight. Every now and then, treat the whole airbrush to a bath in wood alcohol.

*A*drian Chesterman was painting graffiti on walls at the age of five. It was probably very good graffiti, too, because after four years at art school he was accepted by the Royal College of Art in London.

■ Adrian Chesterman: Rothmans advertising poster

■ *Adrian Chesterman: film poster for Handmade Films*

Simultaneously, he was talent-spotted by an illustrator's agent, and a year later he jettisoned the Royal College of Art in favor of full-time illustration. He claims that his studies taught him nothing and that he learnt airbrushing by practice. "I couldn't stand the art snobbery at the RCA and I was beginning to make a real go of illustration, so there was only one decision to be made."

Comment

I hate airbrushing. My masks always bleed, my airbrushes are worn out and filthy, and I just can't help it. So, I keep the airbrushing time down to a minimum with my three airbrushes all going at the same time for different colors. I probably spend double the airbrush time working over the top of the sprayed areas with everything from oil paints to emulsions, crayons to sharpened nails, ballpoints to pencils. If anything, the airbrush, because it's so complicated and messy, actually interferes with the general creative process, and that can deter the beginner. It is a good means of putting down areas of pure or graded tone as quickly as possible, but it is not a panacea for all creative ills. Without conceit, I feel that I've gone as far as I want to in illustration, and I'm now working on my own ideas with the aim of holding an exhibtion in a few years' time. But the gap between fine art and commercial illustration is still as wide as the Grand Canyon.

Equipment

Three Devilbiss 63s, two large-nozzle and one fine-nozzle; large Devilbiss spray gun for huge backgrounds; toothbrush for flicking paint, instead of a spatter cap; "millions" of fine paint brushes – "because I keep pulling the hairs out."

Areas of work

"I began with a cover for *Bike* magazine, therefore tying myself to motorbike illustrations for two years. Then album covers and Penguin book sci-fi covers and then on to advertising, where I remain because of the money. I do occasional album covers, for sanity's sake."

Tips

■ My one big word of advice is not to adopt a purist attitude to airbrushing. Think of it as another tool in the artist's paint box – keep an open mind about mixing media, spray through pieces of absorbent cotton and gauze to get the desired effect, in fact use everything imaginable. No one will mind how you get there, as long as you get the right result.

■ Don't fall into the trap of thinking that the airbrush will be the answer to all your drawing problems. It isn't. You've got to be good at all the basics first – perspective, chiaroscuro, composition, color blending, and so on.

*P*hil Dobson was employed for three years as a signwriter after leaving school – "a great foundation for a career in airbrushing."

Vocation led him to art school, where he helped to finance his studies by lettering price tickets for a local department store: "The price of ladies' undergarments, that sort of thing." On leaving college, he instantly struck lucky in London on the strength of his portfolio, which as yet contained no airbrush work. A couple of years later, his friend and fellow illustrator Mick Brownfield encouraged him to try airbrushing for an advertising commission. The agency liked the illustration, the finished work went in his portfolio, the portfolio was shown to more agencies, and suddenly Phil Dobson was an airbrush artist.

Comment

I used to work solely on PMTs (photo-mechanical transfer prints) which enabled me to put down clearer, more accurate line drawings than any art board. It is a good method but rather limiting and expensive, so now I use Schoellershammer board.

My use of the airbrush is mainly as a filling-in tool for flat colors and textures, so I place a great deal of emphasis on the drawing. I do this with a drafting pen and French curves, so I end up with a strong line drawing which I embellish with the airbrush.

Equipment
Devilbiss Aerograph Super 63, small Fracmo compressor, Magic Color inks, spatter cap.

Areas of work
A little bit of everything; a lot of advertising.

Tips
■ Nothing is sacred when it comes to creating textures. Everything from toilet paper to old socks is perfectly legitimate for spraying through, over, around, or under.

■ Don't be afraid to become "stylized." Nothing could be more detrimental than a nation of airbrush users all churning out the same formula stuff.

■ *Phil Dobson: music book cover*

*D*avid Juniper's work is nearly all advertising-related; this is perhaps not surprising as he is well-known within the industry from his days as a successful art director.

After graduating from an art school course in graphic design, he was taken on by the London office of a leading American advertising agency, Ogilvy and Mather. He subsequently moved to another American-owned advertising giant, Batten, Barton, Durstine and Osborne, before forming an illustration and design company, Wurlitzer, with two partners in 1972. Since 1981, he has trodden the path of the majority of airbrush professionals, working freelance from his London home.

Comment
My method of working is a combination of airbrush and flat color, using shapes of color in a collage style, sometimes using detail sparingly to enhance the overall design approach. Gouache is my preferred medium, because I have found that airbrush drawings executed in inks fade rather quickly. Also, unless your compressor has a pressure control, inks tend to bleed under masking film. I use Schmincke gouache, which is rather expensive, but I have found it smoother than other brands. There are other compressors similar to the Conopois, but in my view the Italian standards of craftsmanship are superior.

Over the last couple of years, I have been moving into the print market and in the future I intend to work on canvas using both airbrush and paintbrush, to overcome the limitations of certain aspects of the airbrush.

■ *David Juniper: artwork for greetings card*

Equipment
Four airbrushes: Devilbiss Aerograph Super 63, Devilbiss MP, Olympos and Conopois. Italian-made Conopois fully-automatic compressor.

Areas of work
Mainly advertising, from both advertising agencies and design groups. A few book jackets and record sleeves, plus some greetings cards, gallery prints and posters. Occasional magazine or book illustration work.

Tips
■ My tip for beginners is elementary, but essential: keep your airbrush constantly clean, particularly if you're using inks or acrylics. Otherwise, paint dries to a crisp coating on the nozzle and needle and it's both difficult to remove and potentially damaging to airbrush parts.

■ When working on a larger project, I always re-mask each new section – I like to get off to a clean start, able to see exactly what I'm doing.

*J*ohn Harwood is a leading exponent of the photographic style of airbrush illustration, much demanded by advertising agencies and their clients. His background represents a classic route for his speciality.

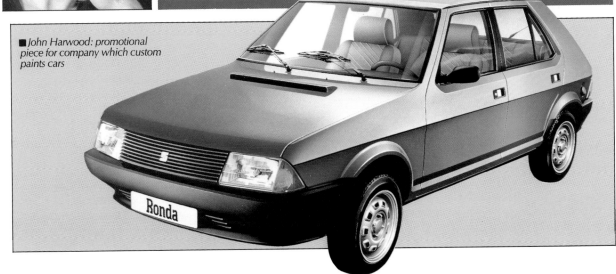

■ *John Harwood: promotional piece for company which custom paints cars*

■ *John Harwood: artwork for Philips shavers*

John Harwood started his training at a technical college, which was followed by employment as a design draftsman, then freelance illustration. Not surprisingly, his formative years with the airbrush were spent doing predominantly technical illustration – "metal, plastic and glass, the sort of stuff that stands me in good stead now that I'm mainly occupied with advertising packaging work." The level of accuracy that he achieves necessitates exacting use of masking film and scalpel, and he is always trying to improve his techniques. "I've still got a long way to go and a lot to learn."

Comment

Things that look perfect don't look real, so I use any method I can to get away from the perfect look. A coarser finish creates depth in an illustration, so occasionally I turn the air pressure down low or work with an airbrush with a blunt needle to achieve different textures. Flicking paint with a toothbrush also helps to add depth, as does spraying at an oblique angle – but underpaint your base color at the correct angle first. The way I

work, nine-tenths of airbrushing is scalpel work. Again, I don't keep rigidly to conventional methods, because I find that I can achieve a nice free-flowing effect by "drawing" freehand with the scalpel, rather than cutting to "stiffer" pencil lines.

Equipment

Lumina airbrush, plus a large capacity Devilbiss spray gun for backgrounds. Hydrovane 6PU compressor, set at 40 psi (2.6 bar).

Areas of work

Mainly advertising at present; usually "hardware" is the subject matter.

Tips

■ Try to incorporate as many stages into as few masks as possible. This is not for economic reasons, but to save double cuts on the artboard and to solve the problem of butting up colors – brown and red areas, for instance, can be dealt with in one mask. Reveal the brown areas first and spray a yellow/gray mix; then reveal the red areas and spray both – thus producing brown in the double-sprayed areas. Note, however, that this works only if you are using a transparent medium.

■ If you use inks, as I always do, it's a good idea to soak your airbrush when it's not in use to clean out any dried paint. I immerse the whole of my Lumina in wood alcohol, which is OK because all the parts are chrome-plated. You'll have to be careful with other makes of airbrush because wood alcohol damages some alloys. If in doubt, do as the manufacturer says.

■ If possible, try to avoid using cans of compressed air. They can be temperamental and, as the pressure fluctuates, you may find liquid gas flowing through instead of air. It is possible to buy a compressor at a reasonable price these days and if you add an appropriate moisture trap you should have a good, reliable propellant system.

■ Airbrush springs get slack, diaphragms get brittle. So I treat my airbrush to a six-monthly service and I'm sure this regular attention pays big dividends in terms of time and trouble saved. I would suggest that even those who don't use their airbrush too often should send it away for a routine service every now and again.

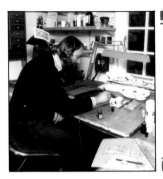

*C*hris Moore lives in a country cottage deep in a rural setting. It seems hardly the right location for an artist who numbers robot pin-ups and sleeves for heavy-metal records among his favorite works.

B ut that's where you'll find him, busily freelancing, as he has been since leaving the Royal College of Art, London, in 1972. At first he rented a studio in central London, close to the companies which commissioned his work, but later moved out to his rural retreat. After all his experience, he would like the satisfaction of getting his teeth into one large project and his advertising work is moving in that direction. He is never short of work and is currently enlarging his range of contacts in Europe and the United States.

■ *Chris Moore: "Tik Tok," book jacket illustration featuring a robot*

Comment
I work mostly on fairly large masked areas, using hand-held acetate masks for detail. I also tend to "draw" a lot with the airbrush, as well as using sable hair paint brushes. I use inks, acrylics, gouache, poster paint and watercolors, and the process is a case of knowing the effect that I want on a particular illustration and using anything and everything to achieve it.

Equipment
Conopois airbrush with miniature-type nozzle, Sim-air compressor, Schoellershammer line board. "The really invaluable tool is Frisk masking film."

Areas of work
Book jackets, record sleeves, advertising, editorial, posters, packaging, wallpaper design, science fiction, cut-out books, pop-up books.

■ *Chris Moore: "High Justice," Sci Fi book cover*

Tips

■ Avoid the temptation to use the airbrush for everything. This can be a mistake, because the nature of the technique tends to dictate the way the illustration looks, resulting in a pervasive similarity in much airbrush work. Use the airbrush as one means of applying color, just as you would a sable brush, rag, sponge or even your fingers.

■ Keep a pencil-shaped typewriter eraser handy – it's useful for taking out highlights.

■ Find out exactly how your airbrush works. This will give you the confidence to handle the instrument with assurance, enable you to work more quickly, and help you to avoid countless hours of trying to get your airbrush to work properly when you've left it bunged up from the night before.

■ Chris Moore: "All Fired Up," record sleeve for a heavy rock band

*M*ark Thomas didn't like the airbrush much at college. However, the airbrush must have liked him, because he achieved the impossible.

No sooner had he left college in 1976 than he was taken on by a top London agent; no sooner had he signed up than he was commissioned by the best of British clients, *Radio* *Times* magazine. He became aware of the value of the airbrush in this work.

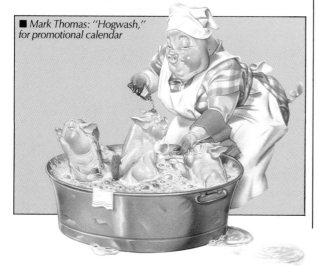

■ Mark Thomas: "Hogwash," for promotional calendar

Comment

I personally like disguising my airbrush work to some extent, or at least I try not to let the "apparatus" become more important than the drawing. Draftsmanship is a considered skill and more attention should be paid to it, rather than to the sometimes superficial effects of the airbrush. I don't work solely with the airbrush or in any particular style, and I like to change my techniques to suit the job. I'm particularly fond of pastiche, and will search around for styles that best communicate the idea of a drawing. Influences bombard me from all angles, most of all from the past: printed ephemera, films (I like shadows so it's *film-noir* and the German/Russian Revolution look) and comic books (I learnt to draw by aping them).

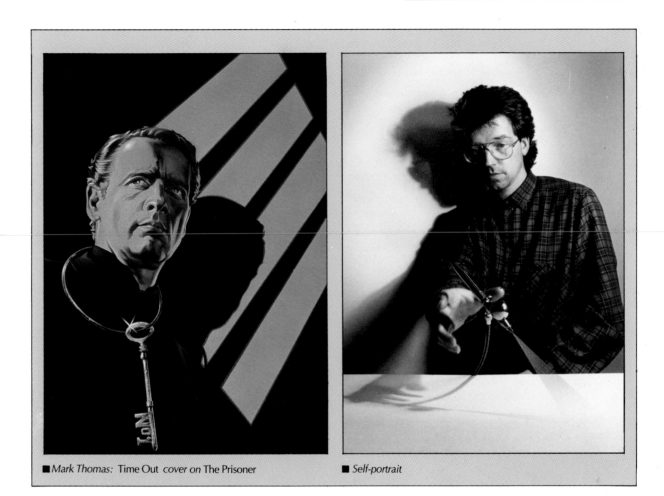

■*Mark Thomas:* Time Out *cover on* The Prisoner ■ *Self-portrait*

To get down to basics, I try to avoid masking films as much as possible: I do use it, but work largely with hand-held acetate masks, which give my work a sort of "chunkiness." My pet likes are using opaque white highlights drawn with a pen, spattering, and using duff airbrushes to get cruder finishes. My pet dislikes are the side effects, like getting bright blue gouache up my nose and ink under my nails.

As for ambitions, it would be nice to do more in the music line – album sleeves, sheet music covers and promo stuff – especially with bands whose music I admire. Advertising didn't appeal much when I started, but now I can't get enough of it. Or rather I can, but more of the same is always very welcome. I only wish someone would work out a way to amend airbrushed artwork quickly because advertising, in particular, sometimes demands very difficult changes at the drop of a hat.

Equipment
"I'm not very technical but I do appreciate the reliability of the Devilbiss Super 63E. Compressors only bother me when they don't work; mine is a Sim-Air."

Areas of work
Originally, mainly editorial: now mainly advertising.

Tips
■ If it doesn't bug you too much, always wear a face mask.

■ Experiment. Don't be scared of the airbrush.

■ Try to evolve your own style, beyond the usual slick, super-shiny look. Funnily enough, the best way to do this is to look at other people's work, past and present.

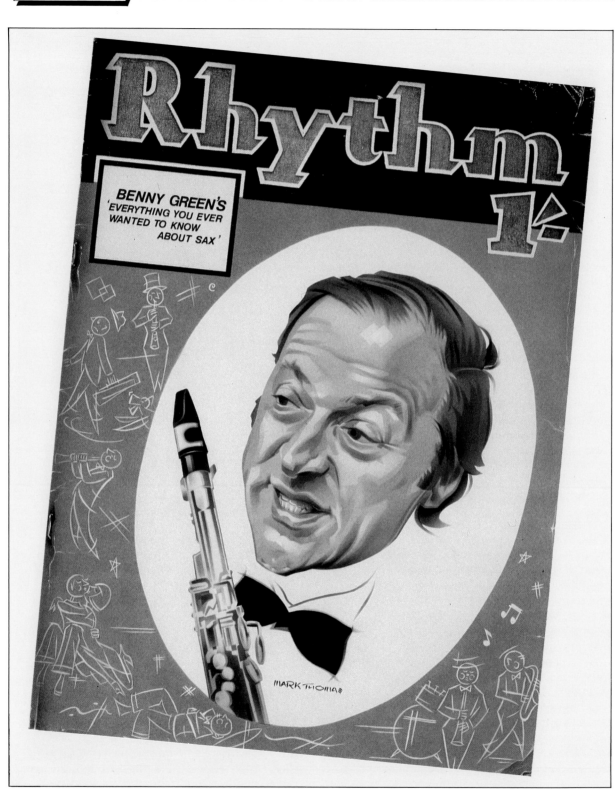

■ *Mark Thomas: illustration of Benny Green for* Good Housekeeping

*J*ohn Shipston began his career in the days when all you had to do to land a job in an art studio was knock on the door and demonstrate enthusiasm. This was the mid-1950s, but even the most talented junior had to work his way up.

John Shipston's first duty was making the tea in a commercial artists' studio. By this means, he learnt the art of airbrushing in the best possible way, looking over the shoulders of the five airbrush artists employed by the studio. At that time, every shot in every brochure was heavily retouched – "indecently so, but that was the style of the day." After months of painstaking execution of engineering diagrams, it was a great day for John Shipston when he was finally given an airbrush all of his own. In a luxury rarely afforded nowadays, when the principle of time-is-money governs all, he was also given plenty of time to practice airbrushing: "tubes and spheres and that sort of thing – it's absolutely essential to be able to light and shade them from scratch, because how can you retouch the image if you don't understand the object's perspectives in the first place." After seventeen years in various studios, John Shipston became a freelance retoucher in 1976.

Comment
Most of my work involves removing unwanted blemishes from the photographic image: de-rusting metal objects, taking out reflections, filling in scratches. I always work 25 to 50 per cent upsize so everything blends together well when the photograph is reduced for reproduction in print. Also, I always do the background last – it's the last mask; if you do it first, there's always a good chance that you'll mark it and have to do it again.

Equipment
Three Devilbiss Aerograph Super 63s and a Sprite Major – "over the years my hand has become Aerograph-shaped and any other airbrush seems alien." Large Aerograph UBI compressor: "it never runs out of puff even on the largest backgrounds." Schmincke retouching paints, Frisk masking film.

Areas of work
Black-and-white photographic retouching, mainly of brochure shots, commissioned by direct clients in manufacturing industries. Some editorial and advertising work, plus some color retouching. A steadily increasing amount of airbrush illustration.

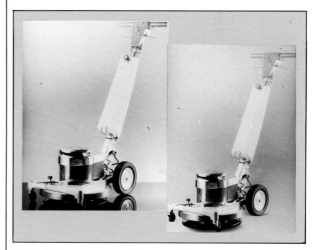

■ *John Shipston: promotional work involving photo-retouching*

Tips
■ If anything, err on the side of spraying too little paint. It's easier to add than to take away.

■ If you're modifying a mat print, you can save yourself time by cutting out the tracing paper stage. Instead, you can draw straight onto the photographic paper with a pencil, and cut masks to the pencil line. Then you can obscure the pencil marks with paint.

■ Cleanliness is everything. At night, I always put a rolled tube of gummed paper over the airbrush tip and color recess, to protect the needle against knocks and prevent dust entering the recess.

*E*leanor Allitt is a former professional textile designer, who now operates her one-woman business from home, producing up to 100 headsquares and scarves a week.

A dissatisfaction with the lackluster colors of mass-produced printed fabrics led her to produce one-off designs with the airbrush: "a quick way to get a design onto silk with a minimum of equipment – also, I like the characteristic way that the colors blend into each other." Having found an effective way of applying color to fabrics, Eleanor Allitt is now looking for a way to combine airbrushing with an equally successful method of printing – "lino-printing could be the answer."

Comments on working method

Working surface I sandwich three layers of cushioning between my solid wood table and the silk. First, on top of the wood, I have a layer of carpet underfelt that acts as padding. On top of that is a waterproof oil cloth to avoid disasters if I spill any paint, and on top of that is a gummed-cotton backing cloth. These layers build up a smooth, padded surface on which the silk can be firmly mounted.

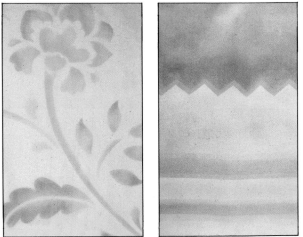

■ *Eleanor Allitt: scarf and fabric designs*

Choosing silk I use lightweight or occasionally medium-weight Habotai silk which is fashion quality but not unduly expensive. It accepts the dyes well and dries very quickly. I work exclusively on white silk because it shows the colors off best. Obviously, there is no problem in spraying cottons, my only advice being to make sure that your combination of fabric and dye or paint is colorfast, weatherproof and machine-washable. My headsquares are 36 in (90 cm) square, scarves are 46 in by 9 in (115 cm by 23 cm).

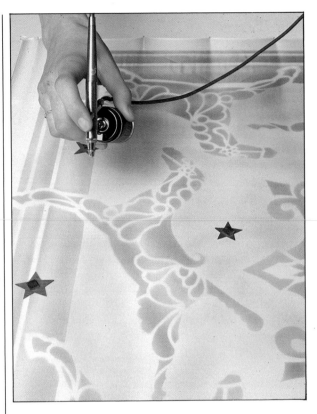

Choosing dyes It's critical to use the right dyes in the right consistency. Those I use are not widely available and not particularly easy to get on with at first. It's perhaps best for the beginner to start by trying a fabric dye recommended for use with an airbrush, such as the German Deka permanent dyes for silk or cotton, which can be found in craft shops. You can thin them with Deka colorless paint or water to ease them through the airbrush. The big advantage of this dye is that you need only iron the silk to fix the color – no steaming is necessary.

Preparation Mount the silk by pinning it to the backing cloth around the edges at 7.5 cm (3 in) intervals. When it's rigid and smooth, iron out all the creases so that the dye will go on evenly. To spray your design (I draw mine up on layout paper first) you'll no doubt need to use stencils and these are best cut out of oiled Manila stencil card. My advice would be to start with an easy shape such as repeating leaves or flowers, but something more abstract shouldn't present much problem. Stencil card is easy to cut with a scalpel and you can weight it down on the silk with any small, heavy object: I use some scrap lumps of lead left over from my studio roof!

Spraying I mix colors in the airbrush color jar, transferring the dye to the jar with a syringe. Alternatively, you could mix them in an old glass jar and transfer the mixed color – it really doesn't matter. With my designs, I find myself spraying, shifting the stencil, then spraying again. It all depends on the pattern you want to achieve. Dyes tend to dry very quickly, and I just hang up the finished silk to avoid creases.

Fixing With the Deka dyes, the manufacturers recommend that you just iron the wrong side of the silk to fix the color. With the dyes I use, steam fixing is necessary. I use a steamer that I bought in Paris at some expense, but an ordinary culinary steamer like those used for steaming vegetables is quite adequate to be going on with.

Equipment
Badger 200 airbrush, and Conopois compressor of Italian manufacture. Concentrated silk dyes "Super Tinfix" by Sennelier of Paris and H Dupont paints (diluted with alcohol and water).

Areas of work
Silk headsquares, scarves and dress lengths, sold at craft fairs and through retail fashion outlets.

Tips
■ Try not to spray too much dye in one pass: it may bleed under the stencil. Practice is the only way round this problem.

■ Be scrupulous about cleaning your airbrush. I take mine to bits when I've finished using it and make sure every part is spotless.

*A*lan Lay will paint anything that moves. He began on a small scale, spraying murals and lettering on motorbike gas tanks and the like, but now his company, Car Decor, can customize anything up to the size of an articulated truck.

His work is split between private customers who give him an open brief to design and execute "mobile" illustrations and companies who wish to incorporate house logos or advertising ideas into their vehicle liveries. He believes, with some justification, that a large mural on the side or back of a truck is a very cost effective way to advertise, in comparison with traditional media, such as newspapers, where the life of an advertisement is often no more than a day.

Comment

I think that the glossy finish attainable with the airbrush is, firstly, more pleasing to the eye than brush-applied signwriting and, secondly, more durable. Also, with a bit of coaxing, it's possible to spray some amazing "trick" paints through an airbrush, as well as the standard pure and metallic pigments. I like to use special prismatic metal flake that refracts under bright lights, breaking into all the colors of the rainbow. There are also paints that change color according to the viewing angle, and these achieve the key effect of any promotional exercise – they get noticed. I only wish more advertising agents and clients would realize the full potential of a quality airbrushed job. To airbrush successfully onto vehicles, you need to be equipped with the same basic grounding as any other illustrator: in other words, you need a feel for design and typography. A good grasp of mathematics is also vital because, believe me, you'll get through plenty of calculations for enlarging and reducing. Above all, you need to be extremely fit – spraying a 30 ft (9 m) truck is very demanding physically. I use a combination of techniques: for lettering and illustrative detail I find hand-cut stencils are invaluable, then I generally follow-up with extensive freehand airbrushing to add the final touches.

■ *Alan Lay: customized artwork for company truck*

Equipment

Iwata HP3 airbrush, Devilbiss G.G.A. airgun, cellulose paints, spray mount masking adhesive.

Areas of work

Promotional vehicles, custom cars and motorbikes, hot rods, dragsters, sporting vehicles, crash helmets, boats, and trade vehicles.

Tips

■ When more than one stencil is required for an illustration or lettering (for example, if you are spraying an identical design onto both sides of a vehicle), use a triple thickness of material and cut all three layers at once with a very sharp knife. You'll save yourself a lot of time and trouble.

■ When spraying cellulose, always wear a mask and never let the air temperature drop below 68°-70°F (20°-21°C). If it is lower, the adhesive properties of the paint can be affected.

■ Always rinse your airbrush between colors. Always keep it clean.

*P*aul Vester has been using an airbrush since 1973 and has seen the use of the technique in film animation grow, peak and then decline. He began making films as an art student and progressed to a postgraduate course in film.

Following graduation, he worked in two top animation studios, scripting and directing shorts, before setting up his own company called Speedy Cartoons in 1973. At this stage, working with only one assistant to help him, he returned to the role of illustrator as well as producer/director, working mainly with markers and watercolors – and his first airbrush. Nowadays, while he still considers the airbrush indispensable, he uses it less than before.

Comment
The airbrush is ideal for filling in backgrounds quickly, with a high degree of delicacy, subtlety and versatility. For instance, instead of fading by camera, I prefer to create dwindling shadows with airbrushed artwork. It's also extremely useful for colorization – enhancing the colors of still photography, or just spraying artwork to be optically combined into animated or live action work. It has to be said that the airbrush isn't in vogue in animation at the moment, but I'm always finding new uses for it and consider it essential for the creation of artwork for my animation. I think the airbrush is to art what the saxophone is to music: it may go in and out of style, but it's here to stay and people will never stop using it.

Equipment
Devilbiss Aerograph Super 63, Sim-Air compressor, Winsor and Newton watercolors, Schoellershammer board.

Areas of work
Animated TV commercials, animated "shorts", live action TV commercials.

Tips
■ Airbrushing is a stenciling medium: don't get bogged down with masking film, use various materials to get various effects. I primarily use acetate and oiled stencil paper because both can be used over and over again, which is vital for animation where much of the work is repetitive. But my advice to the beginner would be to experiment with stencils as much as possible.

■ Buy a compressor, not air cans. Airbrush equipment isn't cheap – it was years before I could afford to buy an airbrush and I got by with an atomizer – but even the cheapest compressor is better than struggling along with cans.

■ *Paul Vester: "Sunbeam," still from four-minute animation short*

■ *Paul Vester: still from TV commercial for Paxo stuffing mixes*

*T*erry Webster is to be found behind the stately facade of a classic English town-house, in a magnificently chaotic studio, producing unique models of hippos slumped in armchairs, lions driving go-karts, and busts of tiger-men.

Terry Webster arrived at modeling via illustration, where he enjoyed success as the creator of the "Captain Hippo" series of posters. His interest in modeling was fuelled by the inspired idea of giving three-dimensional life to the subjects of saucy British seaside postcards, notably fat ladies clad in unflattering bathing suits. He is now concentrating on a collection of major works – such as the tiger-man on page 120 – which he plans to exhibit and sell through private galleries. His primary use of the airbrush is for tinting certain features on the finished model, whether it's the nose of a pig or the highlights on a human cheek.

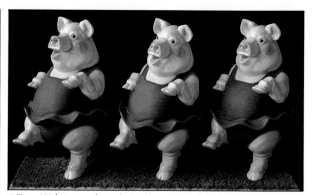

■ *Terry Webster: sculptural pigs for commercial sale*

Comments on working method

The master model I make a solid master from modeling clay, by hand, using the full range of modeling tools. In fact, to create different textures I use anything that I can poke or rub the clay with – fine sandpaper, for instance, is good for smooth noses. When I'm happy with the result, I seal the master with a coat of mat polyurethane varnish, applied with a brush. Then I leave it to dry for three or four hours.

The casting mold The next step is to make a hollow mold in preparation for casting. This is straightforward: I just brush four to six layers of cold-cure rubber onto the master model which, when cured, can be peeled away intact as a flaccid skin. The formulation I use is known as RTV 700, distributed by Sil-Mid. It's expensive and you do need to mix it with proprietary catalysts, but it's durable and produces a near-perfect skin.

The support mold Because the rubber casting mold is flaccid, it has to be supported during casting to prevent loss of shape. I make my rough support molds from plaster of Paris, filling in any undercuts to make sure that the support can be pulled away freely from the rubber after casting. You don't need an immaculate support mold, but you do need an accurate one.

Casting If it's a small object, I fill the casting mold solidly with either plaster of Paris or resin. I sometimes pre-mix a special coloring agent into the resin if the subject of the model has an overall dominant color – say, pink for a pig. If it's a large object, you have to adopt slightly different tactics because resin isn't cheap. Here I mix resin with plaster to a runny paste, then I paint the mixture all over the interior of the mold. I use a stiff hog hair brush to make sure that the paste gets into every nook. One coating isn't enough; I sometimes have to build up half a dozen or so layers. When the paste is dry, it should form a perfect shell – so now you can remove the support mold and peel off the casting mold. If you need to seal the base of the cast, you can use either cardboard or plaster: if the latter, stuff the shell with newspaper first to absorb plaster drips.

Finishing I use all sorts of media applied in all sorts of ways to "decorate" my models. The airbrush is ideal for highlighting features and for graduated fades. Thinned with an equal amount of white spirit, Humbrol enamels spray very well and adhere positively to plaster and resin. Gloss is preferable to mat, because matting agents will clog the airbrush. Masking is rarely necessary, but if I do need to hide areas such as the eyes when I'm spraying cheeks, liquid masking is the best option.

Equipment
Devilbiss Sprite airbrush, Sil-Air fully automatic compressor. Humbrol glass enamel paints, cellulose thinners for cleaning the airbrush.

Areas of work
Models cast in resin or plaster, either commissioned for promotional purposes or produced as limited editions for sale through galleries or quality giftware outlets.

Tips
■ Avoid using old paint because flecks of hard paint cause problems – mix fresh, runny paint as you need it.

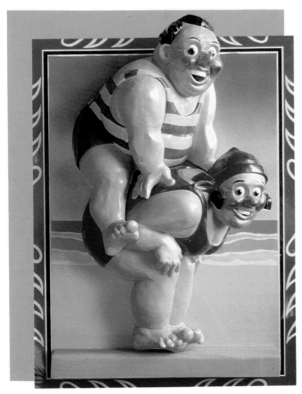

■ *Terry Webster: seaside postcard scene translated into 3D*

GLOSSARY

Acetate A transparent film available in a variety of thicknesses which can be used as a surface in animation; for overlays; or cut into different shapes for stencils.

Airbrush Invented by the watercolor artist Charles Burdick in 1893, the airbrush is a mechanical coloring tool which mixes air and paint together and propels the combination at a surface in the form of a fine spray. The airbrush consists of a fine internal needle, a nozzle where air and paint are mixed, a color receptacle and a pen-shaped body. It is connected by a hose to a propelling device and operated by a lever or push-button control *(See Double-action independent; Double-action fixed; External atomization; Internal atomization; Single-action fixed.)*

Air trap See Moisture trap.

Bar Unit of atmospheric pressure (approximately 14.5 psi).

Bleed Certain pigments stain; when these are covered by another color, no matter how opaque, they will show or "bleed" through. Pigments with this characteristic are clearly labeled by the manufacturer; care should be taken when selecting and using colors that will subsequently be overlaid.

Bromide A smooth, coated photographic paper sometimes used as a surface for airbrushing. It can be wiped clean easily.

Brushwork Many airbrushed illustrations include a fair proportion of brushwork, hand-painted work with a hair paintbrush. Brushwork is usually the final stage of an airbrush painting and is often restricted to fine detail or special textured effects, such as stippling.

Cel Individual acetate sheet used in animation. Airbrushing is done directly on the cels, one for each small change in a sequence of movement.

Color cup Receptacle for holding a quantity of medium which is either mounted on the side, recessed into the top or attached to the underside of the airbrush. In the latter case, the receptacle is often in the form of a detachable jar.

Compressor The usual propellant used to power airbrushes, the compressor has a motor which maintains an air supply at a certain pressure. There are two main types: tank and direct compressors.

Cutaway A style of technical illustration in which the internal components of a complicated mechanism, for example, a car engine, are revealed by cutting away a portion of the outer casing. This usually involves careful study of existing technical drawings; in some cases, the mechanism may actually be cut to provide reference. As in the convention, the cut sections are shown in red in the finished illustration.

Direct compressor A small compressor which does not have a reservoir tank for the air. The air supply is created by a motor fitted with a diaphragm system and pumped directly to the hose connected with the airbrush.

Double-action fixed A type of airbrush design in which the lever controls the supply of paint and air. The paint-air ratio cannot be varied.

Double-action independent The most versatile airbrush design, in which the lever controls the proportion of paint to air and the artist can regulate the density of the spray.

External atomization The simplest type of airbrush design, in which the air and paint are combined outside the body of the airbrush. Most spray guns are of this type.

Freehand Freehand spraying is using the airbrush without masking of any kind.

Frisk film A proprietary brand of masking film.

Ghosting A highly skilled technique of representing the internal workings of a mechanism in technical illustation. The ghosted image – or phantom view – is produced by making the surface layer seem transparent.

Gravity feed A method of supplying the medium in which the fluid reservoir is mounted above or to one side of the air channel and gravity draws the paint into the brush.

Hard-edged The type of airbrushing which displays clean, sharp edges and is produced by masking film – or hard masking.

Hard masking In general, masking which adheres to the surface, giving sharp outlines.

Highlights The lightest areas of an illustration. They can be created by spraying white, if an

opaque medium is used, or by leaving areas masked until the last stage if a transparent medium is used. Highlights can also be scratched back or rubbed back with a hard eraser.

Hose Connects the airbrush to the air supply.

Internal atomization Most airbrushes are designed so that the air and paint are combined within the nozzle to give a fine, even spray.

Knock back To reduce overall tonal contrast by spraying white gouache, for example, over finished work. This is often used to create a distancing effect.

Liquid mask A rubber compound solution which can be painted onto a surface and dries to act as a mask. It can be peeled or rubbed away when the airbrushing is finished.

Loose masking Any mask which is not stuck to the surface.

Mask A mask is simply anything which prevents the spray from reaching the surface. (See *Frisk film; Hard masking; Liquid mask; Loose masking; Soft masking; Stencil.*)

Medium In theory, almost anything which can be made to a certain liquid consistency can be blown through an airbrush. In practice, the most useful media are watercolor, ink and gouache.

Modeling The way artists build up the representation of three-dimensional forms on a flat surface to give the impression of volume and depth.

Moisture trap A unit which fits between the compressor and the airbrush to remove water from the air. Without a moisture trap, condensation can build up and cause blotting or uneven paint flow.

Montage Method of combining parts of different images – often photographs – to make a new composition.

Needle One of the most important and delicate components of the airbrush, the adjustable fluid needle controls the flow of the medium.

Nozzle The tapered casing which contains the needle and in which the air and paint supplies are combined.

O ring Tiny circular rubber washer at the base of the nozzle.

Propellant Any mechanism used to power an airbrush. Aside from compressors, these include air cans, air cylinders and foot pumps.

psi Pounds per square inch (approximately 0.07 bar).

Pulsing A spasmodic flow of air from a compressor without a reservoir tank.

Quick disconnect coupling A miniature joint at either end of the air hose that automatically shuts off the air when disconnected.

Regulator Attachment fitted to a compressor to allow adjustment of air pressure. It also acts as a moisture trap.

Rendering The process of working up an illustration.

Reservoir Sealed steel chamber capable of withstanding high pressure which is present in some compressors. The reservoir is fed from the air pump and supplies the airbrush with air. "Reservoir" is also a term for the color cup or paint well of an airbrush.

Retouching The adjustment of photographic images. The chief aims of retouching are to clean, mend, tint or edit the existing image and the airbrush is an important tool in such work.

Single-action fixed Airbrush design in which the speed or texture of the paint flow cannot be varied.

Soft-edged The type of airbrushed effect associated with the use of loose masking, where spray is allowed to drift and outlines are not clearly defined.

Soft masking Generally, masking which is not applied directly to the surface.

Spatter Granular textured effect caused by increasing the amount of paint and decreasing the amount of air.

Spatter cap Device fitted to the airbrush, replacing the nozzle cap, which gives a spattered spray.

Spray The fine mist of paint and air propelled from the airbrush at a surface. Blown-under spray can occur at the edge of a mask and may be exploited to diffuse contours. Overspray is where fine particles of paint drift over other · sprayed areas.

Spray gun Heavy-duty spraying tool, capable of holding large quantities of paint.

Starburst highlight Star-shaped highlight useful for suggesting a high sheen.

Stencil Ready-made cut-out shape or template which can be used as a mask.

Stipple Series of small dots to give tone and texture, often applied by hand with a paintbrush.

Stipple cap A type of spatter cap which produces spattering in fine, controllable lines.

Suction feed In this method of supplying medium, the color cup or receptacle is fitted underneath the fluid channel and liquid is drawn up into the path of the air. High pressure above forces a drop in pressure below, pulling the liquid up.

Tank compressor Large mechanism for supplying air, usually fitted with a moisture trap and containing a reservoir to maintain air pressure.

Technical illustration Highly finished illustration, usually of mechanical objects or systems, in which the purpose is faithfully to describe internal components, surface appearance, or both.

Torn paper mask Any piece of paper which is torn rather than cut and used as a mask. The uneven nature of such tears gives an effect which is useful for suggesting reflections.

Vignette An area of gradated tone, either within a shape or extended to create a background.

INDEX

Acknowledgements

1 Michael English/Colin Forbes Collection, New York; **8-9** Peter Owen; **10-12** Brent Moore; **13** Roger Stewart; **15** Ian Howes; **16-17, 20-1** Brent Moore; **22-4** Ian Howes; **25** Roger Stewart; **26-7** Ian Howes; **28-9** Roger Stewart; **32** Ian Howes; **33** Simon Critchley; **34, 35**(t) Ian Howes; **35**(b) Simon Critchley; **36-7** Peter Owen; **39**(l) Ian Howes; **39**(r) Fraser Newman; **40** Paul Wood; **41** Chris Moore; **42-5** David Bredin, Simon Critchley, David Evans, Tim Knott, Stuart Morris, Andy Sullivan; **46**(l) Andy Penaluna; **46**(r) Andrew James; **47-53**(b) Peter Owen; **53**(t) David E Weeks; **54** Ian Howes; **55** Lloyd Bugler; **56** Simon Critchley; **57** Paul Wood; **58-61** Lloyd Bugler; **62-5** Andy Penaluna; **66-9** Karl Lloyd; **70**(t) Otis Shepard; **70**(b) George Petty; **71** Simon Critchley; **72-7** Peter Owen; **78-91** Peter Owen/John Wright Photography; **92** Tim Martindale; **93** Mark Healey; **94** Stuart McLachlan; **95** Alan Holwill; **96-7** Jonathan Ninnis; **100** Joan Honour Smith/Royal College of Art; **101** John Shipston; **102** Joan Honour Smith/Warner Bros; **103-5** Joan Honour Smith; **106-7** John Shipston; **108-11** Joan Honour Smith; **112-13** Sue Wilkes; **114-15** Joan Honour Smith; **116-17** Sue Wilkes; **120**(l) DeVilbiss Ltd; **120**(r), **121-2** Ian Howes; **123** Andrew Pagram; **124**(t) Bob Murdoch; **124**(b) Connie Jude; **124-5**(c) Simon Critchley; **125**(r) David Hughes; **126-129**(c) Ian Howes; **129**(b) John Wright Photography; **130** DeVilbiss Ltd; **132** Doug Johnson; **133** John Wright Photography; **136** David Bull; **137** Adrian Chesterman; **138** Adrian Chesterman/Handmade Films; **139** Ken Harrison; **140**(t) Phil Dobson; **141**(t) David Juniper; **141**(b) **142** John Harwood; **143, 144**(t) Chris Moore; **144**(b), **145-6** Mark Thomas; **147** John Shipston; **148-9** Eleanor Allitt; **150** Alan Lay; **151, 152**(t) Paul Vester; **152**(b), **153** Terry Webster.

Key: (t) top; (b) bottom; (c) centre; (l) left; (r) right.